W9-AYV-897

DATE DUE

In This Timeless Time personifies the power of documentary work to humanize the inhumane, to transform the specificity of "being there," in this case a Texas death row, into an expanded, universal expression. Bruce Jackson and Diane Christian, artists and thinkers who work across mediums, demonstrate in this book the power of the long view, a central instrument of documentary. Importantly, Jackson and Christian also make strong policy arguments about capital punishment, using the power of their over thirty years of fieldwork in prisons to reflect on and challenge this abiding and complex issue. The impulse and tradition of using artful documentary expression to reveal and enlighten, and then drive toward social justice and reform, has been a major current in the practice of making documentaries for decades. Whether as interviewers, writers, photographers, or filmmakers, few are as articulate, artful, and relevant, or even timeless, as Jackson and Christian.

—*Tom Rankin and Iris Tillman Hill*

Documentary Arts and Culture

A series edited by Tom Rankin and Iris Tillman Hill

In This Timeless Time

Living and Dying on Death Row in America

Bruce Jackson and Diane Christian

Published by the University of North Carolina Press
in association with the Center for Documentary Studies at Duke University

Designed by Bonnie Campbell
Set in Adobe Electra and Glypha
by Bonnie Campbell
Manufactured in China

Cover photograph by Bruce Jackson

The paper in this book meets the guidelines for permanence and durability of the Committee
on Production Guidelines for Book Longevity of the Council on Library Resources.

The University of North Carolina Press has been a member of
the Green Press Initiative since 2003.

Library of Congress Cataloging-in-Publication Data
Jackson, Bruce, 1936–
In this timeless time : living and dying on death row in America / Bruce Jackson and Diane Christian.
 p. cm.—(Documentary arts and culture)
"Published in association with the Center for Documentary Studies at Duke University."
Includes bibliographical references and index.
ISBN 978-0-8078-3539-5 (cloth : alk. paper)
1. Death row—United States. 2. Death row inmates—United States. 3. Capital punishment—United
States. I. Christian, Diane, 1939– II. Duke University. Center for Documentary Studies. III. Title.
HV8699.U5J325 2012
364.660973—dc23
 2011035951

DOCUMENTARY ARTS AND CULTURE
*Drawing on the perspectives of contemporary artists and writers, the books in this series offer new and
important ways to learn about and engage in documentary expression, thereby helping to build a
historical and theoretical base for its study and practice.*

CENTER FOR DOCUMENTARY STUDIES AT DUKE UNIVERSITY
http://cds.aas.duke.edu

16 15 14 13 12 5 4 3 2 1

For all the victims

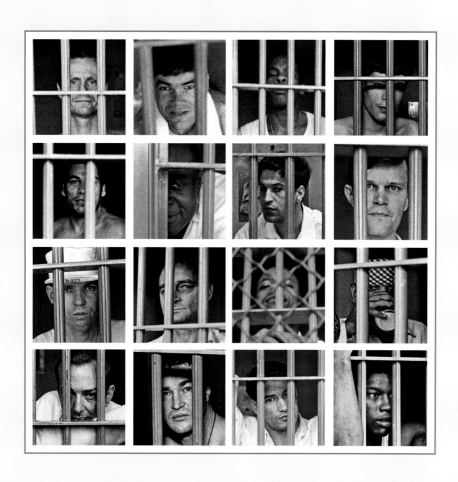

*When you go to the shower they holler, "Hurry up, hurry up and
take a shower. Hurry up and get back in your cage." And I tell
them, "I don't get no hurry from nowhere. I ain't going nowhere.
I ain't coming from nowhere. I'm right here, right now, always."
And that's all it is.*

—Thomas Andrew Barefoot, Texas execution number 621, in
conversation with Diane Christian, April 1979.
Put to death, November 30, 1984, Huntsville, Texas.

Have you ever thought of what it's like to live on Death Row?
Do you care? Do you really want to know?
We're kinda like an idling car slowly running out of gas
We really don't know how much time we will have to pass
Do you know what it's like to cry inside
or to wake up in the dark of night
Afraid you'll die without a fight?
We all live with one fear or another
Mine is how this hurts my mother
To see the pain behind her eyes
She just can't hide it no matter how hard she tries.
What makes this time so hard to bear,
Is knowing so many people just don't care
You all know we're here to die
We ask for help but you won't try
You just don't care about us as men
You think your killing ain't a sin
So we go on in this timeless time
And the law makes our people the victims of our crime.

—Donnie Crawford, Texas execution number 569,
 April 13, 1979. Sentence reduced to life, November 27, 1987;
 paroled, April 2, 1991.

CONTENTS

Preface. On Death Row xi

Part I. Pictures

1. The Row 3
2. Food 19
3. In the J-23 dayroom 29
4. A volleyball game in the cage 35
5. Hands and mirrors 45
6. Eight who were resentenced to life and are now doing time 59
7. Three who are still there, one who was resentenced to life and then paroled, and one who was set free after twenty-one years and then exonerated 83
8. Twelve dead men 97

Part II. Words

1. Being there 135
2. Killable killers 135
3. Dangerous people 138
4. Good time and hard time 140
5. The prisoner Jack Smith and the late Excell White 141
6. Terminology 142
7. Getting to J 143
8. Ellis's yellow line 148
9. Visitors 148
10. Counts 149
11. Recreation 151
12. Porters, floorboys, building tenders 154
13. Noise 155
14. Night, Brandon, Emily, and George 157
15. Violence 160
16. Craziness and boredom 162
17. All the things a man might do on the Row 163
18. Sockets and glass 164
19. Nowhere land 166
20. Time 168
21. Living space and killing space 170
22. The death house 173
23. Getting off the Row 175
24. Why execute? 177
25. Equity: *Callins v. James* 182
26. Giving up on death 187
27. Trends 188
28. Records 189

Part III. Working

1. Avoiding the Row 193
2. An invitation 193
3. Building tenders 195
4. Documenting the Row 196
5. Bona fides 198
6. "I'd like to cut your fuckin' throat" 201
7. Trust 204
8. Why talk? 207
9. Punishing Diane 208
10. Testifying 211
11. Screening *Death Row* 212
12. Brent Bullock Jr. and Norman Mailer 214
13. *In This Timeless Time* 216

Appendix 1. Layout of Ellis Unit inside the Fence 219
Appendix 2. The DR Three-Ring Binder 220
Appendix 3. Justice Thurgood Marshall's Dissent in *Gregg v. Georgia*, 428 U.S. 153 223
Acknowledgments 229
Notes 230
Sources and Further Information 235
Cases 238
A Technical Note 239
Index 240
About *Death Row* 242

On Death Row

Death Row is the generic and specific name for the special prison maintained in all U.S. juris-dictions with a death penalty. Death Row is for people in the legal limbo between the moment a judge pronounces a sentence of death and the moment that sentence is commuted, reversed, administered, or trumped by natural death, suicide, or murder.

In This Timeless Time is initially about life on Death Row in Texas. It is also about all the other American Death Rows, which across time and in various places differ in marginal ways but which, at their core, are not significantly different from one another.

This book has three parts. Part 1, "Pictures," consists primarily of photographs that Bruce took in 1979 while Diane and he were doing fieldwork for a documentary film and a book about Death Row in Texas.[1] The Death Row we visited occupied two sides of cell block J in Ellis Unit of the Texas Department of Corrections. Ellis is twelve miles north of Huntsville, where the system's headquarters and oldest prison are located. The oldest prison is officially named the Huntsville Unit, but it is called "The Walls" because it is the only building in the entire Texas prison system surrounded by a classic, old-time prison wall. All of Texas's executions take place at The Walls in a small building between the warden's office and the prison yard. On the day of execution, prisoners who are to be killed are brought from a facility where the guards and staff have known them for years to The Walls, where they and the guards and staff who take part in the killing operation meet one another for the first and—unless there is a reprieve that is vacated at a later date—only time.

Part 2, "Words," features commentary written in 2011 about that special prison and others like it, as well as information about the system that engendered and maintains them. Part 3, "Working," tells how we were able to document the Row, a place from which outsiders are usually excluded, and describes some things that happened during the course of that work.

We have included some things in the text parts of the book that we also have said or quoted in the picture part. We apologize for these repetitions or near repetitions, but the contexts were different and it seemed useful to put some information in more than one place. It is our hope that each of the book's

three parts makes sense on its own, and that the three in juxtaposition—one primarily of images and the other two primarily of words—inform one another in ways that make a coherent whole.

Some men whose images appear here have been executed, some have died; some have been moved into "population" (all prisoners other than those sentenced to death or in protective or punitive custody are said to be "in population"); some have been released; and one was released after three trials and a plea deal, then proved by DNA evidence to have been innocent.

Approximately 600 men were in Ellis prison for murder the day Bruce took the photograph of the Death Row count board (p. 4), but only 101 of them were there with a death sentence. Thousands of other men and women were doing time for murder in the twelve other state prisons scattered across east Texas. There was nothing, so far as we could tell, that distinguished the men on the Row under sentences of death from the men and women doing time for murder in Ellis and other units in the system, a fact pointed out to us many times by guards, convicts, wardens, and even the present and former directors of the prison system. There were men on the Row who had committed particularly gruesome murders or a lot of murders, but men who had committed particularly gruesome murders or a lot of murders also were on every other Ellis cell block and in just about every other Texas prison—and all those others were doing time rather than waiting to be put to death. The only differences anyone could point to were race and class of the victim (hardly anyone was on Death Row for killing a black person); the political ambitions of the district attorney (a case that might have pled out in an ordinary year could fuel a highly publicized trial in an election year); the location of the murder (some counties never went for a death sentence, while others seemed to cherish every opportunity to pursue it); and the quality of legal representation at trial (many Texas court-appointed lawyers were awful, or did awful jobs; only one man on Death Row when we were there had retained counsel, and a few years later his sentence was reversed and he was set free).

Sometimes pursuing the death penalty depended on how good a case the prosecutor thought he had. If he was sure he had a lock, he might go for the capital conviction; if he was a little iffy or the evidence was a little dirty, he might threaten going for death and then offer life in exchange for a guilty plea. An indigent defendant, looking at the power of the state on one side and a court-appointed attorney he had barely met on the other, might very well take the deal, no matter the quality of the case against him or the truth or falsity of the charges. Conversely, a defendant who was in fact innocent or who thought the prosecutor did not have enough evidence to get a conviction might turn down any kind of deal at all—

which was the choice made by Cameron Todd Willingham, executed in Texas in 2004 for killing his three children in an arson that experts now say never happened. The prosecutor offered Willingham life in exchange for a guilty plea; he insisted he was innocent and he was put to death.[2]

We have likewise been able to find no significant difference between the condemned men on Death Row in 1979 who were subsequently executed and those whose sentences were commuted or reduced to life or to a term of years. The closest we can come is this: some of them got lucky and some didn't. If there is a guiding principle in any of this, we have never found it and don't know anyone who has.

In two key cases—*Furman v. Georgia* (1972) and *Gregg v. Georgia* (1976)[3]—the Supreme Court attempted to eliminate or significantly reduce unfairness and capriciousness in the application of the death penalty. Those attempts failed. As Justice Harry A. Blackmun eloquently pointed out in his dissent in *Callins v. James* (1994), and as Justice John Paul Stevens reiterated in *Baze v. Rees* (2008), the application of the death penalty remains unfair and capricious. We shall have more to say about all of this in part 2.

At least one of the men we spoke with on the Row had not done the crime he was sent there for. Some had done far more crimes than the authorities suspected. Some people told us stories about their cases that we believed; some told us stories about their cases that we didn't believe. Our belief had nothing to do with the truth of the matter because we didn't know enough to know the truth of the matter. The one thing we knew for certain—hence the one thing we can tell you with confidence—is that every man whose image you see in this book was on the Row because he was a guard, a trusty, or a prisoner convicted of capital murder by a Texas jury and had not yet found a court willing to overturn that conviction or reduce that sentence. To explore the cases and the various factors that lead to capital trials rather than ordinary trials would be another project entirely, an inquiry into crime or the workings of the Texas criminal justice system.

Death Row differs from all other prisons in this one regard: it is the one prison in which everything happens outside of official time. Every other prisoner in the penitentiary is *doing* time; the condemned are suspended in a period between times when the official clocks are running. The clock stops the moment the judge announces the sentence of death; it resumes when the sentence is carried out, transformed into something else, or vacated entirely. The condemned live, as Donnie Crawford put it in the poem from which this book takes its title, in a "timeless time."

That doesn't mean that natural time doesn't go on for those men exactly as it does for you, us, and

every human being. Jack Smith was forty years old when he came to Death Row in 1977; he was forty-two years old when we met him two years later; he is seventy-four years old as this book goes to press, and he is still there. Time on the Row is timeless only in this sense: the criminal justice system takes no notice of it because it has no relation to the sentence that is keeping the prisoner there. If, because of an error at trial or a change in the law, a death sentence is converted to a life sentence or a term sentence, then the years on Death Row *do* count. But that is because the change in sentence is the justice system's way of saying "we shouldn't have put you there in the first place."

Some Death Rows are meaner and nastier than the Death Row we documented in Texas three decades ago—the current Texas Death Row, in which all condemned prisoners are subject to almost total isolation and a huge measure of sensory deprivation, is one of them—but the essential condition of being on Death Row is the same in all of them. In that regard, the recent conversations we have had with residents of Death Rows differ not at all from the conversations we had with residents of cell block J of Ellis prison in Texas. The transcendent fact is being in a situation where you are under total institutional control, living in a minuscule space, and waiting to get lucky or to be killed by people who want nothing you have, are not angry with you, and are authorized to put you to death in an orderly and tranquil fashion free of any moral or legal liability.

In our 1979 film and 1980 book, we tried to give the residents of the Row a voice about what it was like to live in that place and be in that condition. In this book, we try to let you see them as the individuals they in fact are and to tell you what has happened in the interim to some of them and to the system that undertakes the killing operation.

In This Timeless Time, then, is based on what we have come to understand about the things we heard and saw on that specific Death Row, about the institution that created it, and about the process and conditions that maintain and populate all of our Death Rows today. It is about capriciousness in the justice system's most significant process and act. The pictures in part 1 document a specific moment in the past; the book as a whole is about the present. The condemned live on Death Row, but the institution is, now as then and forever, ours.

Buffalo, New York | June 1, 2011

PART I

Pictures

A guard opening the door of row J-23 on Ellis Unit of the Texas Department of Corrections. Death Row was the two sides of cell block J—rows J-21 and J-23. Each row had three tiers, also called "rows." Each row had twenty-one cells, the first of which was a shower, which meant Death Row could hold as many as 120 condemned men. A few years later, the Row would overflow into block H, and then it would take over that whole end of the building. To the left of the J-23 sign are the bars of the "hallway picket," a cage accessible only from the corridor and from which another guard controlled all 120 cell doors on the two sides of cell block J.

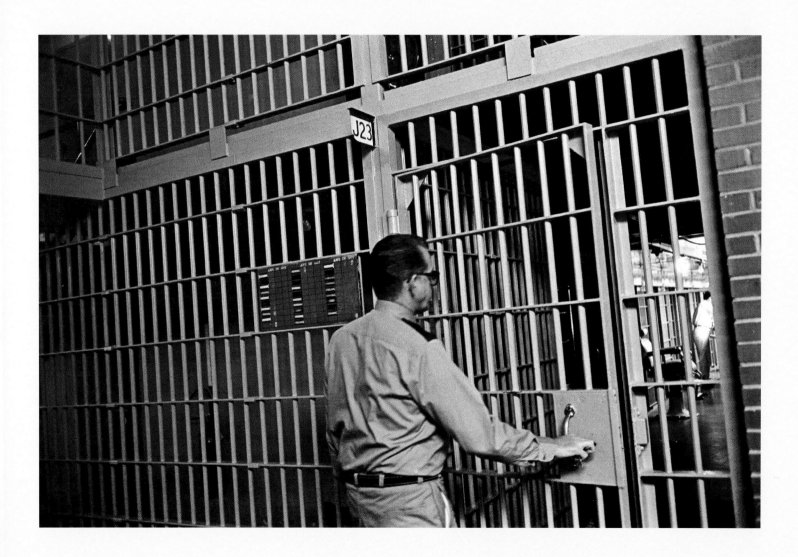

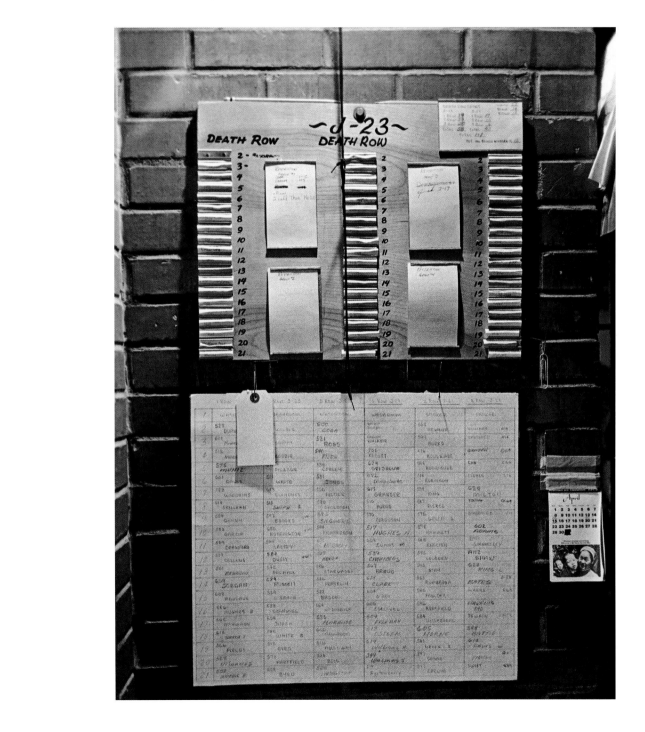

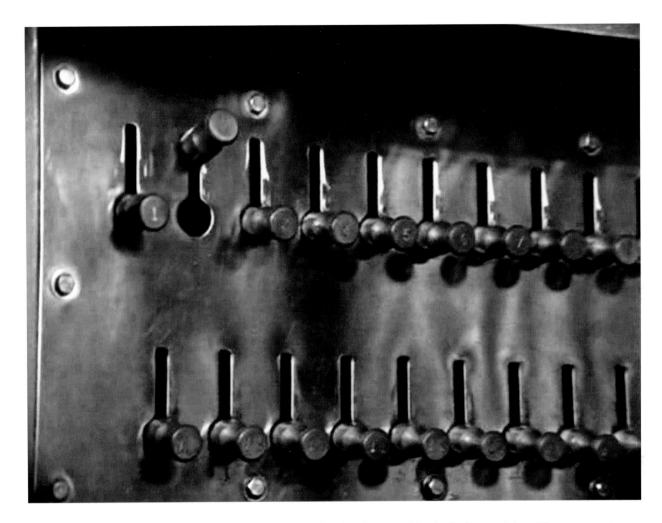

The pins that permit cell doors to be rolled open or shut by the guard in the hallway picket. There were six such panels, each located in the hallway picket at the corridor end of the six rows in J block.

The count board and cell occupant map on the wall at the guard's station on J-23. The slips of paper in the count board show which prisoner is in which cell of J-23; the occupant map has the names and execution numbers of all the prisoners on J-23 and J-21, as well as the names of protective-custody prisoners housed on three row of J-21.

The view from the corridor end of three row on J-23. Eight television sets were bolted to the walls between the windows. The men on one row watched television through their bars; the men on two and three rows watched through the cell bars and the wire mesh as well. Men on two row looked directly at the upper row of television sets from anywhere in their cells, men on three row had to move close to the bars and look down, and men on one row had to move close to the bars and look up. On clear days, the frosted windows around the television sets were very bright, so men watching afternoon soaps often squinted the entire time. Afterward, when they moved back into the darkness of their unlighted cells, they had difficulty seeing anything at all.

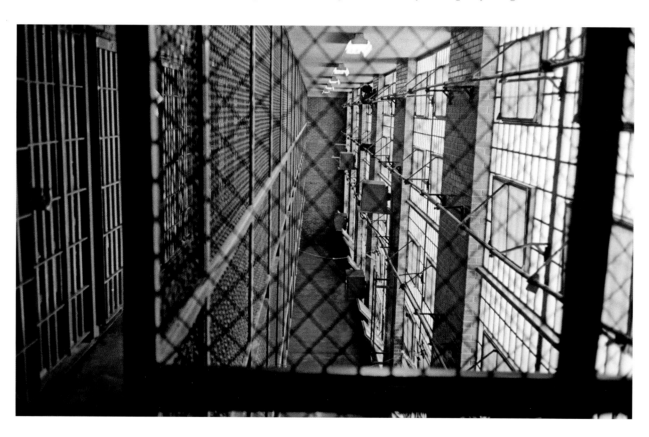

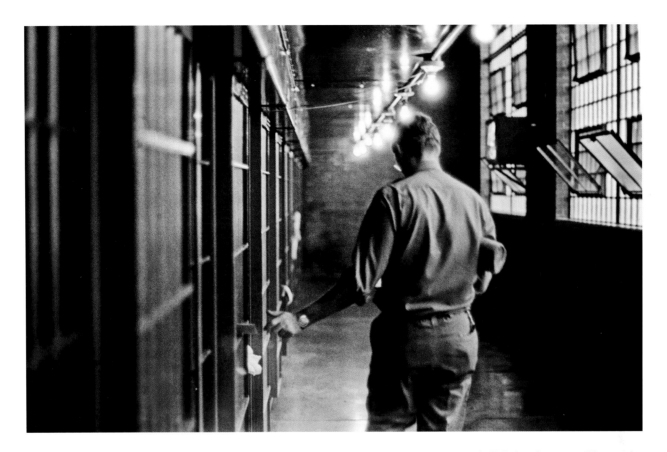

Correctional officer Scott Summerfield, the day-shift guard on J-23, delivering mail. "My hardest part," he said, "is deciding what to watch on TV at night. Because you got so many people wanting to watch this show and you got so many people wanting to watch that show. I can't take a vote in here because if I do, sports programs would get voted out all the time because there are more movie watchers than there are sports fans. And I have to use my discretion, which, at times, may not be the best choice as far as programs. They get riled up and hollering and shake the bars. And that gets on my nerves. And I try to help them out as much as I can as far as watching TV, but you just can't please them all the time. It's either I put on this show and I'm damned if I do and I'm damned if I don't. Someone always complains about it, no matter what it is. And that wears me down after so long."

THIS PAGE:

Every day, Summerfield would go to every cell on all three tiers with trays of safety razors; his counterpart on J-21 would do the same. The men who wanted to shave would take their razor from the tray and a dollop of pink shaving cream from the cup. A little while later, Summerfield would come back with his tray and collect the razors. Before he put a razor in its slot, he would always make sure the blade was still in place. Prison officials worried about injector razor blades because an inmate might melt the dull edge into a plastic toothbrush handle, thereby turning it into what they said was a dangerous slashing device.

Andy Barefoot, who was in the third cell of the first tier, found both that assertion and the razor distribution and collection process absurd. "They allow us to have glasses and everything in there," he said, "but they won't let you have no razor. You take a mirror, which is, I'll say, six, eight inches around, and you could take and break it if you wanted to kill anybody. I would know about it. I mean, I have been in this life of crime all my life and I would know how that you could harm somebody if you wanted to. Or the wire around the notebook papers, you snap a man, cut his neck completely off with it. But they won't let you have a little ol' razor which, if anybody came in on me with a little ol' razor, I'd laugh at him."

NEXT PAGES:

Emery Harvey, day-shift Death Row porter, mopping and talking on three row. "You have to be a social worker or a psychologist," Harvey said. "Just a good listener at times 'cause you come down the run with a mop, they'll stop you just for any little thing. An article in the newspaper, ask you questions, just to stop you to have somebody to talk to."

Charles Grigsby, second-shift Death Row porter on J-23. The porters three on J-21 and three on J-23—were all regular convicts, trusties doing time. They worked eight-hour shifts, seven days a week. They would all come out to help when meals were being served. All six were housed in the first three cells of J-21, two men to each cell. Everyone else on J block—the condemned men and even the protective-custody prisoners on three row of J-21—was housed singly.

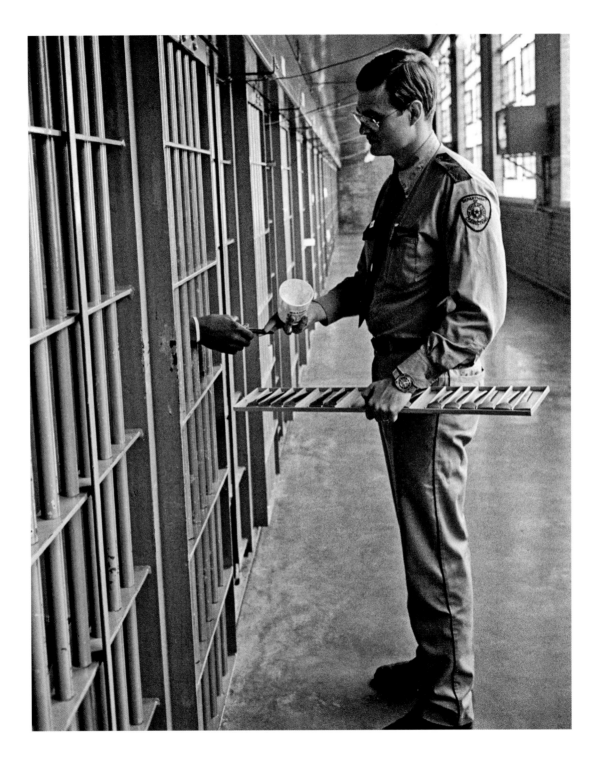

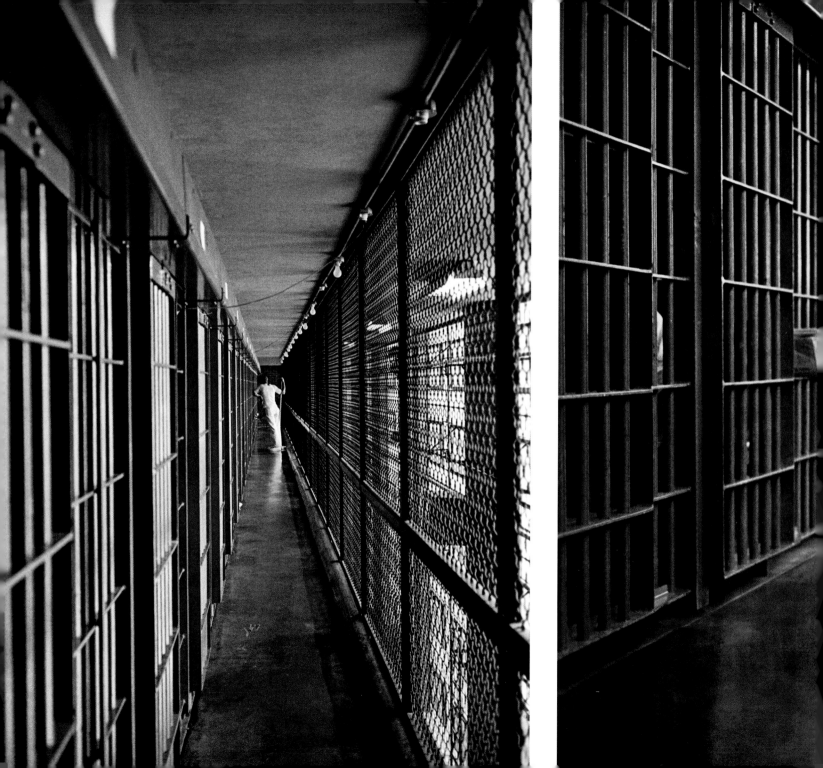

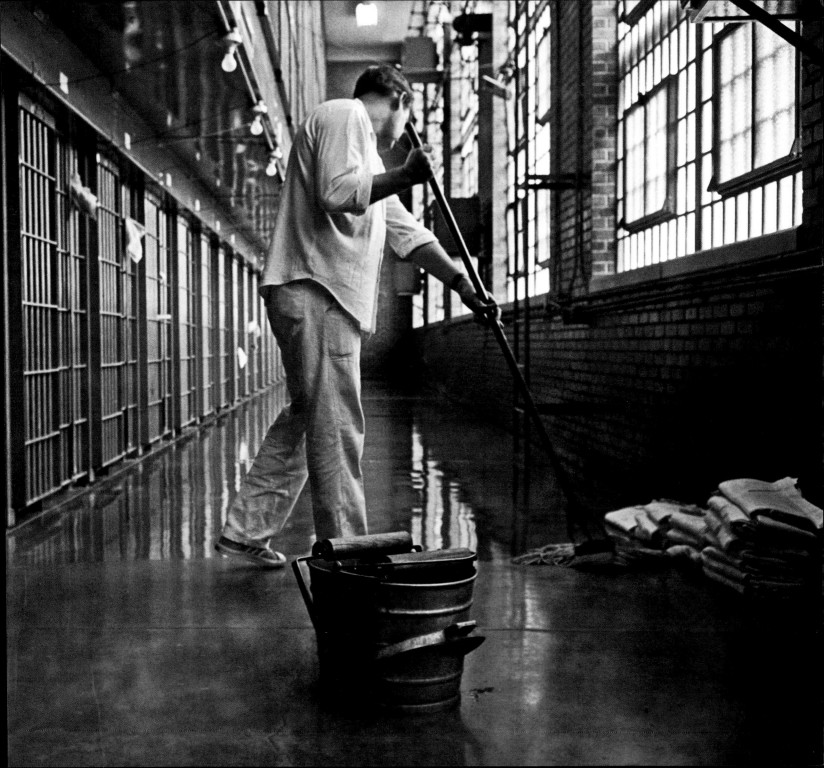

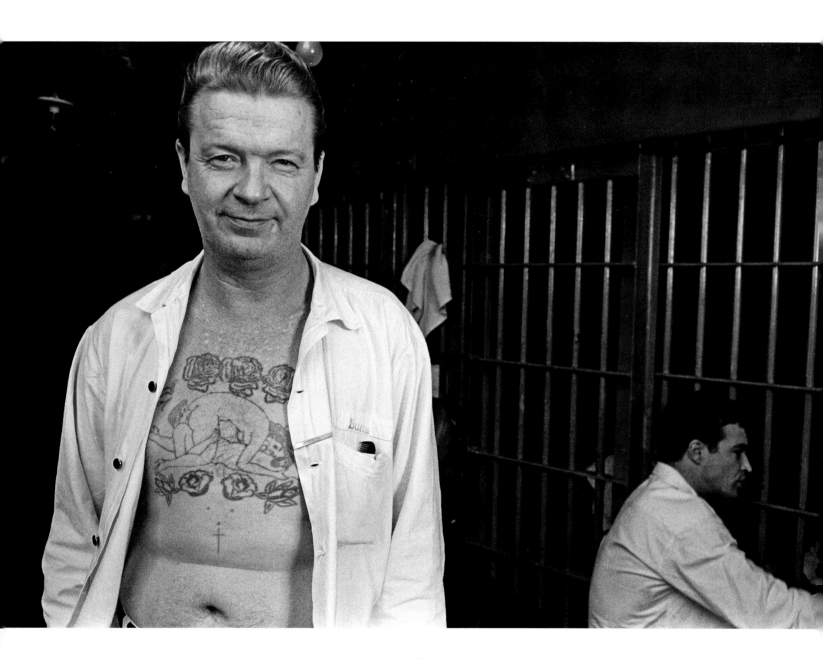

Donald Burns, the Death Row barber. To his right, Andy Barefoot, waiting for his cell door to open after a shower, talks with Mark Moore in cell 4.

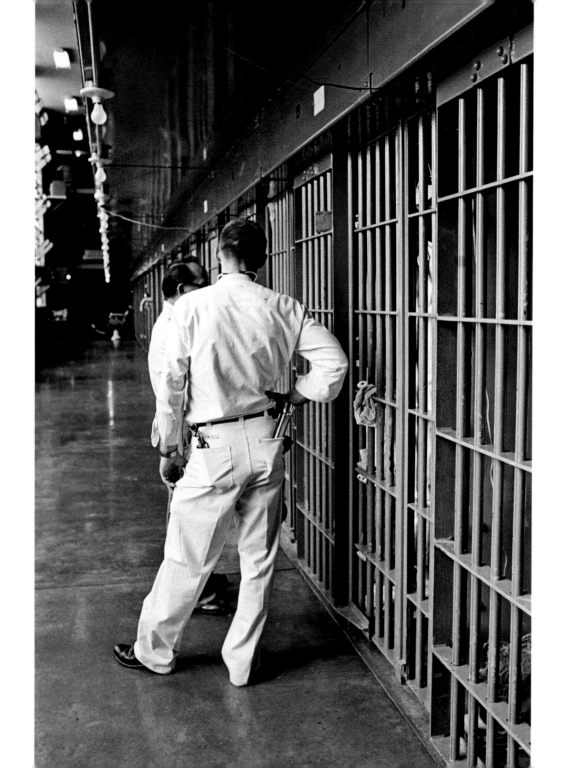

The prison doctor on one of his infrequent visits to the Row, accompanied by his convict orderly. Except for rare visits from a family member or a lawyer, or an even rarer court appearance, prison officials hardly ever allowed condemned men to leave the Row. If they fell seriously ill—*really* seriously ill—they might be taken to the prison infirmary, and if they needed surgery, they might get a trip to MD Anderson Hospital in Houston, which had a high-security prison ward. Occasionally, Death Row prisoners would get lucky and be taken down the hall to get some dental work done. Otherwise, any treatment they received was given to them in their cells.

Most of the time, such treatment was minimal. A retired navy corpsman visited the cells every day carrying a plastic fishing tackle box containing aspirin, which he'd give to whoever he thought really needed it, and any prescription drugs the prison physician had ordered. If he thought someone had a problem he couldn't fix with one of his pills, he'd ask the doctor to visit the Row. Sometimes the doctor came, and sometimes he didn't.

The prisoners on the Row didn't like the physician; several told us his English was bad and he had difficulty understanding their symptoms. We never found out whether that perception was correct because the physician came to the Row only once during the time we were there. He didn't stay long, and he wouldn't talk to us. He stood outside two or three cells and briefly talked through the bars to the inmates inside. A convict medical orderly stood at his side, a stethoscope around his neck and his pockets stuffed with things the doctor might need—tongue depressors, a blood-pressure device, a flashlight—but the doctor never seemed to need any of them. He made a few notes and was soon gone.

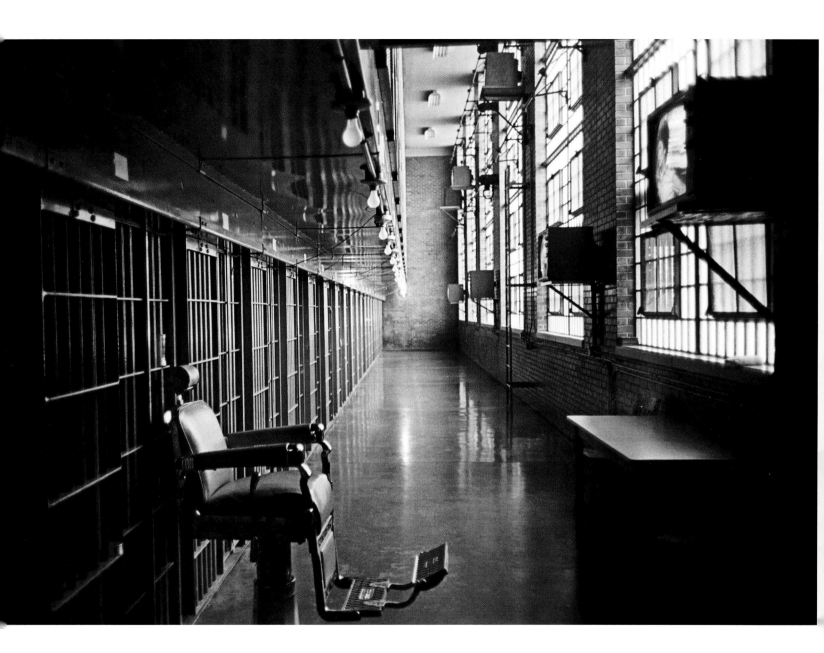

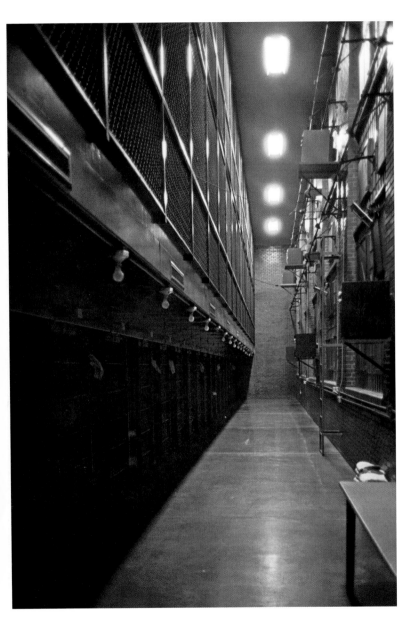

The barber chair on J-23. At mealtimes, they pushed it against the wall under the television set to get it out of the way of the cart and the porters carrying food trays. The rest of the time it was in front of cell 2, usually occupied by the guard or porter on duty watching soaps during the day and movies at night. "When they bring me in the door," Billy Hughes, one of the Death Row prisoners, said, "I see the barber chair down there and thought I was seeing the electric chair. It just about freaked my mind out."

J-23 at midnight. The high lights never went out, so the cells in three row, the top tier, never got completely dark. The cells in two row were dark at the back and light at the front. One row was in darkness between lights out and dawn. Prisoners on one row slept better, but prisoners on two and three rows could read or write all night long.

Death Row food cart in the center of the Ellis corridor on its way to J-23, coming abreast of a prisoner being patted down by a guard on the left as other prisoners head toward the dining hall along the wall on the right. Only free-world people, prison staff, the convict pushing the food cart, and Death Row prisoners being taken somewhere or being brought back to the Row were allowed to walk between the striped yellow lines.

Food

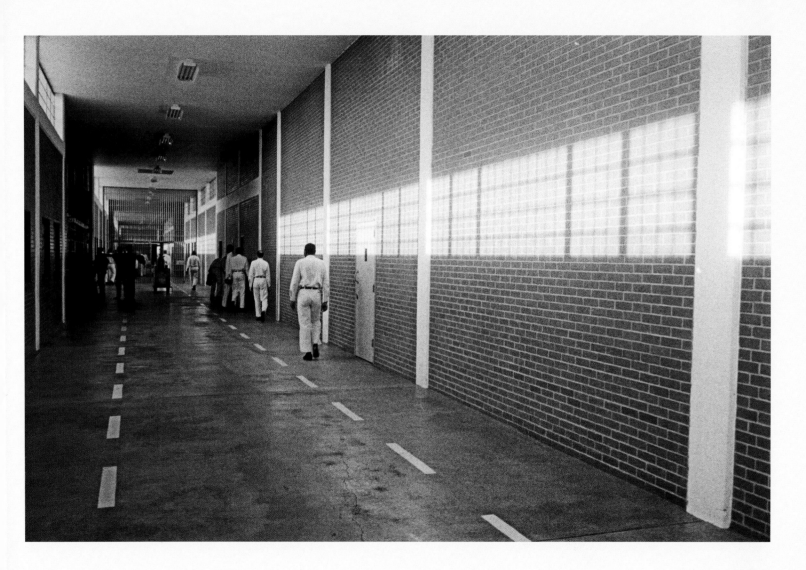

Ordinary Ellis prisoners were fed in the large dining room on the west side of the prison's quarter-mile-long central corridor. Prisoners in punitive or protective-custody cells and Death Row prisoners were served in their cells on trays loaded from hot carts and slid under their cell doors.

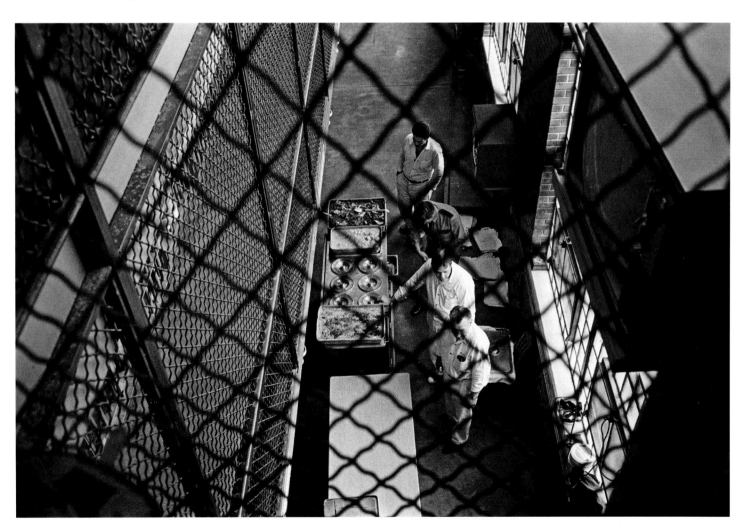

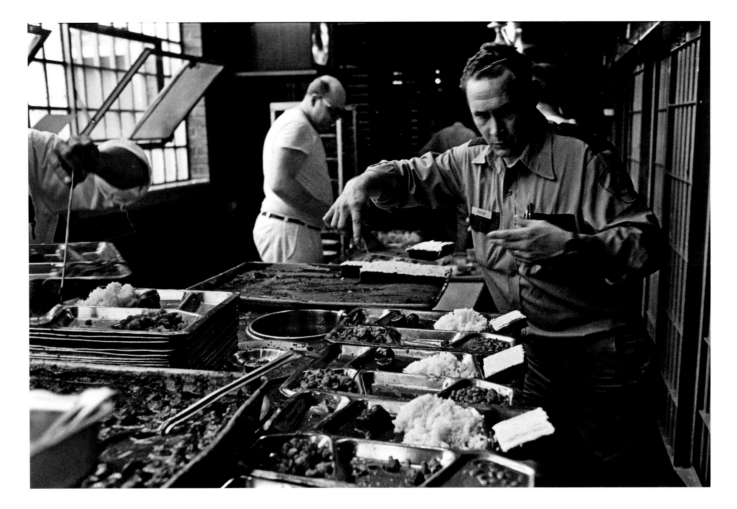

The guard and porters from J-21 came over to help fill the trays on J-23, then the J-23 porters and guard did likewise with the trays on J-21. That way, the food that was supposed to be served hot was at least warm when the trays were slid under the cell doors.

NEXT PAGES:
Guards on the Row spent most of their time sitting on the wood chair in front of the count board or in the barber chair watching television, but some of them helped load the trays at mealtimes just to get some movement in their day.

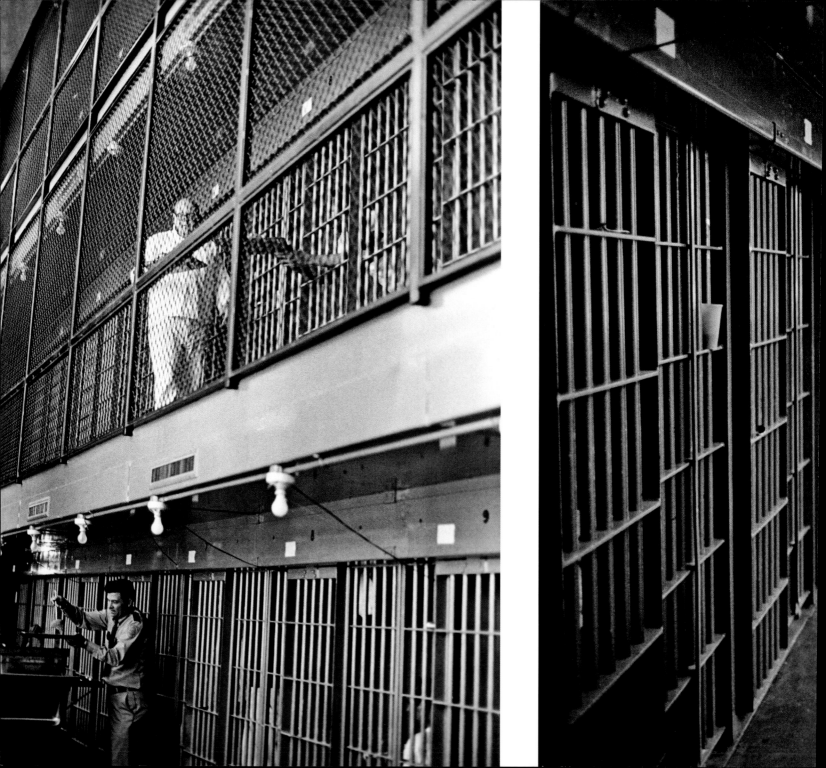

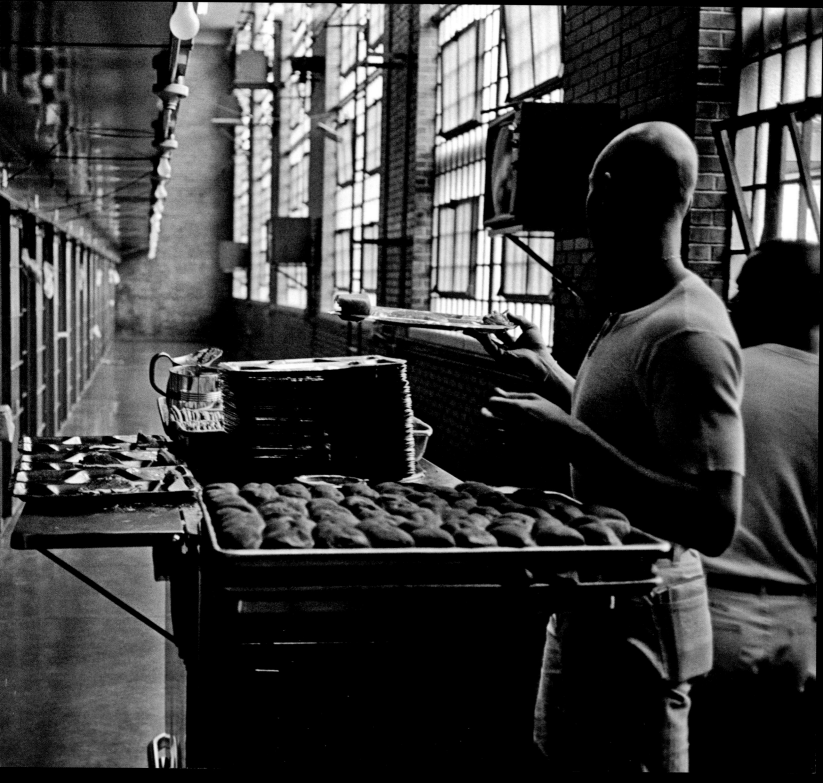

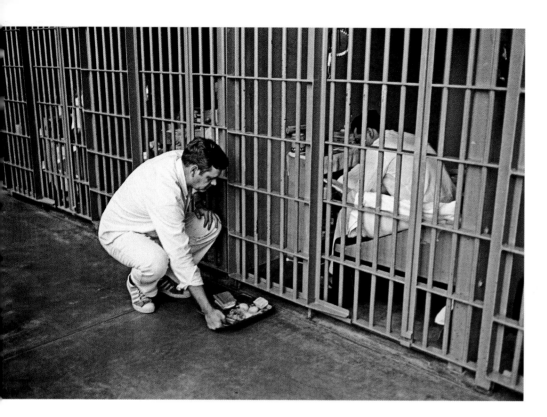

THESE PAGES:

LEFT: Charles Grigsby sliding a food tray under Paul Rougeau's cell door. DRs—Death Row prisoners—cleaned their cells; porters cleaned everything else on the Row. During morning cleanup, the porters' mops slapped against the cells' bottom bars. Afterward, some of the prisoners would be on their knees with wet towels washing the bottom side of the horizontal bar under the door. "The food is bad enough," one said. "I don't have to eat floor soap and dust too." MIDDLE: The food cart was heated, but even so, the contents of the larger trays started to coagulate before serving even began. RIGHT: Ellis's ordinary convicts in the huge dining room sat at iron tables with attached wooden seats. They couldn't all fit in there at once, so guards encouraged them to eat quickly and go back to their cells. Even so, there was time to talk a while with the other three men at the table, and a man could sit with whomever he wished, sometimes people who lived on other rows or had other work assignments. Death Row prisoners had meals only in their cells—always alone—and they had only three seating options: on the bunk, with the tray on their lap or at their side; on the bunk, with the tray on the bookcase; or on the toilet, with the tray on their knees. Because they couldn't talk to anybody and the porters wanted to get the trays scooped up and be done with the meal, each meal was served and eaten very quickly.

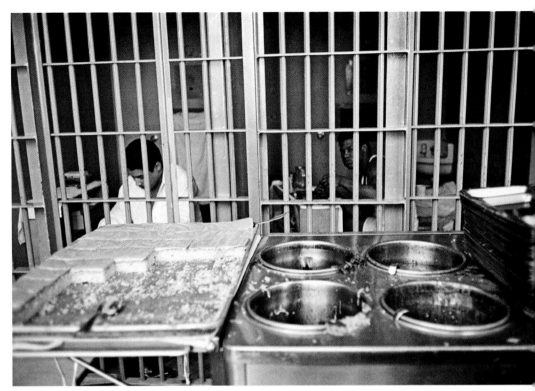

NEXT PAGES:

The porters liked to stack the trays as they picked them up so they wouldn't have to make more trips along the runs than were absolutely necessary. Even if a man didn't eat, they wanted him to push out an empty tray. So all during the meals, you'd hear steel trays banging against the porcelain toilets followed by a lot of flushing, then the trays scraping along the concrete as they were pushed back out under the doors and loud metallic slams as they were picked up. *Bang! Flush! Scrape! Slam!* This cacophony went on for maybe twenty minutes three times a day, then it was back to the ordinary noise of the Row: an occasional flush, once in a while a cell door rolling, but mainly the blare from the radio speakers in the cells and the eight television sets bolted to the wall.

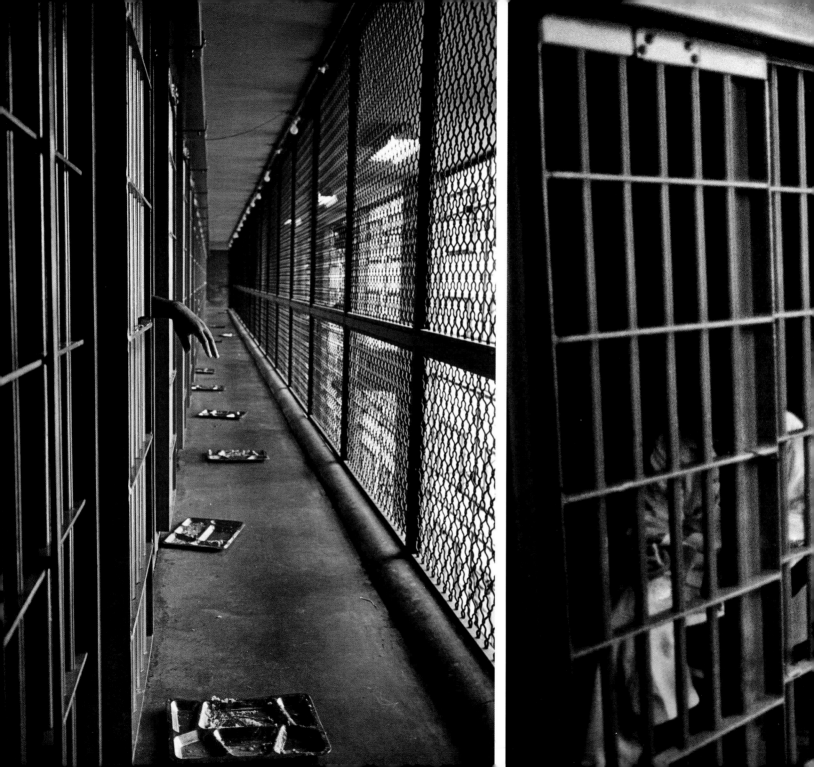

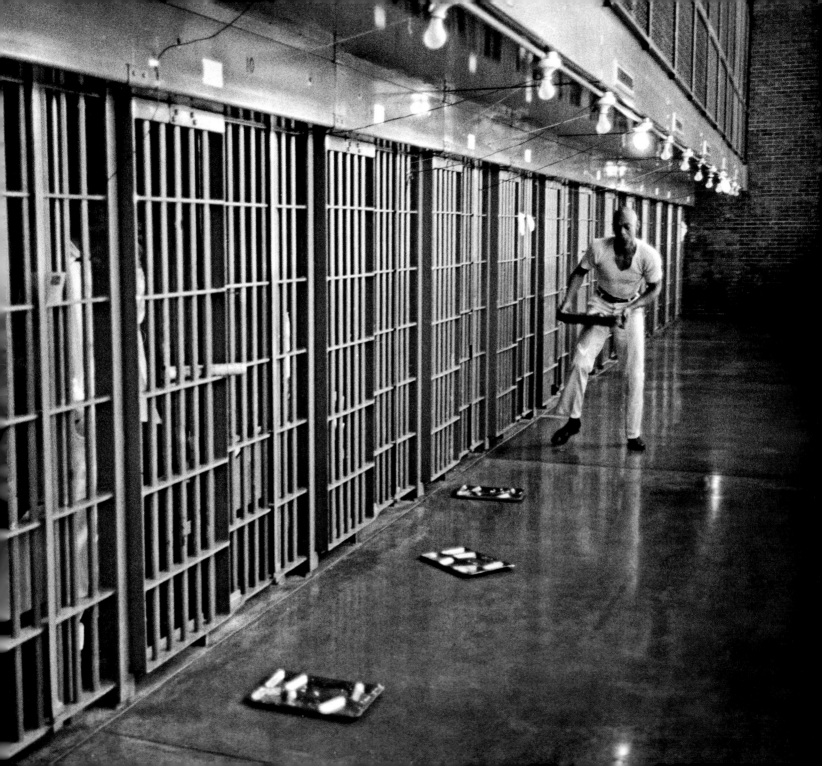

Thomas Andrew Barefoot, Doyle "Skeet" Skillern, Paul Rougeau, and Pedro "Lobo" Muniz hanging out and talking in the dayroom during one of their three weekly ninety-minute recreation periods. People in adjoining cells could see one another while they talked if they held mirrors through the bars, but those minutes in the dayroom were the only times prisoners on the Row could have a conversation with more than one person at once, talk to several people and be able to look at every one of them, or look at one person and then turn and look at another. Some people used their time in the dayroom to play cards or dominoes, but others just used the time to talk and hang out. These four men would all be put to death by the state of Texas: Andy in 1984, Skeet in 1985, Paul in 1994, and Lobo in 1998.

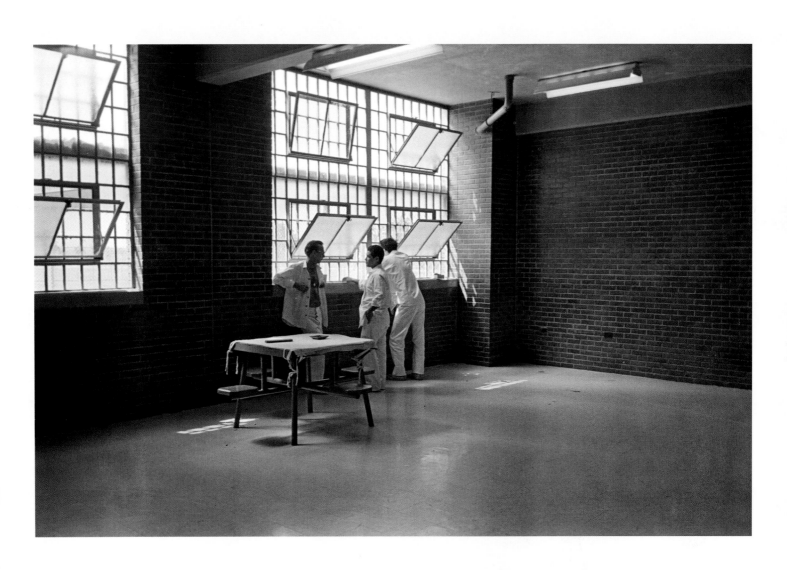

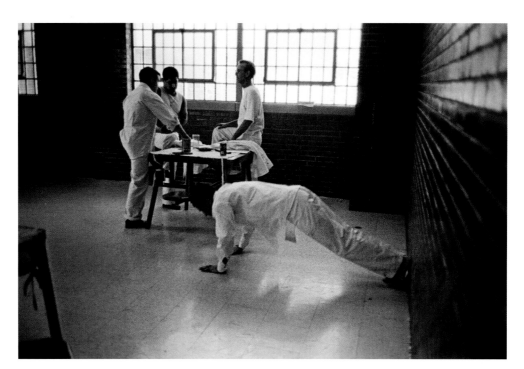

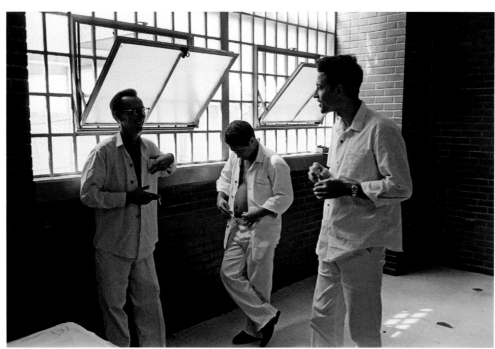

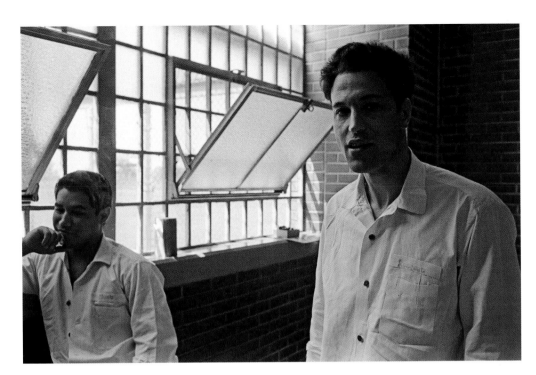

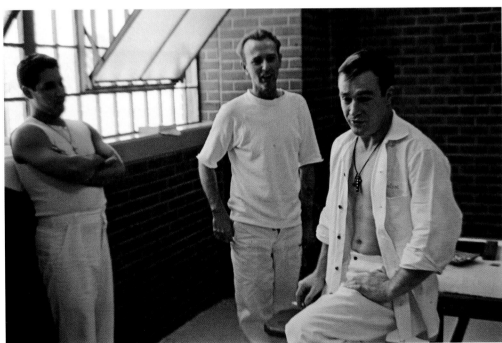

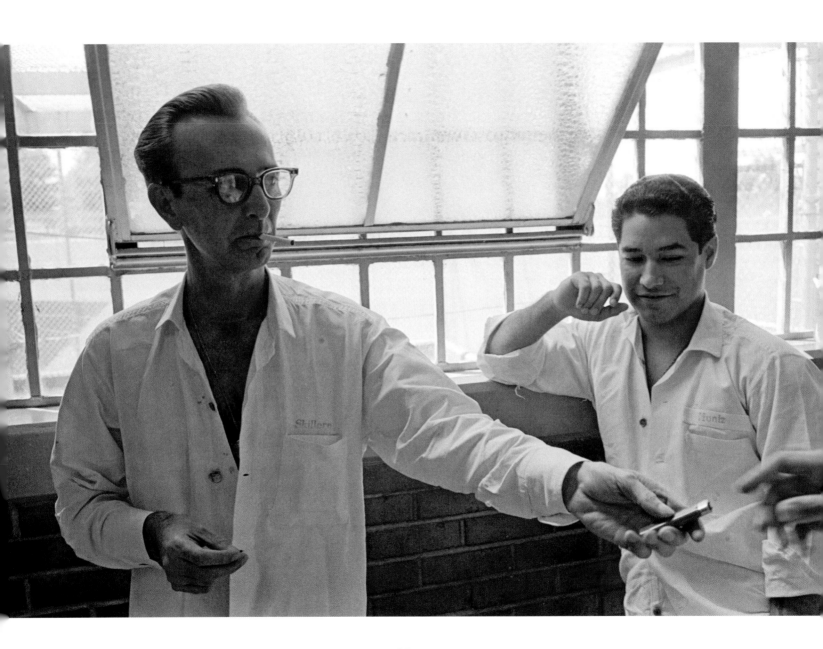

The exercise cage, which was entered from a door off the dayroom, could only be used when it wasn't raining, the ground wasn't muddy, or it wasn't too cold for the guard who sometimes sat on a chair outside the cage, watching. Sometimes months would go by without anyone getting to go outside.

A Volleyball Game in the Cage

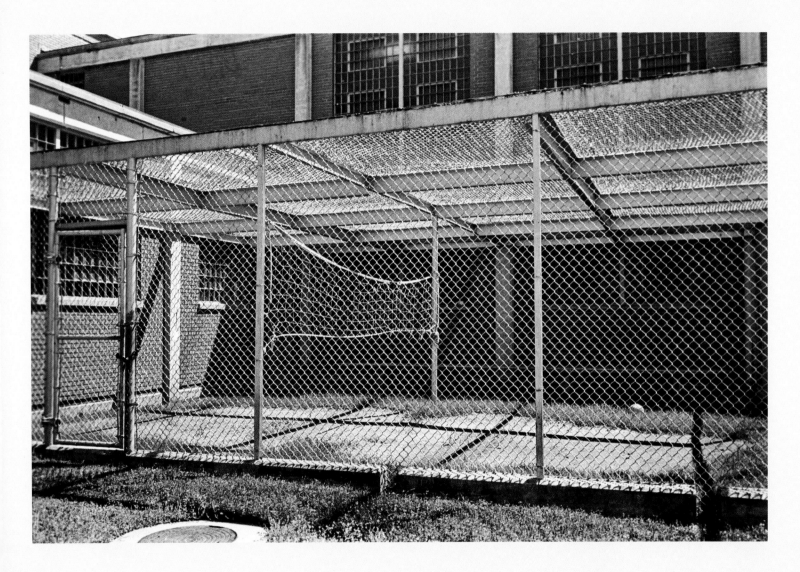

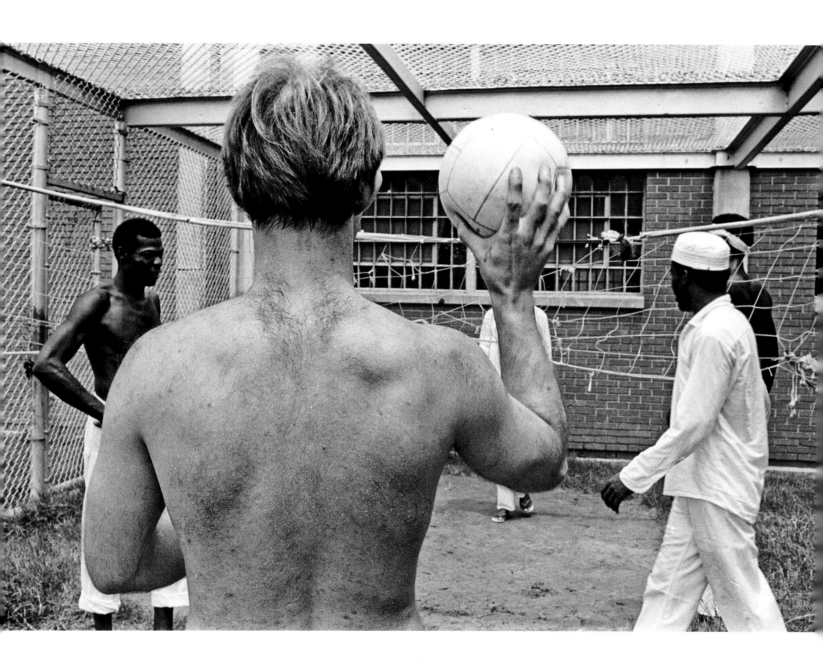

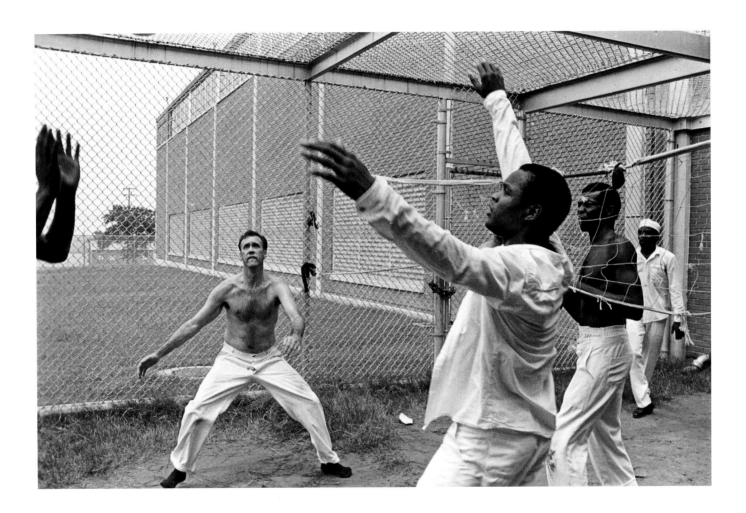

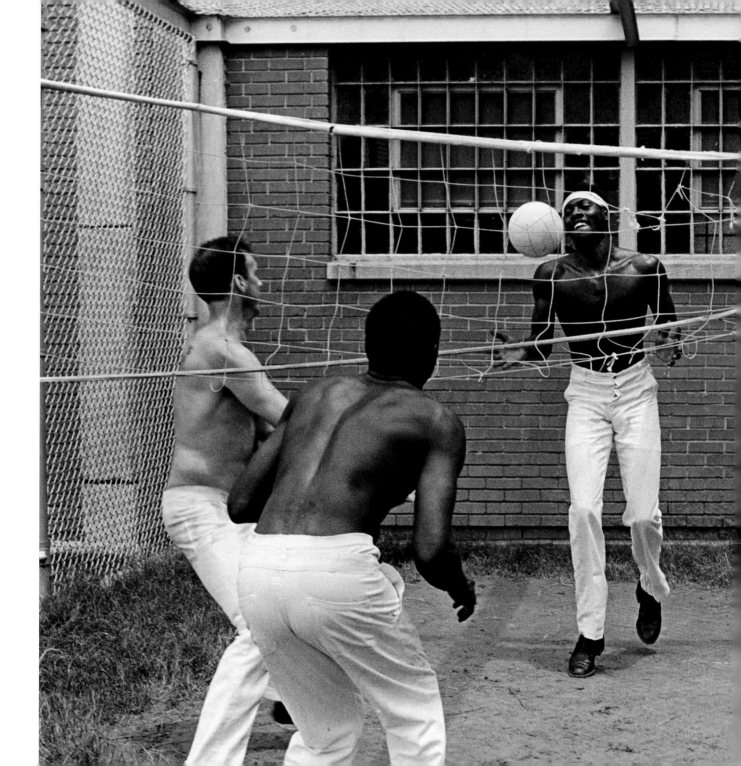

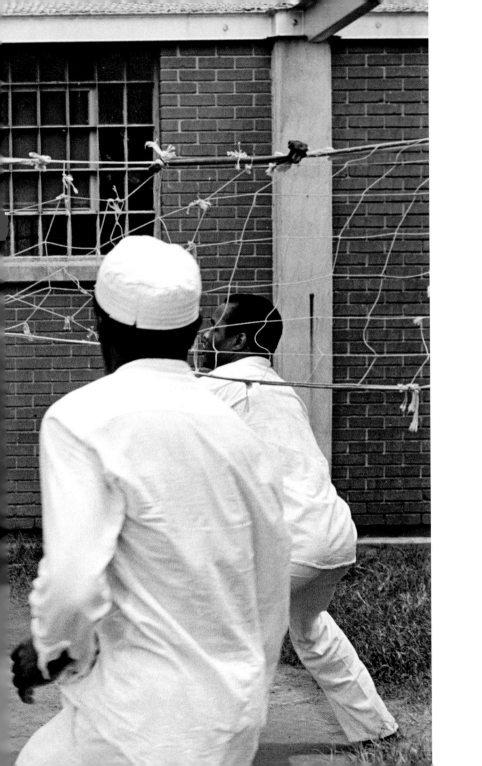

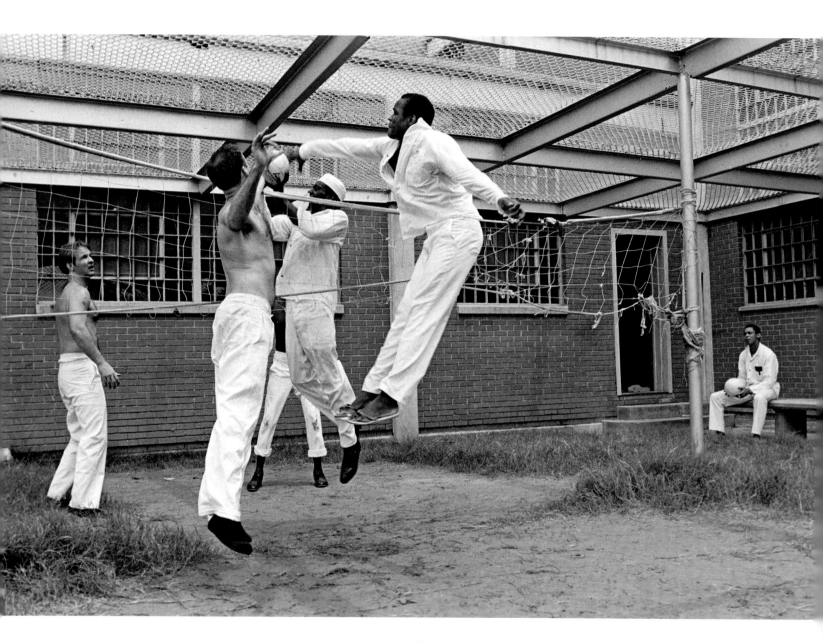

40

The volleyball game was the one time the men could, however briefly, fly. But there were limitations, even beyond the demands of gravity. If you jumped too high, the I-beams and mesh ripped your knuckles off. If you backed up too far, you slammed into the brick wall on one side or the chain-link fence on the other. If the ball hit the I-beam or the mesh, it took a crazy bounce that nobody could figure, so sending the ball into the metal was an automatic point for the other side. None of this can happen now: the Row has moved to the Polunsky Unit, and regulations there permit only one Death Row prisoner at a time in a very small recreation area.

Three of the volleyball players would be put to death: Kenneth Granviel (1996), Billy "Steel Bill" White (1992), and Jerry Bird (1991). One, Jessie Jones, had his capital murder conviction reduced to ordinary murder; he was resentenced to life, but he died in prison anyway (1994). And two had their sentences reduced to life and are still there: Larry Ross (1982) and Alton Byrd (1984).

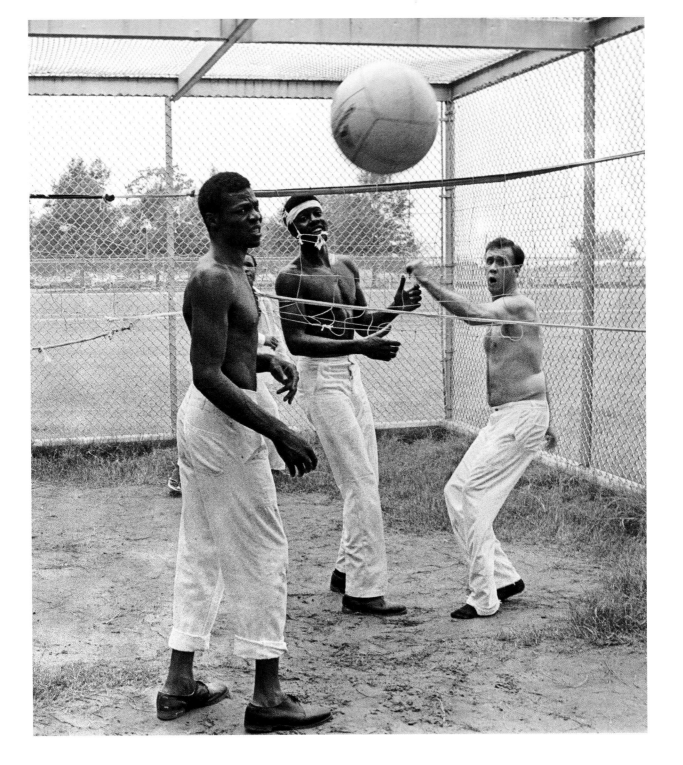

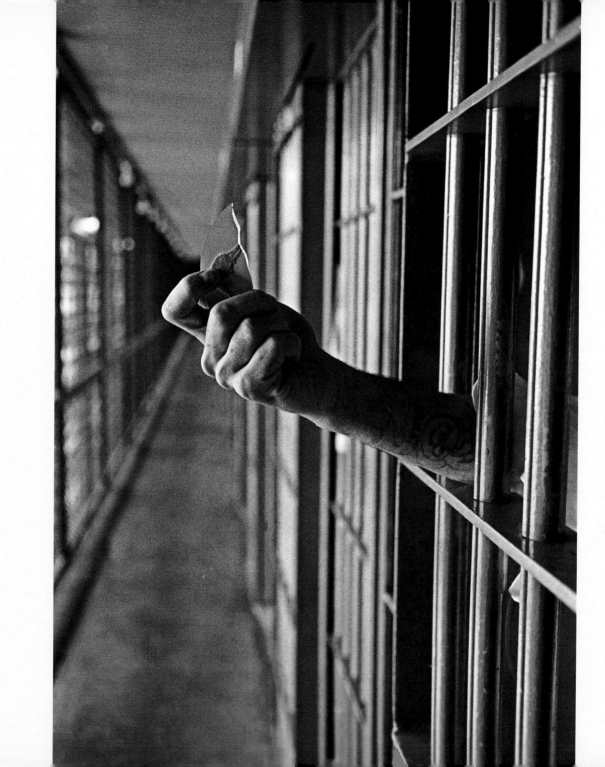

5

Hands and Mirrors

Three row: James Livingston, cell 21. All day long, mirrors came out from and withdrew back into the cell bars as people talked to one another or tried to see what was going on elsewhere in the Row. Without the mirrors, the only action men in the cells could see were things that took place directly in front of their cells or on the television sets bolted to the wall between the large window frames.

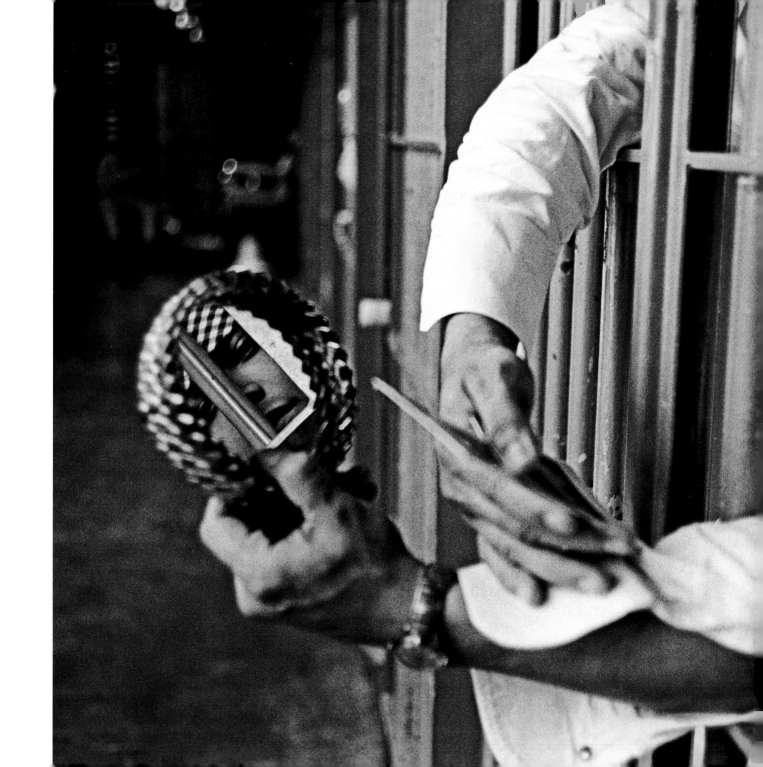

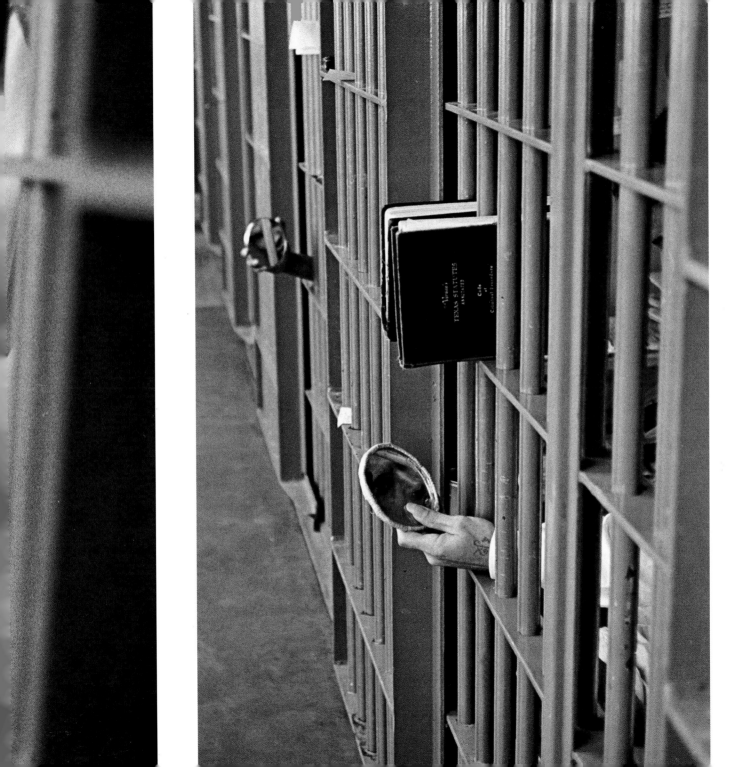

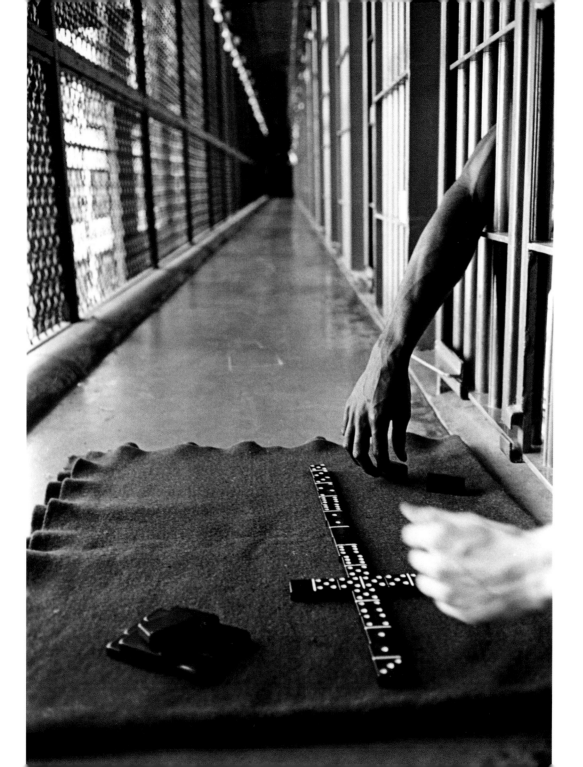

PAGES 46–47:

One row: Moses Garcia, cell 10. "You want to have a frame for your shaving mirror," Moses Garcia said, "so you don't get fingerprints on the mirror all the time when you're holding it outside the bars."

One row: Clarence Jordan, cell 14, and Paul Rougeau, cell 15.

PAGE 48:

Two row: Billy White, cell 18, and Jerry Bird, cell 19. Hands came out of adjoining cells to play dominoes on the run or chess on handmade boards suspended by string from the bars where the cells joined. Men would compete in dominoes or chess for years without ever seeing one another's faces as the moves were made or contemplated.

PAGE 50:

One row: Clarence Jordan, cell 14, and Paul Rougeau, cell 15.

PAGE 51:

One row: Moses Garcia, cell 10; Murriel Crawford, cell 11; and Clarence Jordan, cell 14. If you stood at either end of the run and looked down along the cells, you would see hands coming in and out, sometimes lingering a long time, sometimes for a brief moment. All day long and into the night, the hands came out, rested, then withdrew. Sometimes it was when they were watching a program on one of the television sets or when the food trays were being loaded. Just as often, nothing was going on; it was just the hands doing something the rest of the body couldn't.

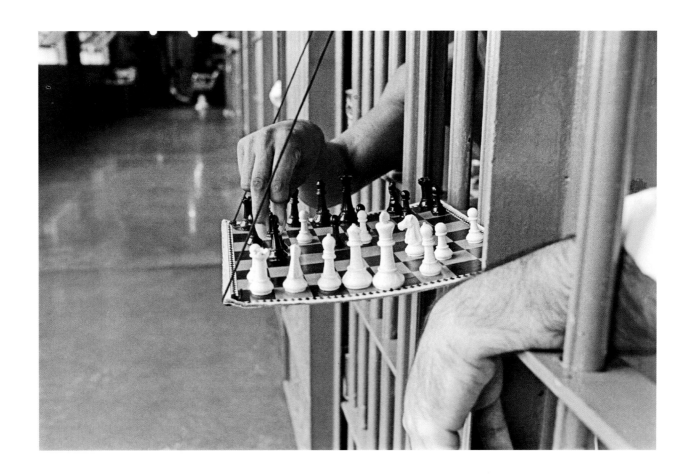

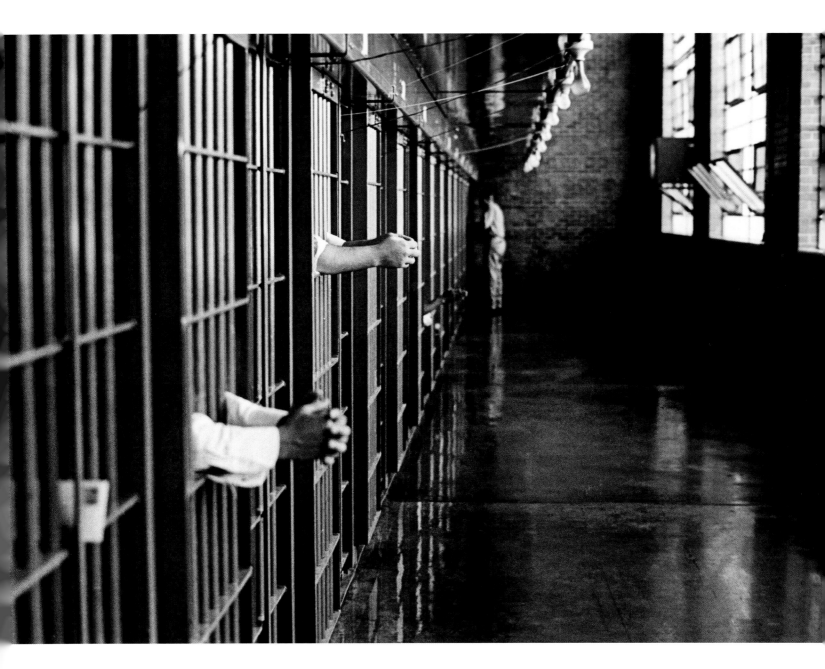

One row: Billy McMahon, cell 17, and Jack Smith, cell 18.

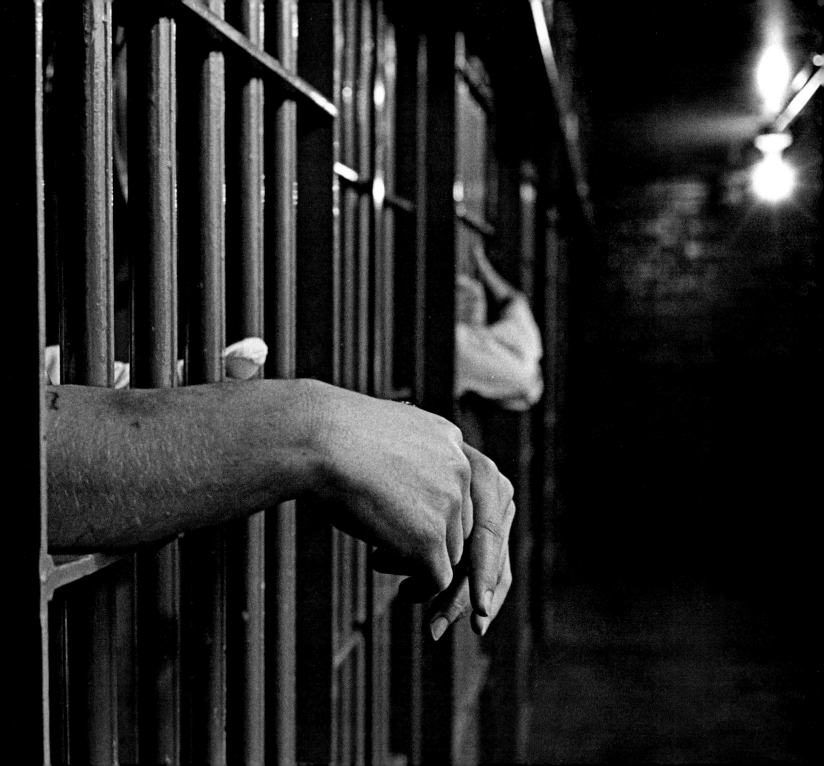

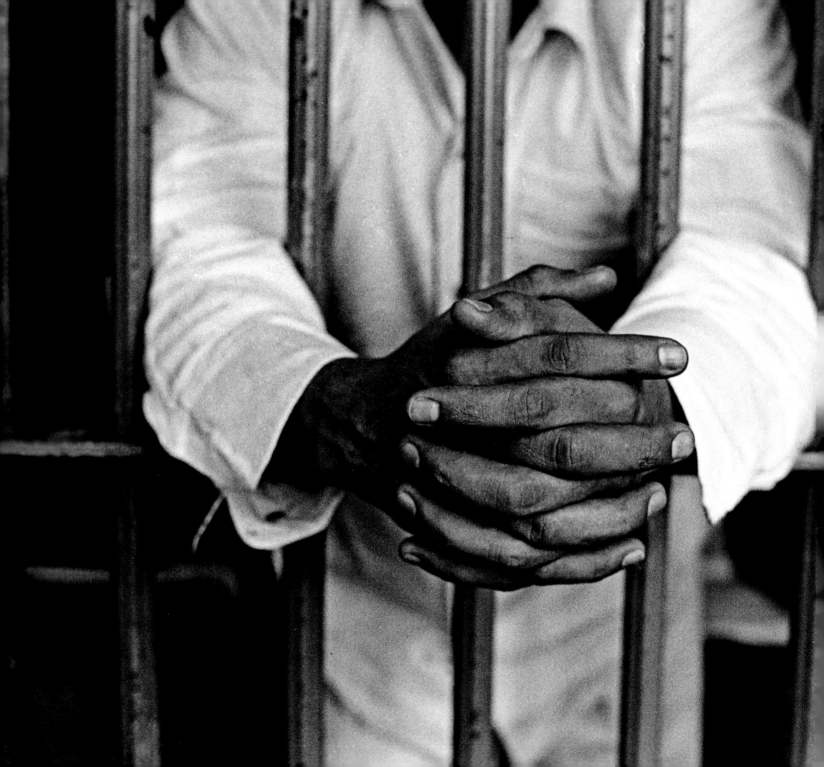

One row: Moses Garcia, cell 10.

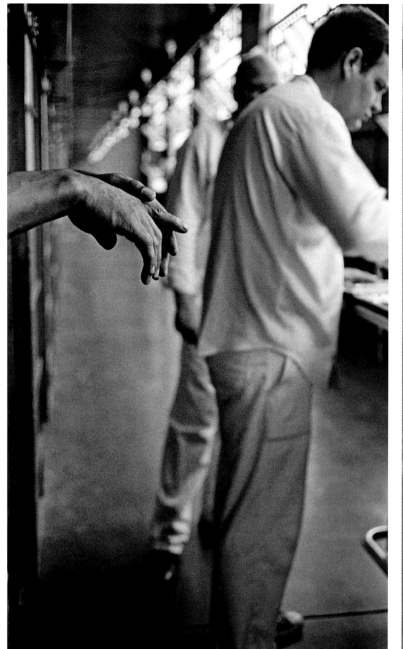
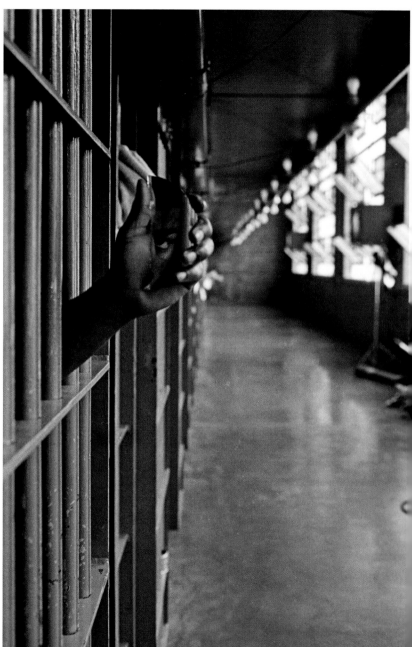

OPPOSITE LEFT: One row, Pedro Muniz, cell 5. OPPOSITE RIGHT: One row, Kenneth Davis, cell 6.

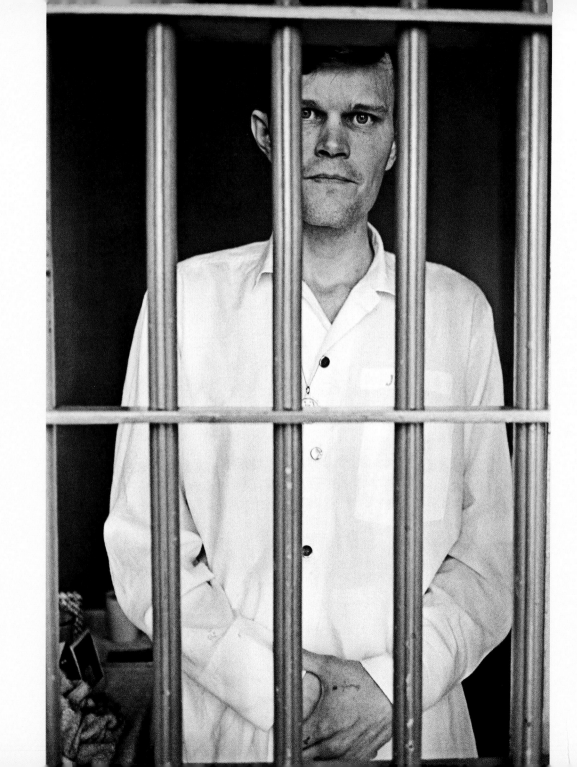

6

Eight who were resentenced to life
and are now doing time

Jerry Jurek. Sentence reduced to life, January 29, 1982. Once Jurek's death sentence was lifted, his time behind bars counted for him, just as it does for any other noncapital prisoner. The prison arithmetic set his parole eligibility date at April 29, 1981, nine months before his sentence began. The absurdity bothered no one: Texas officials had no intention of paroling Jerry Jurek then, and they have none now. He is still doing that life sentence.

"I've been here five full years," Jerry said. "When I first come down here, you couldn't even come in the door without getting your head strummed. They had two dudes here, they moved them both off. One died. I think it was in Galveston hospital, had something wrong with him and he died over there. The other one, he got sent to New Mexico and three days after he was over there, somebody stabbed him to death. So ever since then, since they left and moved out, it's been a lot better. We haven't had no more beating ups." Jurek's was one of the four cases decided July 2, 1976, along with *Gregg v. Georgia*. Those five decisions permitted executions to resume, ending the hiatus that began four years earlier with *Furman v. Georgia*.

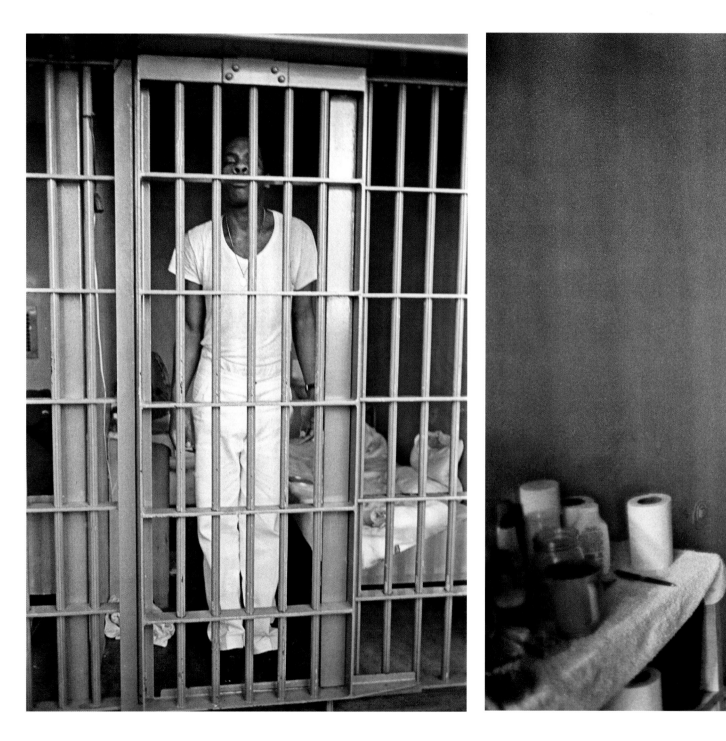

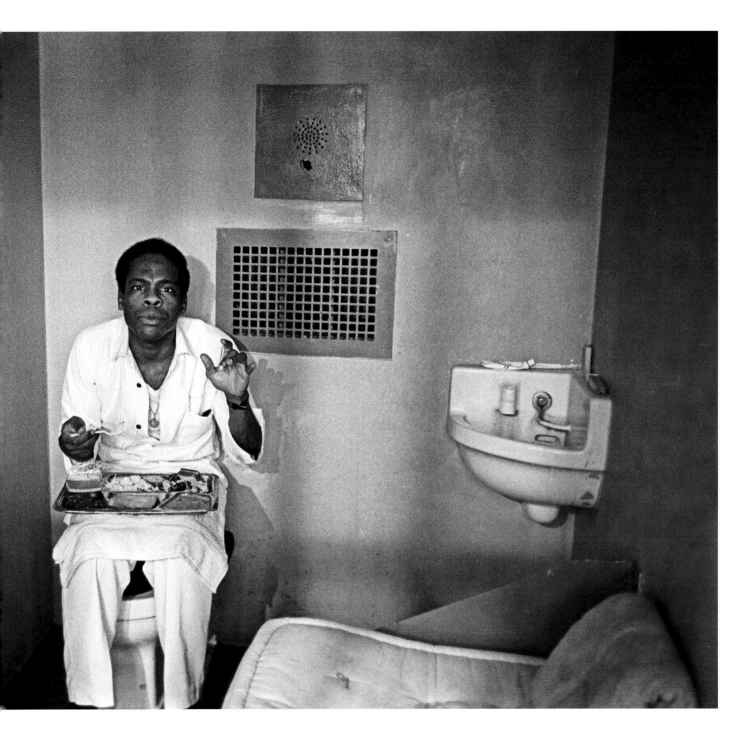

PAGES 60–61:

Thelette Brandon. Conviction reduced to murder with a deadly weapon; sentence reduced to life, July 28, 1982. Eligible for parole since August 2, 1984.

Every night, Brandon argued for hours with Emily and George, a couple that he insisted lived in the pipe chase, the narrow passageway behind the air vents and between J-21 and J-23, where the electrical and plumbing lines were. Sometimes he stopped arguing and sang to them. From time to time, people beat him up in the dayroom or punched him as he passed by their cells in the hope it would get him to shut up and let them get some sleep. Nothing ever worked. Except when he was standing at the bars meditating or sitting on his toilet or bunk eating, Brandon was in constant motion, sometimes silent, usually not.

THIS PAGE:

Moses Garcia. Sentenced to death, October 6, 1975; sentence commuted to life, April 6, 1983. Eligible for parole since January 19, 1997.

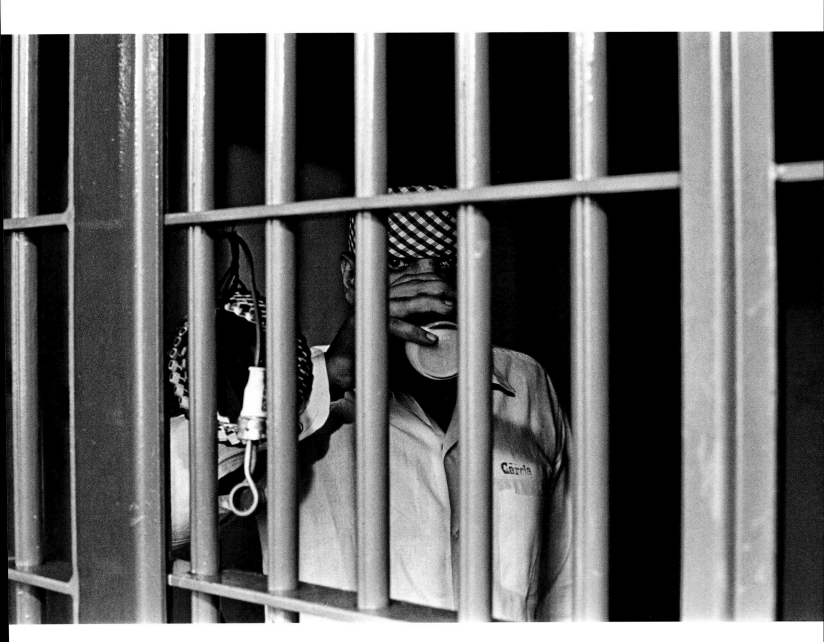

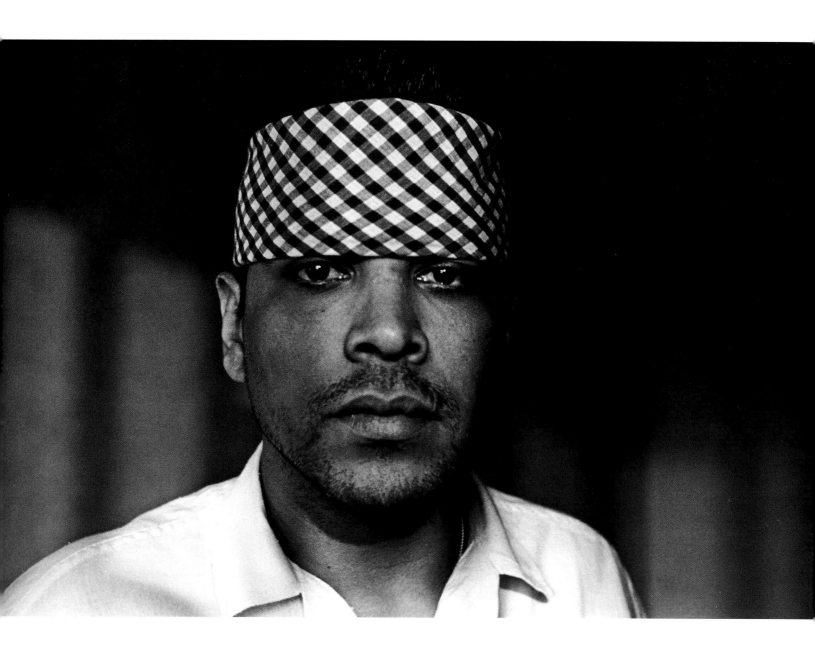

"It takes a lot to be on Death Row," Moses said. "It's hard. But you deal with it day by day and you learn to get along. And if you don't, that's your problem."

"What happens to those who don't?" Bruce asked him.

"I had this old friend of mine who come down here. They moved him a few times because he was asking for his medication. They finally put him back on this side again. And he said, 'I want my medication.' He talked to doctors. He talked to guards. They wouldn't do nothing about it. He cut himself. They took him to the clinic, put some stitches in him, brought him back. The next day, they put him in another cell, and on the edge of the bunk, he hit himself on the forehead. And it cracked the skull. For one hour, he hit his head on the bunk, on the edge of the bunk. After one hour, doctor finally come down here while the boss, the young boss they had, he stand in front of his cell and just look at him and laugh. Laughed at him."

"Did you see this?"

"That's right. And finally, about an hour later, came the doctor. Took him to the hospital. We learned later that he had lost some fluid from his head. He lost a lot of blood. That was his way of telling them he needed medication."

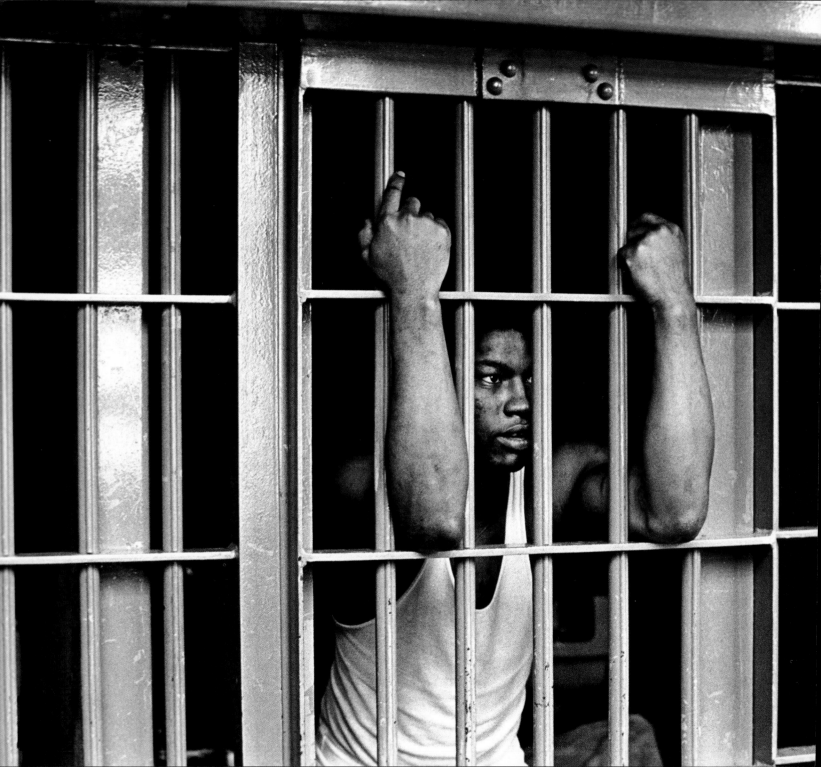

Kenneth Davis. Sentenced to death, December 19, 1977; sentence reduced to life, November 13, 1981. Eligible for parole since December 19, 1997.

Kenny spent hours every day cutting and folding tobacco wrappers to make picture frames, crucifixes, shaving mirror holders, and cup holders. He'd trade them for things. People would save their empty Marlboro and Bugler tobacco packages for him. He'd fold the wrappers the way he wanted them ("You can get four patterns," he said), then make the cut with the thin wood back of a matchbox. He wasn't the only man on the Row who wove wrappers, but he was the one Bruce saw doing it the most and whose work he saw most in the other cells.

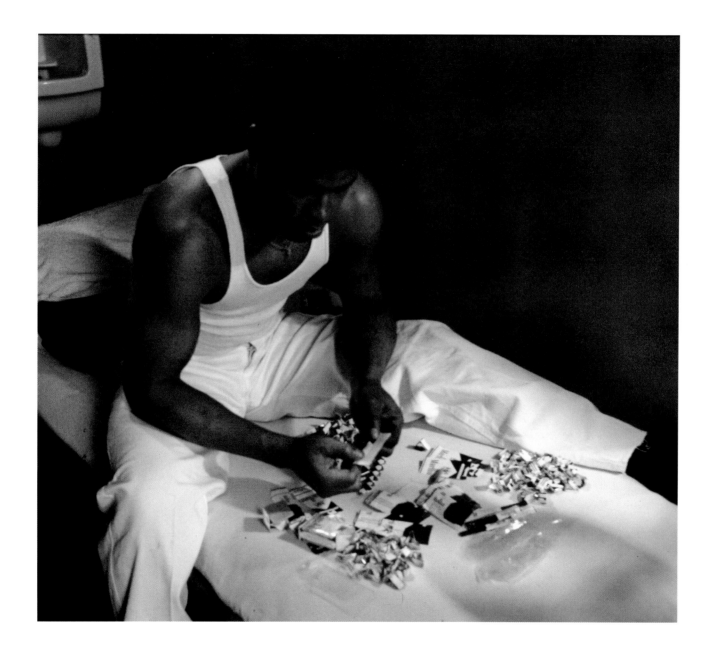

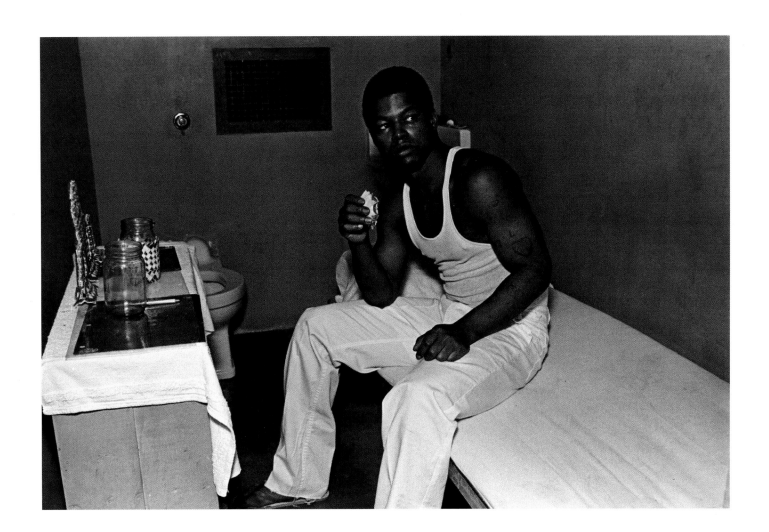

The bookcase in Kenny Davis's cell, which was always perfectly neat, perhaps the most Spartan of all the cells on J-23. He gave Bruce a picture frame like the small one on the right, and we traded for a mirror in a holder. Bruce traded with somebody else for one of Kenny's crucifixes.

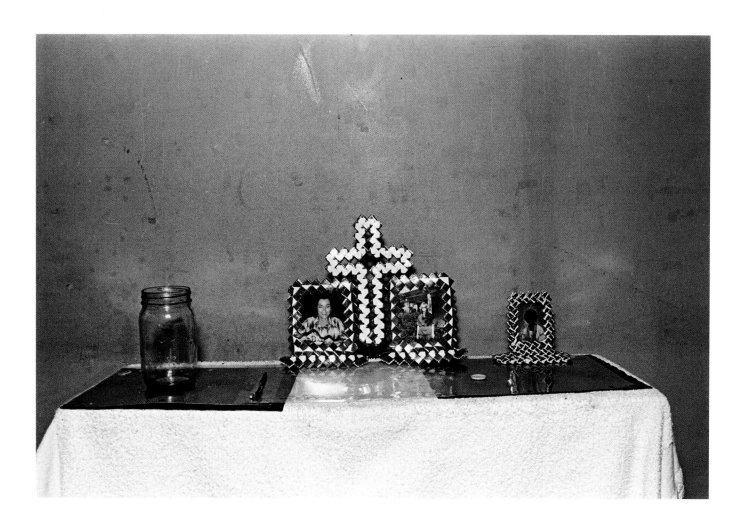

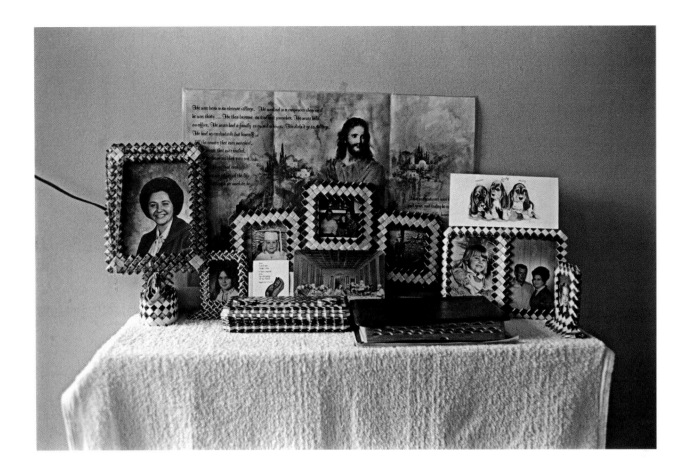

Billy McMahon, who was eleven cells farther down one row from Kenny Davis, had far more pictures atop his bookcase, all of them in frames made from Bugler tobacco sacks and Marlboro and Camel cigarette-pack wrappers. He also had an intricate box made from those wrappers, a Bible, a postcard from his family, and a holy greeting card. If Billy were on the Row now (his conviction was reduced to murder in 1983 and he was sentenced to sixty years, so he's somewhere else in the system), he'd be allowed to have none of that stuff out, other than the Bible. Nobody is allowed to smoke in Texas prisons now, so there's nothing to weave those frames and boxes with, anyway.

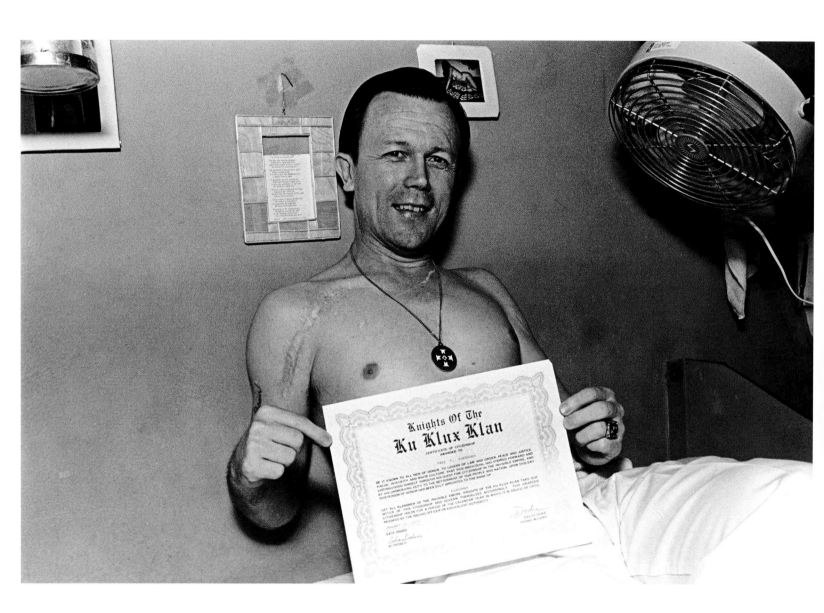

72

Fred Durrough. Conviction reduced to murder, sentenced to life, June 14, 1982. Eligible for parole since August 3, 1980. When Bruce began taking pictures in his cell, Durrough put on his Ku Klux Klan medallion and held up his membership certificate, which had arrived only a few months earlier. "There is no deterrent value in the death penalty as long as it's set up as it is right now," he said, "where you take somebody out at midnight and in the presence of only a few select people, you kill him. If it's really a deterrent value, then why are the politicians and prison officials and all these other people that are pro–death penalty afraid to put it on national television at eight o'clock at night? Now, I don't know that that would be a deterrent, but at least if there is any deterrent value in killing someone, the person that you're trying to deter has to see the effects of what you're trying to deter him from. As so long as you keep it hid, it is just an abstract concept rather than reality. But if you see somebody—however you kill him, whether you throw him off a bridge or whatever—maybe it would strike home. As it is now, there's nothing to it. You read about it in the paper the next day. You go to bed at night and the next morning, 'Well, old so and so was executed last night. Big deal.' No drama was involved. So I think it's all a bunch of bullshit."

Wilbur "Wolf" Collins. According to the Texas Department of Criminal Justice (TDCJ) Web page "Offenders No Longer on Death Row," his sentence was reduced to life on February 1, 1983. But according to his TDCJ online "Offender Information" page, his sentence was reduced to life on November 29, 1982, and his parole eligibility date was January 27, 1982—eleven months earlier.

"A friend of mine down the run here, we were talking one day and he said, 'Man, how old are you?' I said, 'Well, I'm twenty-seven.' 'No, you're not twenty-seven.' 'Yes, I am.' 'No, you got to be at least thirty-five, forty . . .'" And I took a real close look at myself and said, 'Gee, I really do look that old. I really do.' And it's hard to believe that one can age so swiftly in that amount of time. But I guess it's all to do with the mental pressure. There's a lot of mental pressure, but you don't let yourself go. You try to suppress it. You keep something going with the fellas along the Row, jokes going and so forth, to more or less keep the position that you're in off your mind. But it's steady there, it is constantly there anyway. You might not realize it, but it's there and it's working on you. You know, day by day, regardless of what you do, it's always there in the back of your mind: 'Hey, you on Death Row. You could be executed. They could kill you.'"

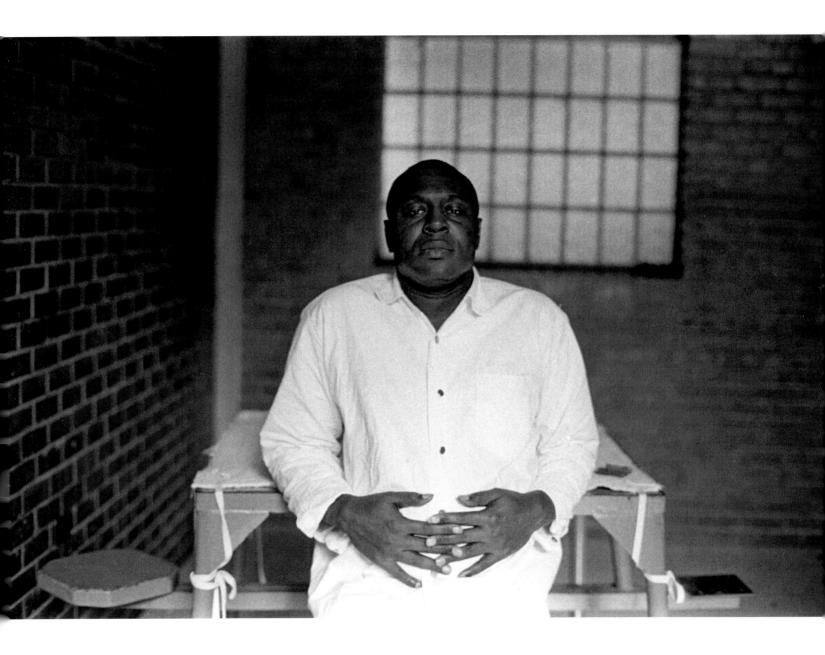

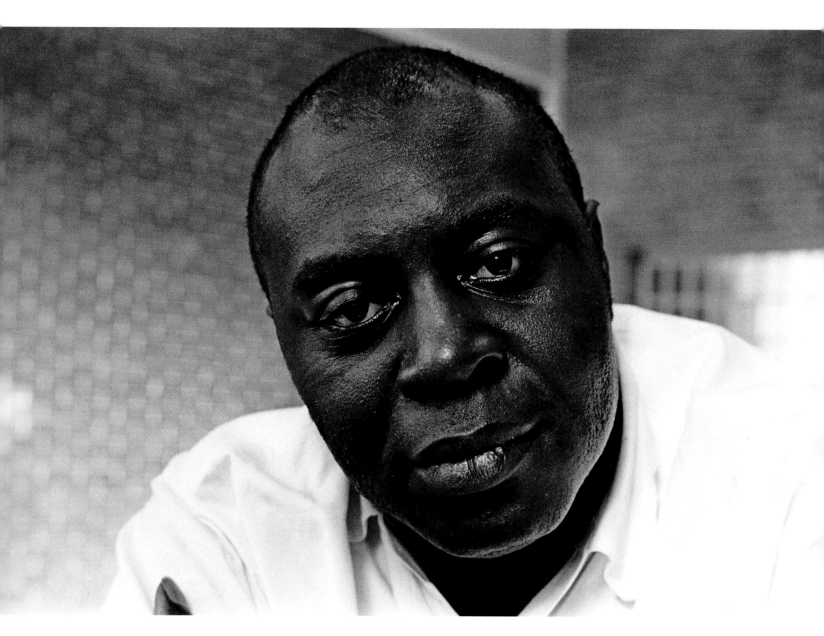

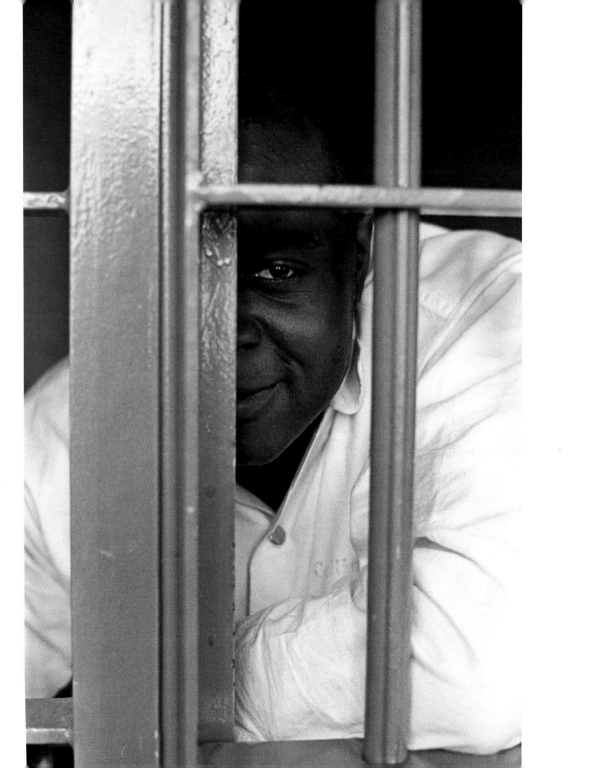

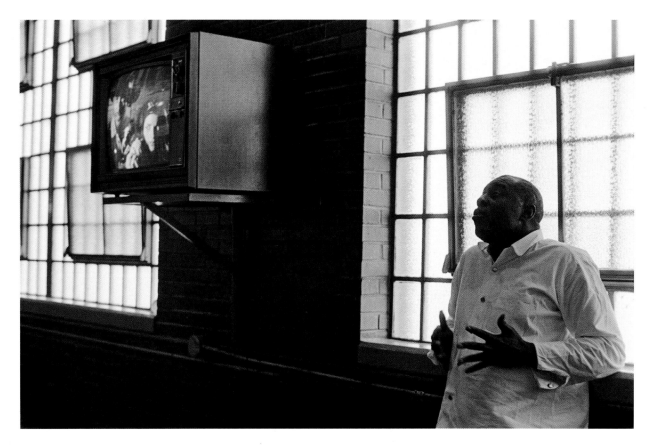

Wolf waiting for his cell door to be rolled open. He stands in front of the frosted-glass windowpanes opposite his cell. Not long after J-23 was designated as Death Row, an official had all 3,120 panes of clear glass on J-23 replaced with panes of frosted glass. They made the same change on the big (but not the small) windowpanes in the dayroom. We asked officials at the prison and a former director of the prison system why that had been done, but nobody knew or could remember why the glass had been changed.

Mark Fields, who lived in cell 19, on his way to the shower, which was in cell 1. His sentence was reduced to life on February 16, 1984, and he became eligible for parole on September 20, 1984. He is presently serving a life sentence at the Bill Clements Unit in Amarillo, one of the many Texas prisons that didn't exist when this photo was made. He has no scheduled release date and, according to the online offender information sheet, his sentence expires (theoretically) in 9999.

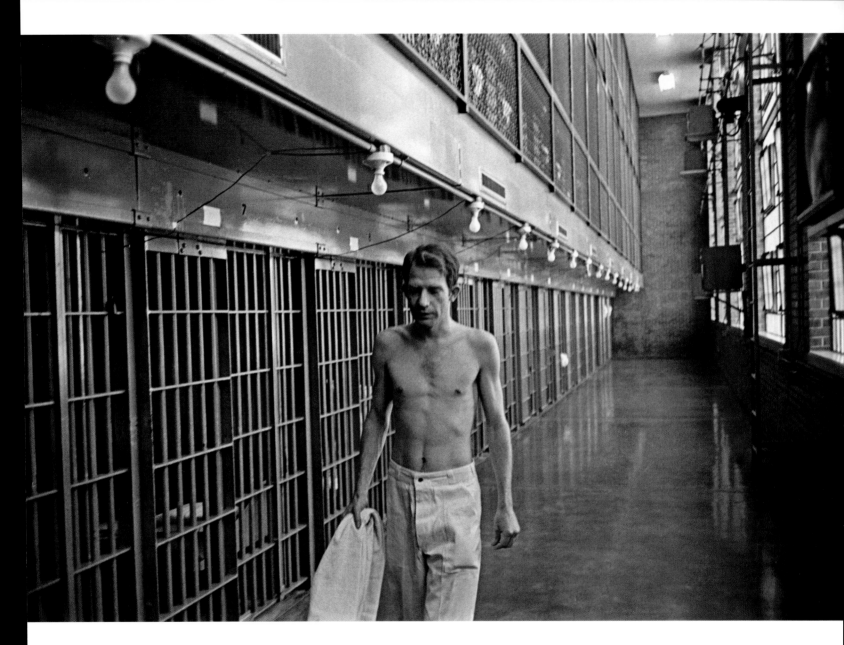

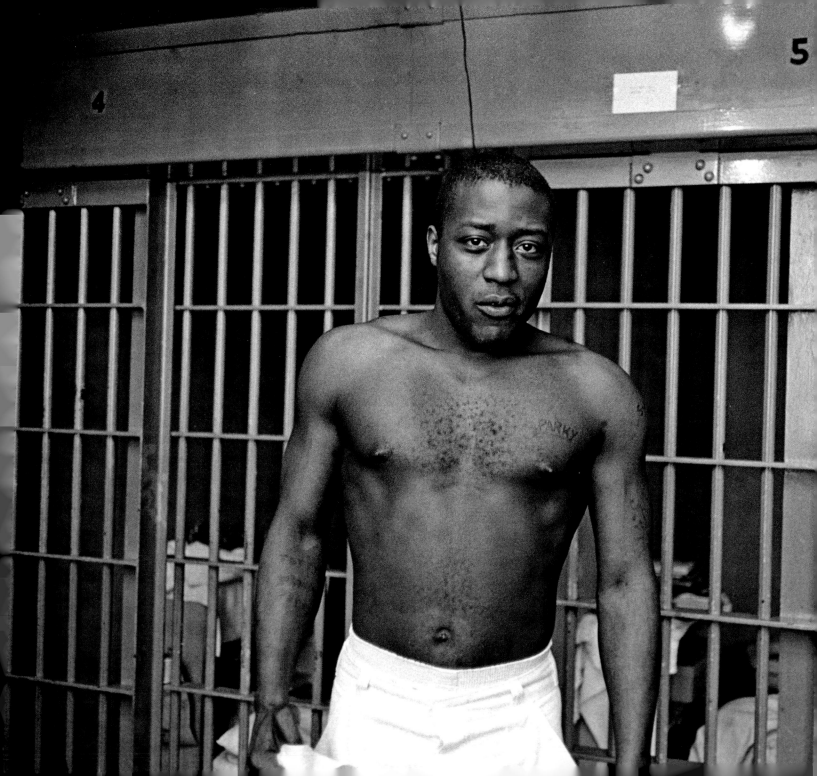

Mark Moore, the seventh prisoner to come to Death Row in the post-*Furman* era. His sentence was reduced to life on September 24, 1982, and he has been eligible for parole since November 19, 1980, two years and two months before his current sentence began. No one cares. Like Mark Fields, Moore's offender page on the prison's website says his current sentence expires in 9999, a little less than 8,000 years from now.

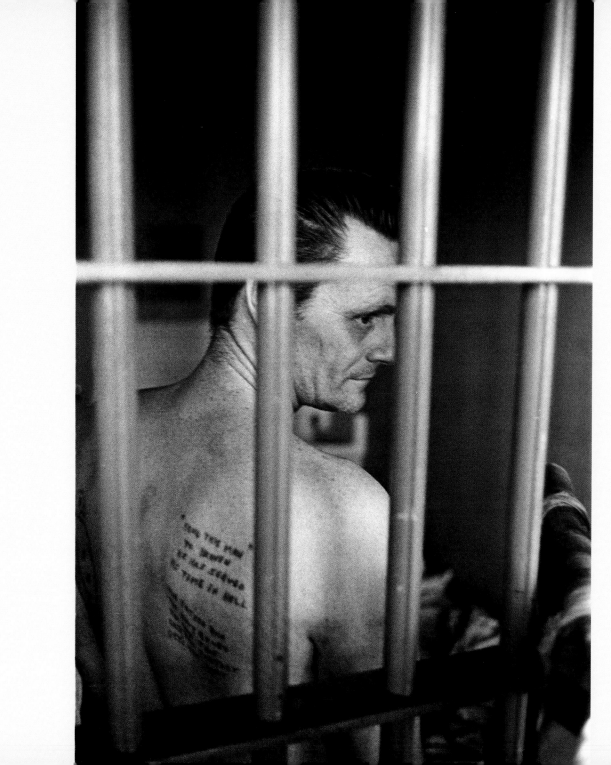

Three who are still there, one who was resentenced
to life and then paroled, and one who was set free
after twenty-one years and then exonerated

Jack Smith was forty years old when he came to Death Row in 1977. He has spent more time on Death Row than half of all Americans have been alive.

Jack couldn't read very well, so he tied a shaving mirror to two rolled-up newspapers and used it to look at Mark Fields in the adjoining cell, who often helped him with his legal work.

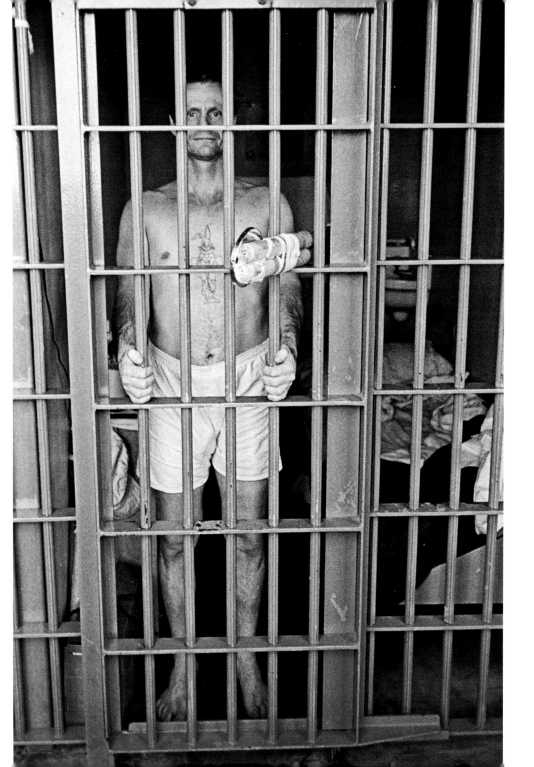

The four men in the background—Pedro Muniz, Andy Barefoot, Doyle Skillern, and Paul Rougeau—have all been executed. Three of the dominoes players—Kenny Davis on the left, Moses Garcia with the bandana, and Mark Moore on the right—are now doing life. The dominoes player looking into the camera, Clarence Jordan, arrived on Death Row on September 12, 1978, a little less than a month before Jack Smith. Like Jack Smith, he is still there.

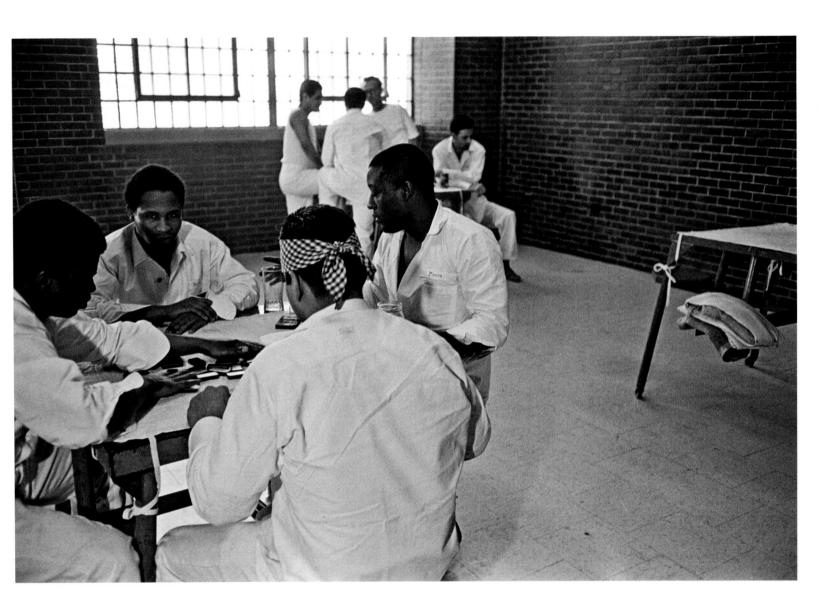

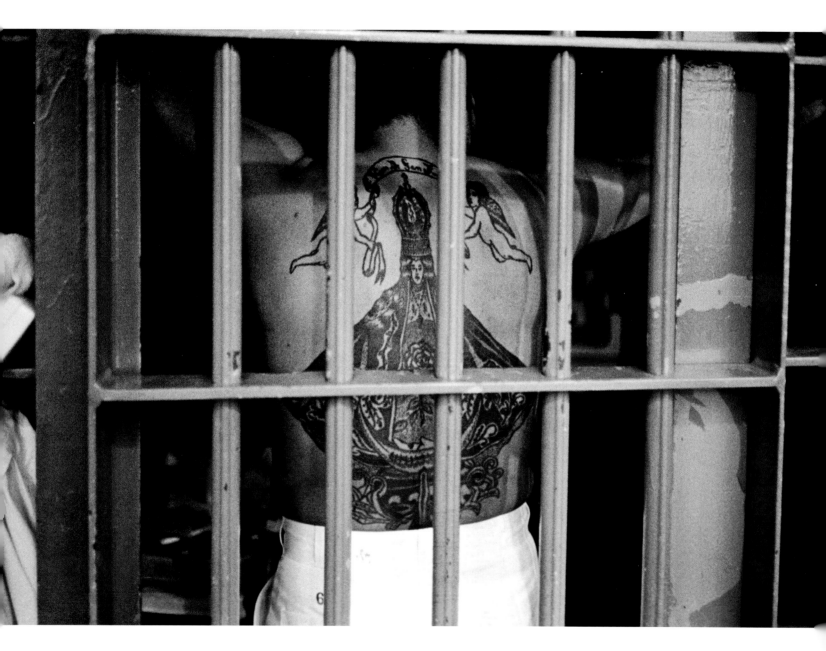

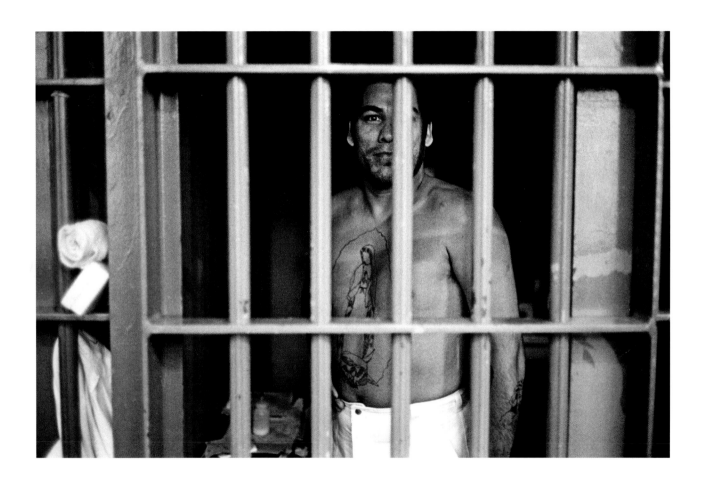

PAGES 88–89:
Arturo Aranda arrived on the Row on May 18, 1979. He, too, is still there.

The Virgin of San Juan on Arturo Aranda's back had lots of detail, but the Virgin of Guadalupe on his chest had almost no detail at all. "Why doesn't your Virgin of Guadalupe have a face?" Bruce asked him. "They sent me down here before I had time to get her one," he said. If he'd been in population, someone might have finished it for him. The artwork and coloring wouldn't have been as good as the free-world tattoo on his back, but at least the Virgin would have had a face.

THIS PAGE:
Murriel "Donnie" Crawford. Sentence reduced to life, November 27, 1987; paroled, April 2, 1991. Donnie had a gallery of family photos on top of his bookcase and often said that the pain his death penalty put his family through was far more distressing to him than his own situation. He wrote poems about that, one of which provides the first motto and the title for this book.

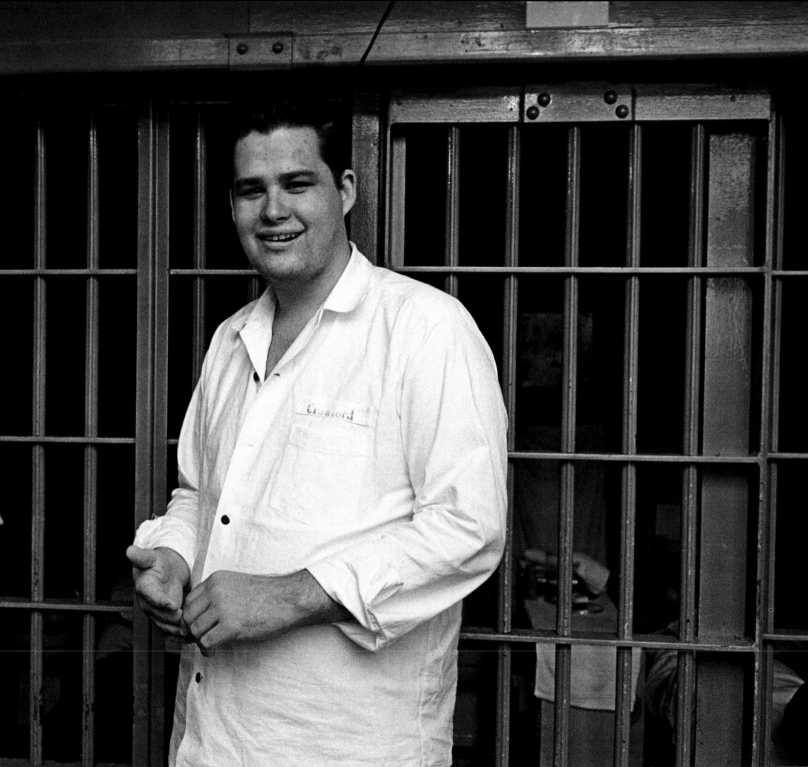

THIS PAGE:

Kerry Max Cook. Exonerated, 1997. "This place here is a nightmare and you don't never wake up," Kerry said. "You keep hoping you'll wake up, but you don't."

PAGES 94–95:

Kerry spent twenty-one years on the Row. He had three trials and was convicted and given the death penalty at every one. Each time, appellate courts threw the verdicts out because of egregious prosecutorial misconduct. After the third death sentence was thrown out and the appellate judge told the prosecutor he couldn't use his fabricated evidence against Kerry in any more trials, the prosecutor offered Kerry a deal: plead guilty and he would recommend time served, making Kerry a free man. Kerry still insisted he was innocent, and his lawyer was confident he'd win acquittal at any fourth trial, but after three convictions and three death sentences, Kerry wasn't willing to take the risk another time. He pled guilty without admitting guilt—the first time a Texas judge let anyone do that in a murder case—and was set free. A few months later, the Innocence Project was able to run DNA tests on the physical evidence. The test showed Kerry could not have been the villain, but because the proof of his innocence came after his guilty plea, he didn't receive any compensation for the three wrongful convictions and the twenty-one stolen years.

Kerry wrote a book about what happened to him—*Chasing Justice: My Story of Freeing Myself after Two Decades on Death Row for a Crime I Didn't Commit* (2007)—and his story was one of the six that were the basis of Eric Jensen and Jessica Blank's award-winning play *The Exonerated* (2002). Richard Dreyfus and Aidan Quinn are among the actors who have portrayed him in the stage version; Quinn also played him in the film version (2005). Kerry is still haunted by his years on the Row. Neither writing the book nor being depicted in the play has rid him of that. "Freedom came," he wrote to us in 2010, "but the shadow of bars follow me."

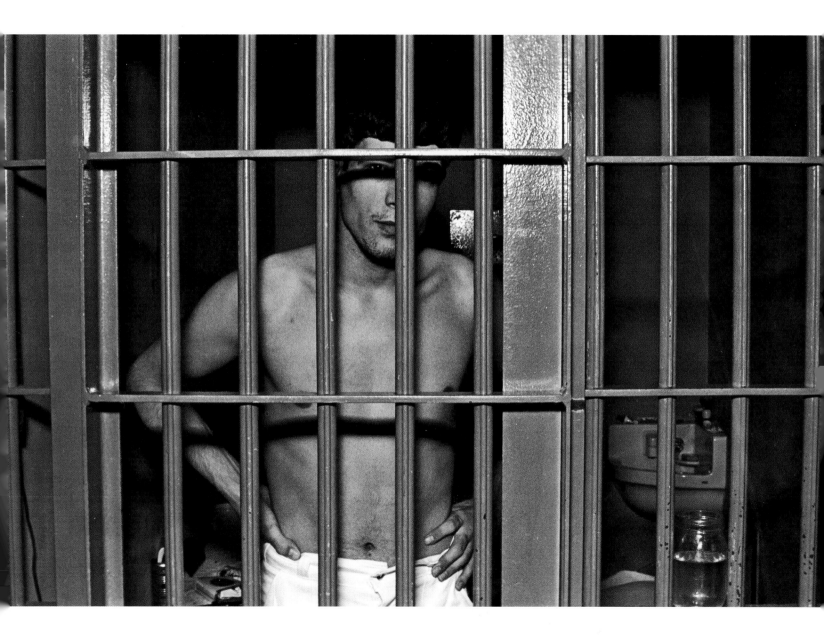

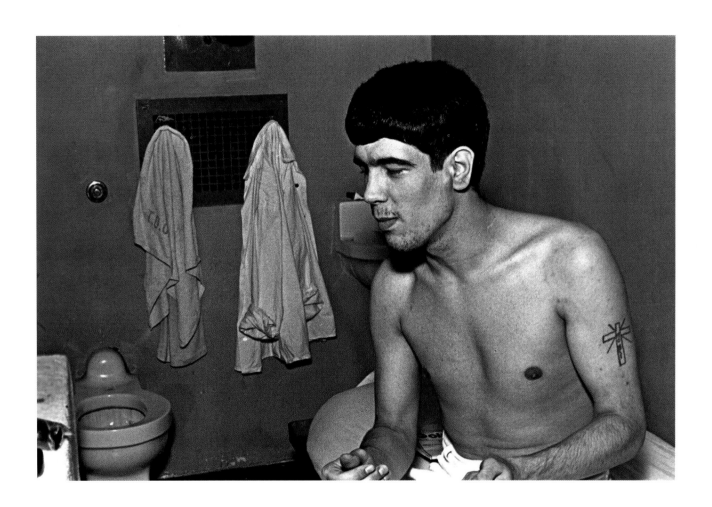

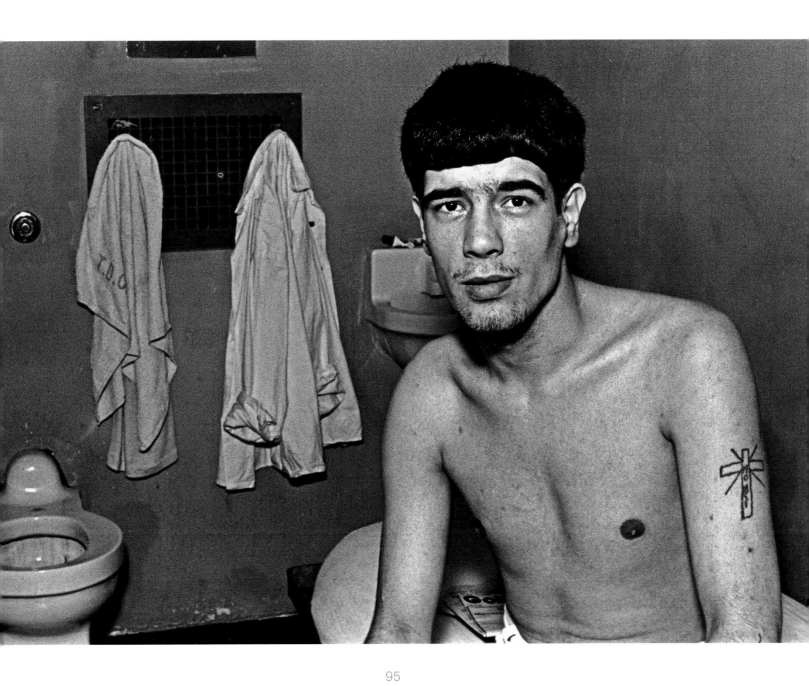

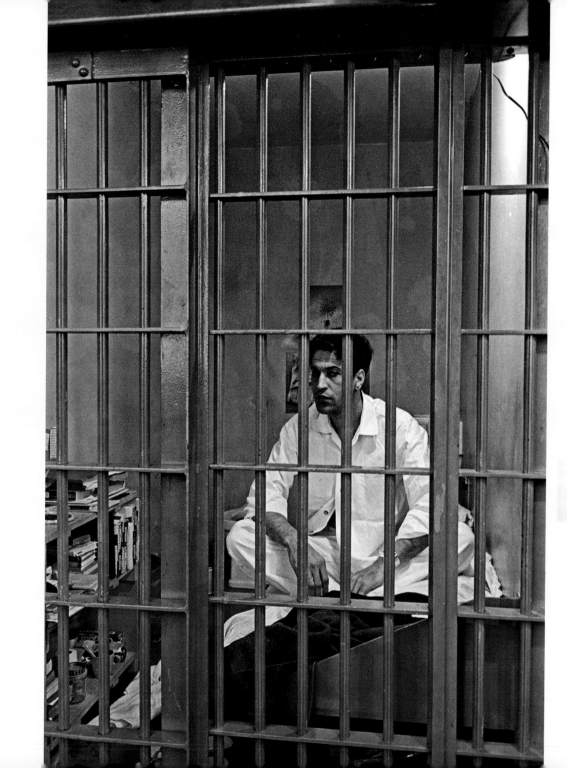

8

Twelve dead men

Paul Rougeau. Put to death, May 3, 1994. His cell is far brighter than it or any of the cells on the Row normally were: a small light we'd used in filming was still in place on the inside of the top crossbar in the cell. There was no electricity in any of the cells on J-23, so the only light came from outside the bars, leaving the back part of all the cells in perpetual shadow.

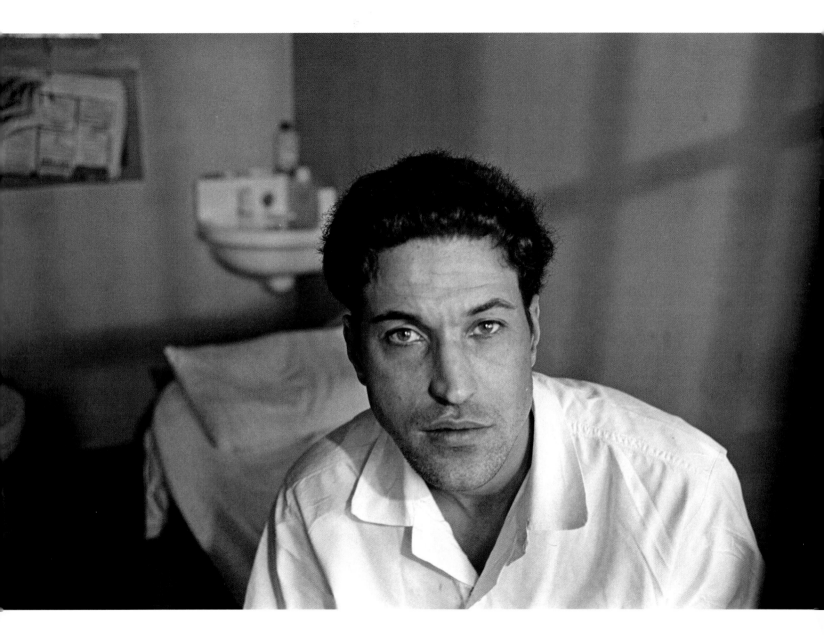

"My wife was coming. Well, I call her my wife. Her name is Vernadine. I stayed with her a while. We was common law married. She was coming to sit down and talk with me for a couple of hours because she had just got a new job and it had been a while she hadn't come to see me. So the warden—Rushing—and the priest was white. They thought I was white because if I don't tell nobody I'm black they really don't know. The priest told the warden that my wife was coming to see me, asked if it's all right. He said, 'Oh, yeah, yeah, it's all right. It's all right.' So when my wife got by the gate the man called and he said, 'Rougeau got a visitor.' The warden said, 'Send her on in.' Man, when he seen she was black, he must have turned red as a crawfish. 'Boy, you just got half an hour!' He started cussing and making all kind of squabble. . . . Sometimes I wonder why. Why? How did that really get started? To start judging a man on his color and stuff like that. What devil? I know it's the devil working on us."

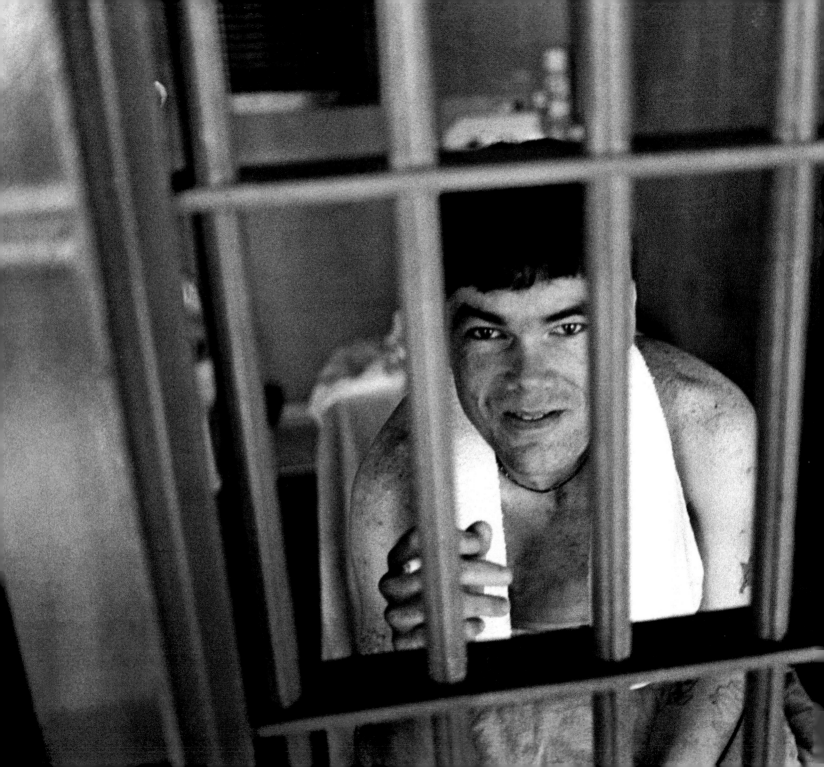

John R. Thompson. Put to death, July 8, 1987. "I think now they have the injection instead of the electric chair," he said, "I think that I could face it. I think that's a lot more humane than the electric chair. I'd cop to a life sentence if they still had the electric chair. I couldn't face walking up to the chair. Because I been electrocuted before. I stepped on a bare wire and been knocked out for a few minutes. I know what it is like to be shocked, electrocuted. And I just couldn't stand being strapped down in a chair waiting to be jolted. But I know what injection is like 'cause I shot dope all my life, and from what I hear it's something like sodium pentothal or some cousin to sodium pentothal. And I've been put to sleep with that during an operation when I broke my arm once. You just go to sleep, you know."

Excell White. Put to death, March 30, 1999. "I've had a death day set on me three different times," he said. "And each time, facing death wasn't no problem. It was the up, the stay of execution, the kickback on it. That's what really hurts you. My last time, I got within three days of execution. I was ready to go on. It didn't bother me a bit. And turned around, come up with a stay of execution. That's what hurt. Like to put me in a state of shock. As far as that goes, a man just lives and survives on Death Row."

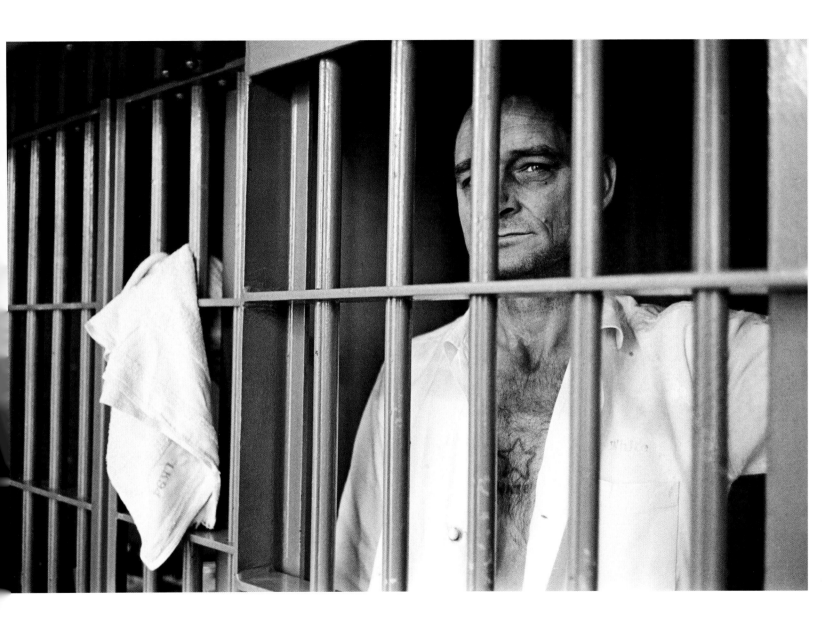

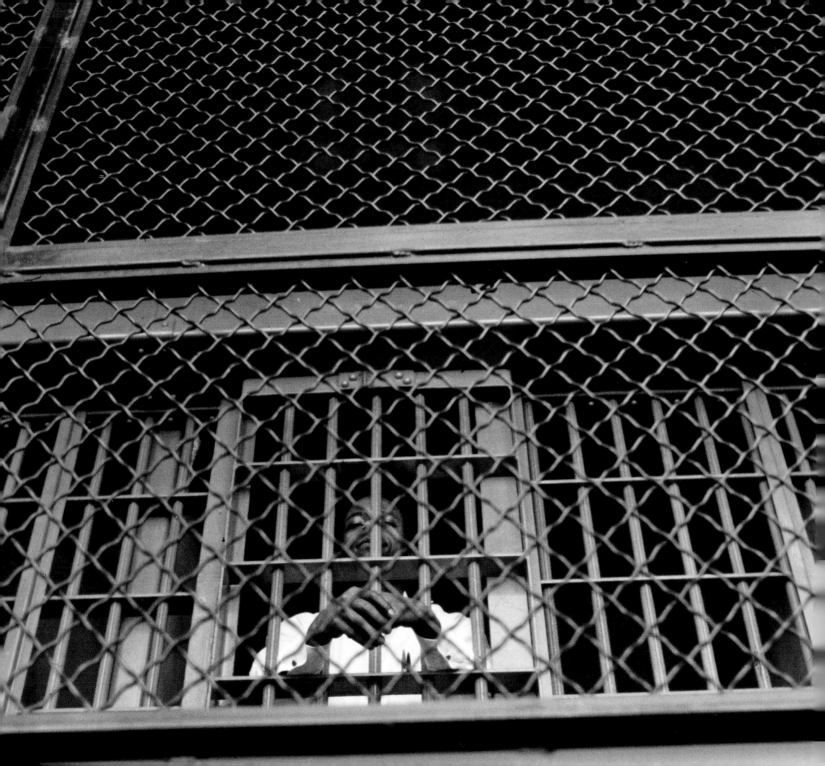

James Russell. Put to death, September 19, 1991. He was missing two front teeth, so he made a tooth-shaped insert from a plastic cigarette package that he put in his mouth at night. He said it kept his upper lip from falling inwards. He asked the prison dentist to replace the two missing teeth, but the request was turned down. "You're on Death Row," he said the dentist told him, "you're going to die so you don't need no teeth." He spent his time working on two lawsuits, one about his case and the other about his teeth.

Ronald "Candyman" O'Bryan playing dominoes with Raymond "King Motto" Riles. Candyman got the nickname because he murdered his son with cyanide-laced Halloween candy for the insurance money. He was put to death on May 31, 1984, the third man to go down in the post-*Furman* period. Riles is still on the Row. He and Ronald Chambers were the two longest residents: both arrived on April 11, 1975, but Chambers came in with a lower execution number (539 to Riles's 541). Chambers died in the Dallas County Jail while awaiting a new sentencing hearing in November 2010.

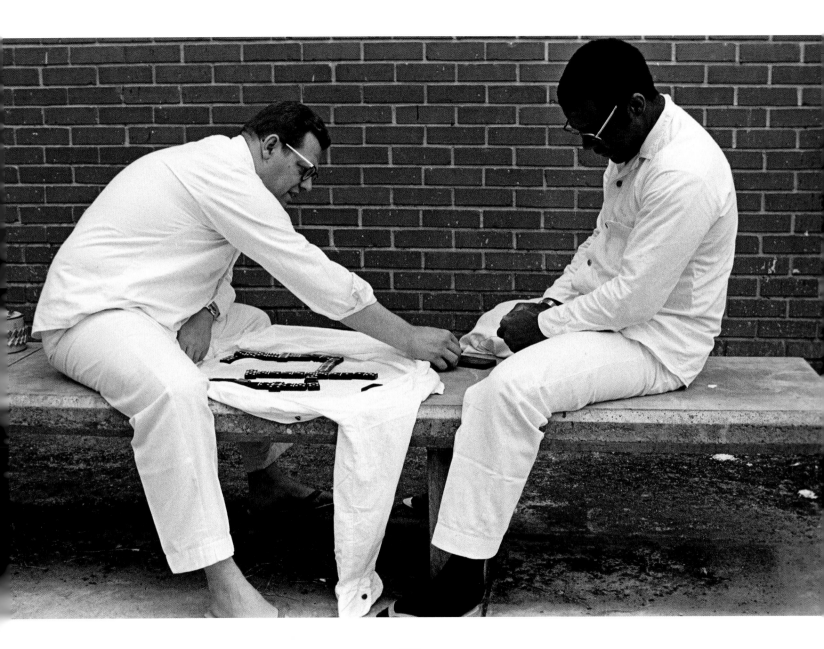

Doyle "Skeet" Skillern. Put to death, January 16, 1985. "I had finally made it to the Death Row 'Work Capable' Program in the mid-'80s when Skeet was executed," Kerry Max Cook wrote to us in a 2009 e-mail. "They would have in-and-outs on the hour every hour just like general population. The first cell on G-13 was designated as 'Death Watch' (the holding cell before transferring the condemned over to the Walls Unit for execution at 12 midnight, under the old law). Skeet was scheduled for execution and was in the 'Death Watch' cell on G-13. I slipped in the empty cell on G-15 during an in-and-out and talked to him through that grated ventilation system at the back of the cell. You remember those and the pipe-chase that separated the cell blocks of G-15 and G-13. Now Skeet was a tough ol' boy, but I knew from that day on just how tough the dying part was really going to be: he was hours away at that point and his only chance was pending before the U.S. Supreme Court. He looked so haggard. 'Kerry,' Skeet said, 'it's much, much harder than I thought it would be. I had to get the doctor to give me a shot of Vistaril.'"

The story was that Skeet was in one car and his fall partner, Charles Victor Sanne, was in another with the man to whom they were selling some pills. The man was an undercover police officer. Something went wrong. Sanne shot the police officer six times. Sanne, who confessed to the shooting, wound up getting life, and Skeet, who wasn't there when it happened, was executed. The key question in the punishment phase of a capital trial in Texas has to do with whether or not the defendant will be a continuing danger to society. In Skeet's case, the expert providing that testimony was the forensic pathologist who did the autopsy on the dead policeman. That pathologist, whose field of expertise was cadavers, got on the stand and testified that to a "reasonable degree of medical certainty" Skillern would continue to be a threat to society. Skeet's lawyer objected that the pathologist had no expertise in this area. The judge said, "This witness is a medical doctor and I believe that the testimony shows that he has studied human behavior, had experience with it, and is giving this testimony to aid the jury, if it does." A few years later, the part of the law about associates was changed, so Skeet wouldn't even have been charged with a capital offense in the first place.

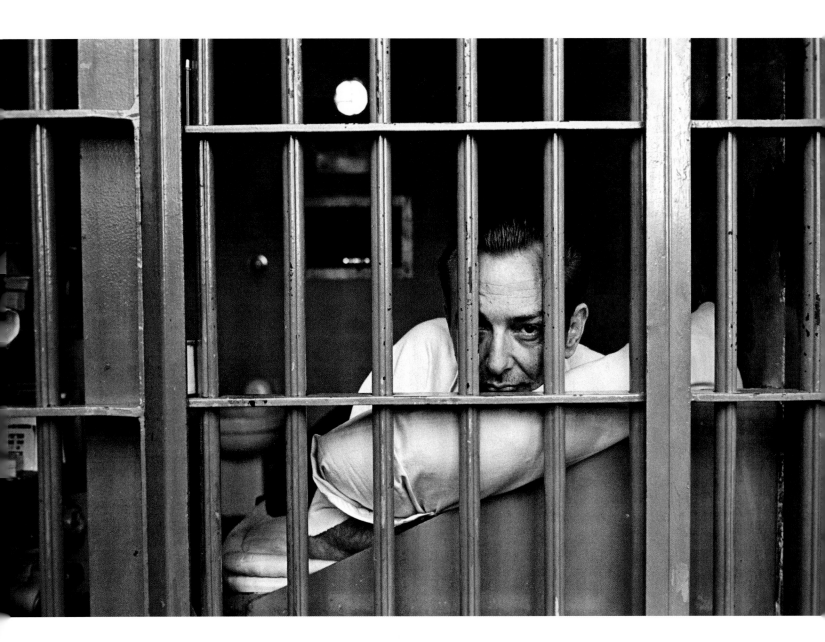

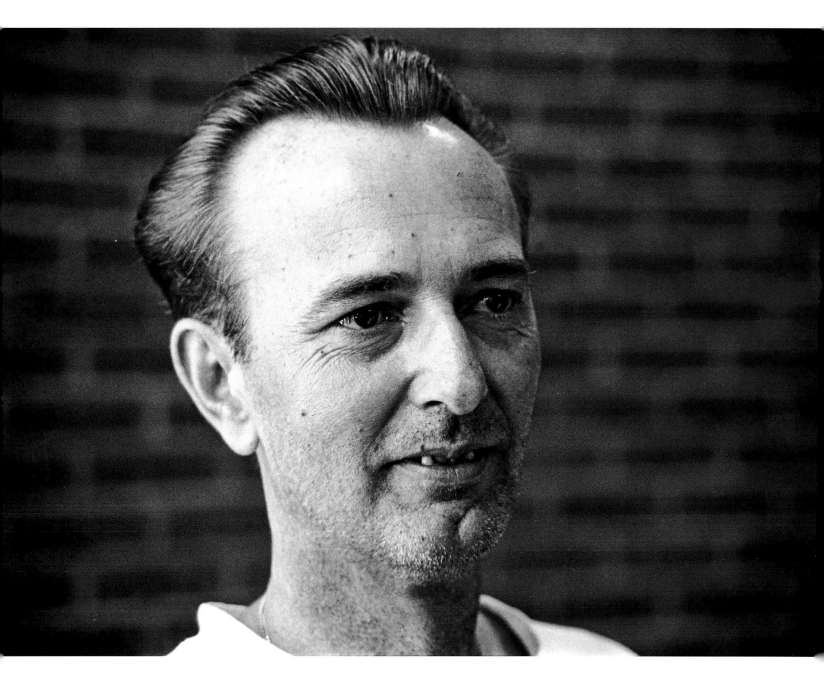

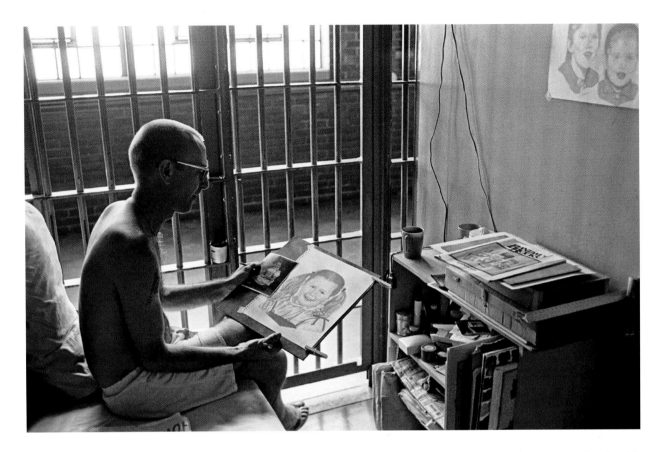

Skeet (who'd had a buzzcut that morning because one of the officials told him his hair had grown too long) with a drawing made from another prisoner's photograph. He would do these drawings and trade them for commissary. "The first couple years I was here, I worked crossword puzzles almost every day," he told Bruce. "And I finally got burned out on them and had to find something else to do with my time every day. So one day I picked up a pencil and started to do a little sketching. And it turned out to be nice. So I felt that I possibly have a little talent. I started in drawing, and I've been drawing for the last two years. I make greeting cards, and I've gotten off into doing portraits and larger paintings of scenes with birds and trees and so forth. If there's anything good that's come out of receiving the death penalty, it's that I've discovered that I have a little talent in art. So I can be thankful for that."

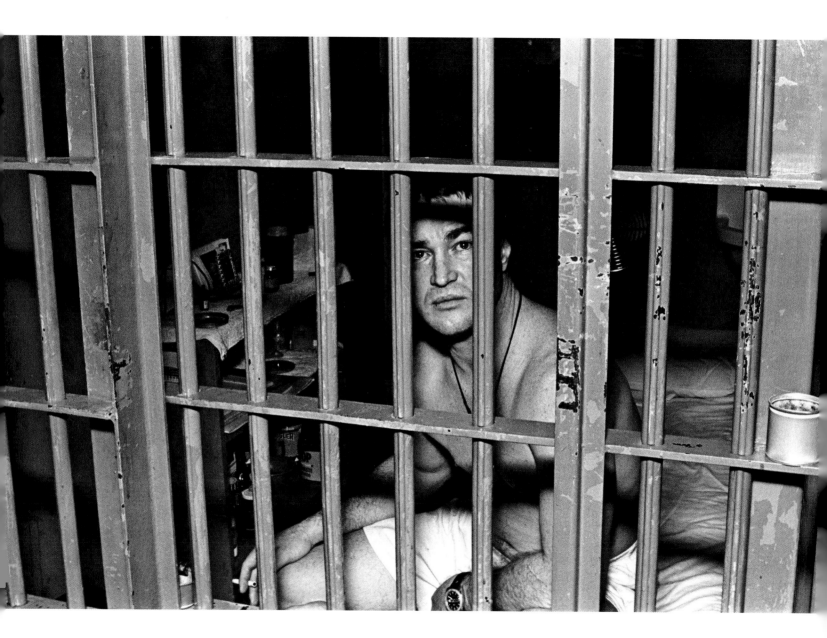

Thomas Andrew Barefoot. Put to death, November 30, 1984. "When you go to the shower," he said, "they holler, 'Hurry up, hurry up and take a shower. Hurry up and get back in your cage.' And I tell them, 'I don't get no hurry from nowhere. I ain't going nowhere. I ain't coming from nowhere. I'm right here, right now, always.' And that's all it is."

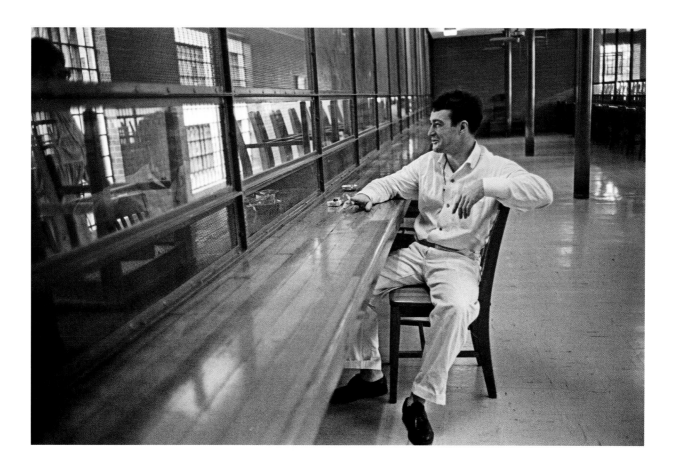

Andy Barefoot with his mother in the visiting room. When Andy introduced us and she saw Bruce's camera, she said, "Make sure they can't see my face."

"Each time I got out of prison," Andy Barefoot told Diane, "and it's been four times, this was the fourth one, I find myself getting right into the same rut again. And them deep ruts, they just going right back to the same place again. And I figured it all out now how it is. And I will get out of here. I know that. God told me so this morning."

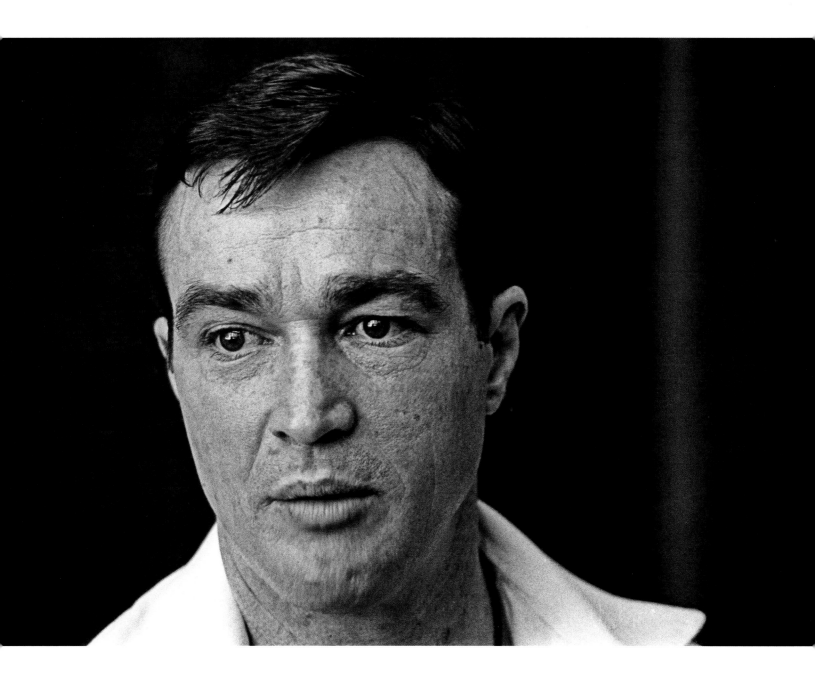

Billy Hughes. Put to death, January 24, 2000. Billy's first trial lasted three days, and, to go by the transcript, which he lent us for a while, his court-appointed lawyer never went off autopilot. A police officer testified that only six shots were fired at Billy's car; according to forensic testimony, there were seven bullet holes in the car; Billy's lawyer never inquired into the discrepancy. There were guns found in Billy's car, but no evidence was introduced at trial connecting any of those guns to the bullets taken from the slain policeman; Billy's lawyer seems never to have asked for a ballistics report. Would any such inquiry, or any of the others that weren't made, have changed the outcome? We'll never know. Two days after the jury came in with the guilty verdict, Billy was on Death Row at Ellis.

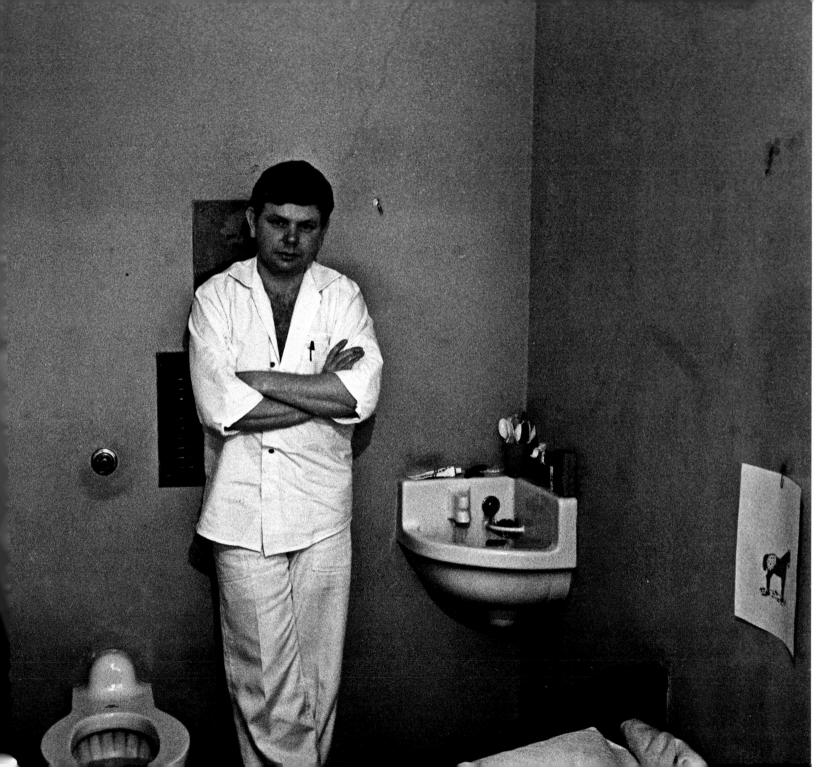

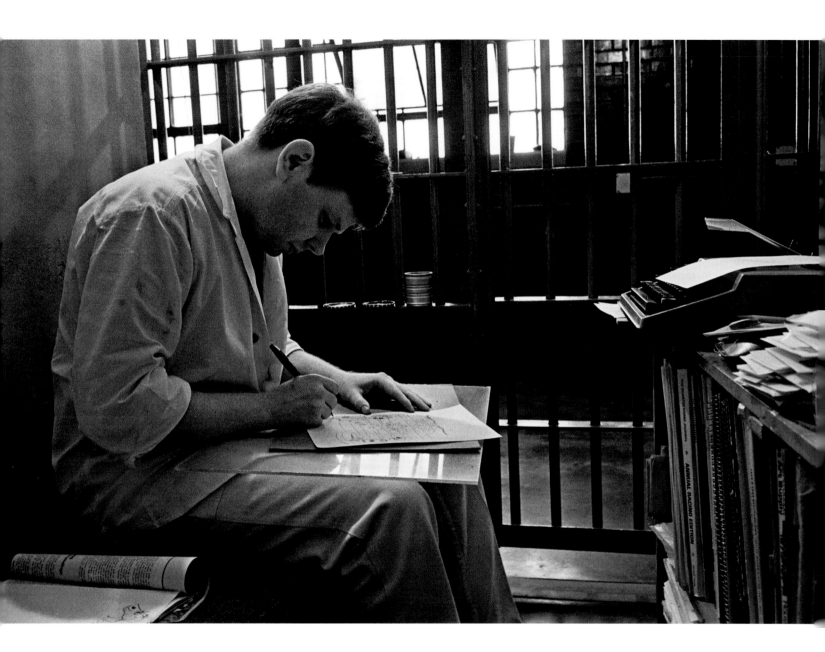

Billy liked to draw horses. "It's a known fact," he said, "that horses for centuries took care of themselves. And then suddenly they become owned by somebody and they end up being controlled and locked up and told what to do and what they can't do and where they can go and where they can't go. And I have to relate psychologically to these horses." After a while, he started sending his drawings and cartoons to magazines. "I'd say, if you like them, use them. Free." He started getting checks. "Since then," he said, "my family has not sent me any money. Because if I need anything, I take care of it. I'm making money, a living. Or, I'm making money here to buy my own commissary."

NEXT PAGES:
Billy got a retrial. He wrote a letter telling us that the prosecutors had offered to let him plead guilty to a life sentence from which he might get paroled in a few years, but he thought he could get an acquittal if he went before a jury, so he turned them down. A year or so later, he wrote that he was going someplace down on the Gulf for his trial. He was very optimistic about how things would go. A few weeks later, he called us from a county jail and said, "I got another death sentence. My lawyer put me on the stand and had me hypnotized. And while I was under I confessed."

We were stunned. The basic rule of courtroom lawyering is you never ask a witness a question you don't know the answer to beforehand. Who knows what anybody will do or say under hypnosis?

"I thought you had a good lawyer this time," Bruce said.

"So did I," Billy said.

Bruce later e-mailed someone who had been on the Row at the same time as Billy and mentioned Billy being hypnotized and confessing. The man didn't know what had happened to Billy in that second trial, but he didn't buy the story. "I can tell you as an expert regarding criminal trials and the death penalty law," he wrote to us, "that no attorney in the world would put a client—especially one in a death penalty case where the victim was a Texas State Trooper—on the stand—period—much less under any quack science of 'hypnosis.' THAT would be ludicrous. It simply cannot be true, Bruce. That is a case we would still hear about today. I have never heard of it."

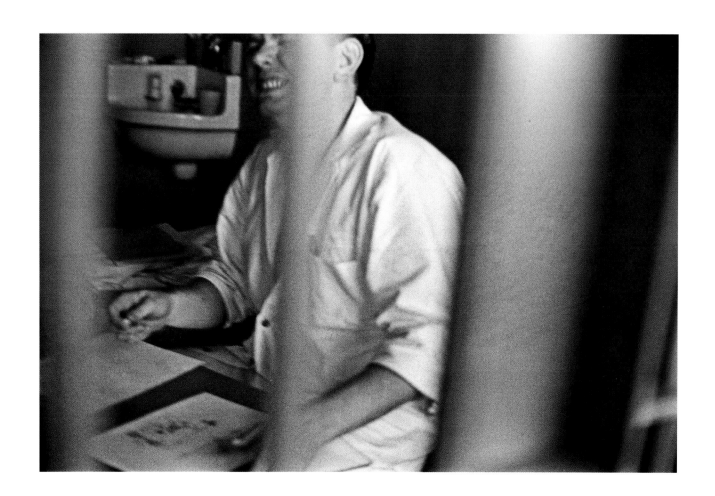

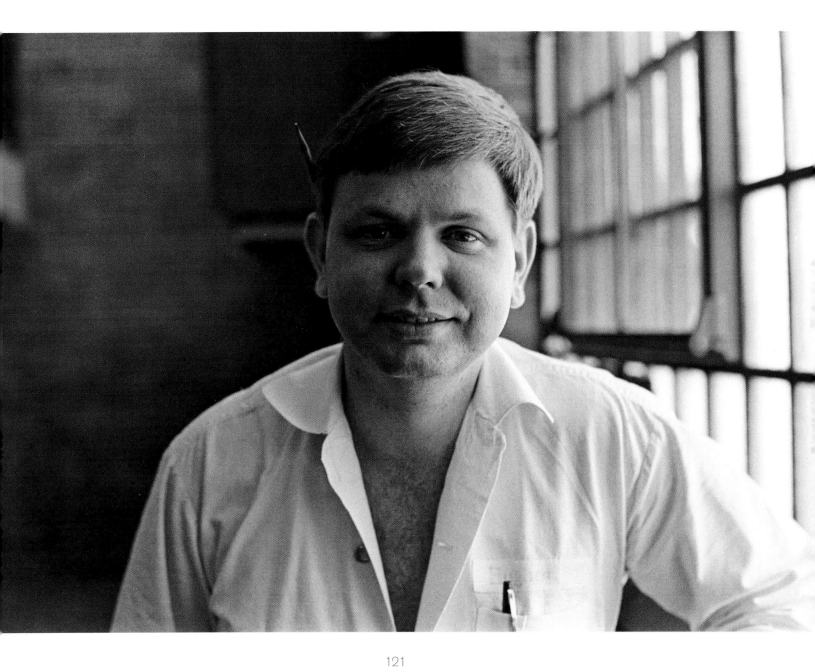

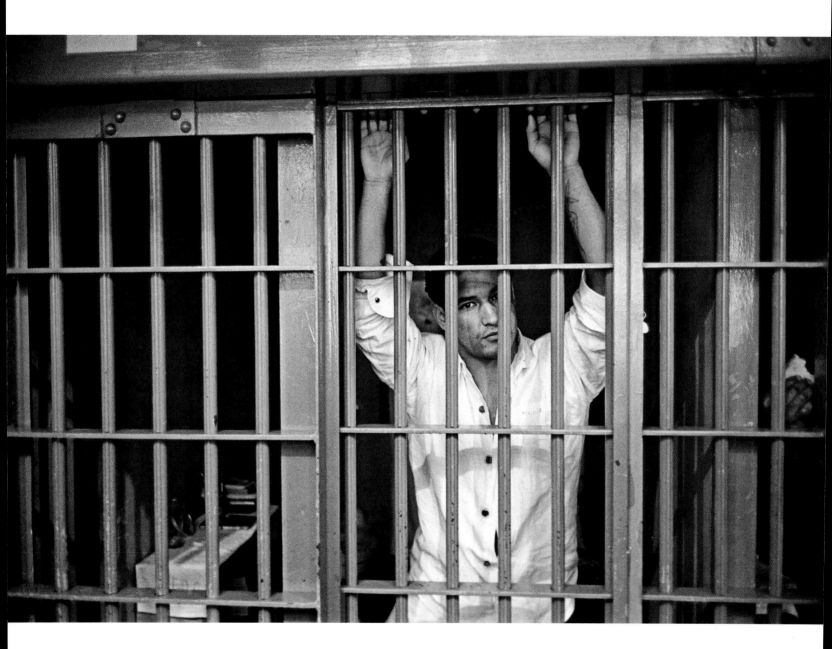

Pedro "Lobo" Muniz. Put to death, May 19, 1996. Almost every time Bruce passed by Lobo's cell, except at mealtimes or late at night (and even then sometimes), he'd be standing close to the bars with his arms raised and the tips of his fingers on the top rail. He'd watch television like that, and he'd talk to someone on the run like that. Sometimes—as here—his fingers seemed to be barely touching that top rail; sometimes he seemed to be hanging from it.

Lobo and his two Wolf spiders. He'd caught them in the recreation yard, near the fence. When he cleaned his cell in the morning, he'd look for bugs, which he'd drop in the hole in the cardboard lid he'd made for his spider jar. Then he'd sit on his bunk and watch the spiders deal with the bugs. Most afternoons, after lunch, he stood with his hands on the cell bars, watching soaps. Almost everybody on the Row watched soaps. Lobo and other guys on the Row talked about characters in *Days of Our Lives* and *As the World Turns* by their first names.

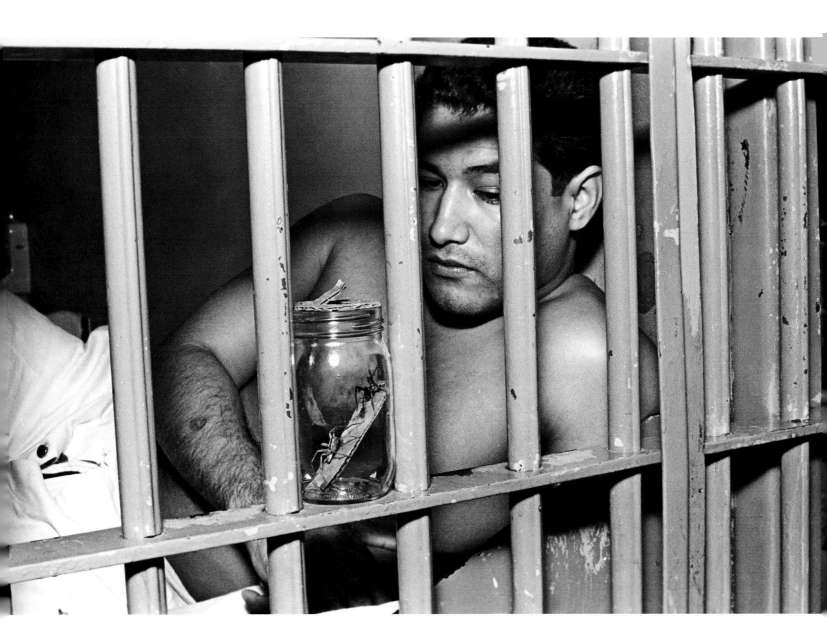

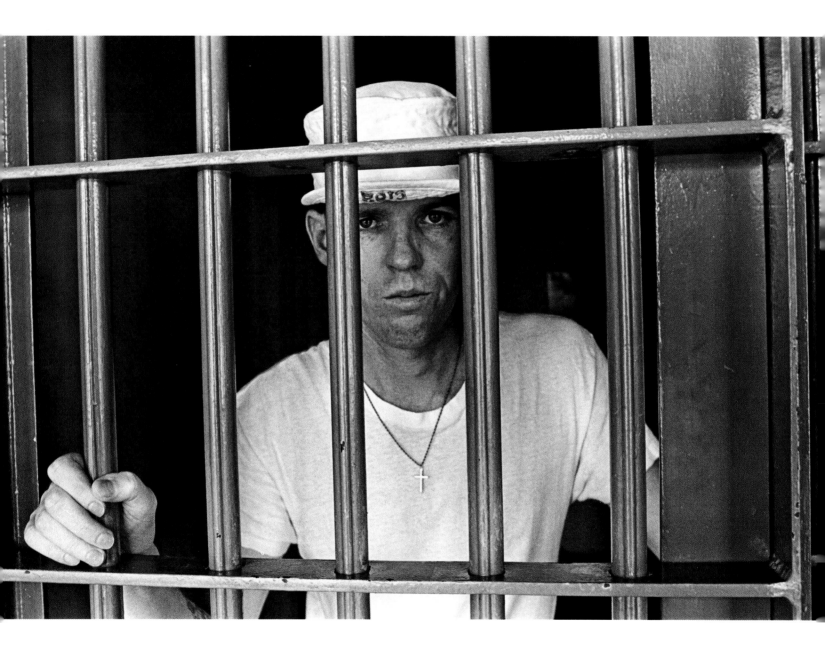

Kenneth Albert Brock. Put to death, June 19, 1986.

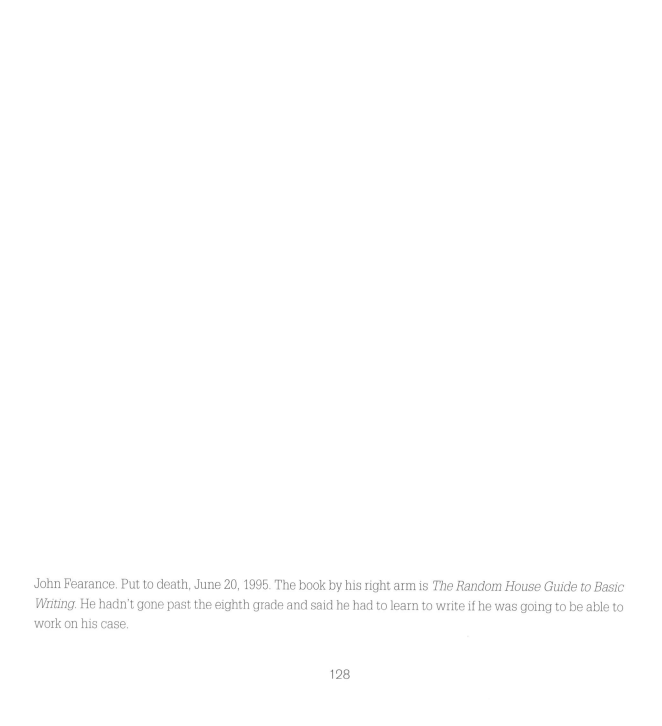

John Fearance. Put to death, June 20, 1995. The book by his right arm is *The Random House Guide to Basic Writing*. He hadn't gone past the eighth grade and said he had to learn to write if he was going to be able to work on his case.

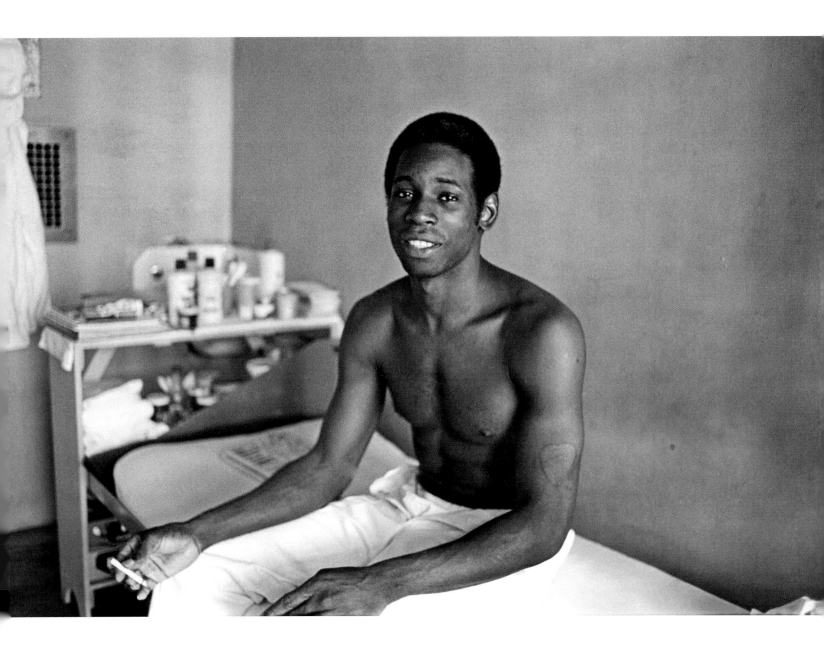

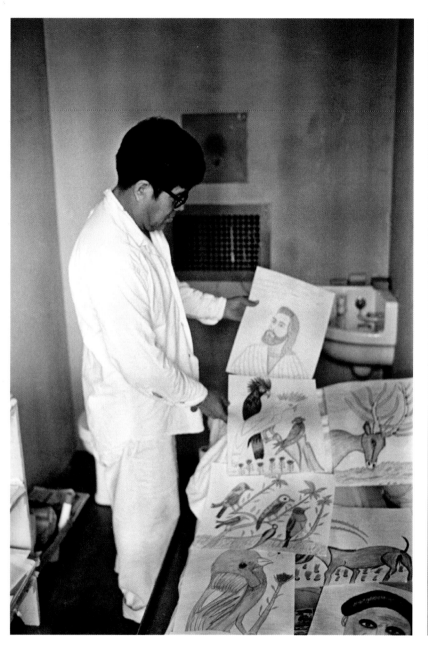

Ignacio Cuevas. Put to death, May 23, 1991. Cuevas spent his time on the Row doing colored-pencil drawings of animals, saints, and Jesus. One day, Bruce went by his cell, and several of the drawings were arrayed on the bunk. "Take my picture with my drawings," Cuevas said. "Okay," Bruce said.

Cuevas was on the Row because he was one-third of a 1974 escape attempt at The Walls organized by Fred Gomez Carrasco, a big-time south Texas heroin dealer and killer who was serving a life sentence for attempted murder of a police officer. The escape turned into an eleven-day siege that ended with two murdered hostages (schoolteacher Elizabeth Beseda and librarian Judy Standley) and two dead convicts (Carrasco and the third member of the plot, Rudy Dominquez). At the time of the escape attempt, Cuevas was serving a forty-five-year sentence for murder.

PART II
Words

1. Being there

The images in the first part of this book are, like most documentary images, made with an outsider's eye and emotions. Some nights, Bruce drove back out to Ellis prison late, sat in the barber chair, and listened, but he could always leave any time he wished while the inmates could not, and in that option lay a gap no words or images can or could ever bridge—and we all knew it. We can only show you what we saw and tell you what we remember and have come to understand about that place and what transpired there.

Bruce often talked with a young man on the Row named Billy Hughes. Diane also met with him several times; she spent more time talking with him than with any of the other prisoners. Billy had been born on January 28, 1952, which means that he was twenty-seven when we met him and four days short of his forty-eighth birthday when he was put to death on January 24, 2000. Billy liked to draw horses. He sold his drawings to horse magazines, thereby earning enough income to never have to ask his family for any spending money—a fact that he was very proud of and referred to on several occasions, even in one of the last letters he sent to us.

Billy gave us two beautiful watercolors for our daughters, Jessica and Rachel, and designed a desk pad for Jessica, who was fourteen at the time. He offered to send Bruce a watercolor as well and asked if he had any preferences. Bruce and Billy sat on his bunk and talked about various situations in which horses found themselves, and Billy showed Bruce photographs and his drawings and paintings of Arabians, Morgans, palominos, quarter horses, appaloosas, and other breeds. Bruce told him that he'd rather have a drawing about the Row. "What part of the Row?" Billy asked. Bruce told him any part he wished, perhaps a drawing that expressed something of his feelings about being there. "Okay," Billy said.

Several months later, a large manila envelope arrived, addressed to Bruce. It contained a beautiful watercolor of an appaloosa; there was no sky or ground or shadow or any other object or detail, just the spotted horse motionless against the white of the paper.

2. Killable killers

On June 29, 1972, the U.S. Supreme Court held in *Furman v. Georgia* that capital punishment as then administered in the United States was unconstitutional. The five-to-four decision in *Furman* was one of the longest ever published by the court—200 pages and nine separate written opinions. Two justices

(William Brennan and Thurgood Marshall) found capital punishment unconstitutional in and of itself; three others (Potter Stewart, Byron White, and William O. Douglas) did not object to killing by the states but rather to what they saw as inequity in the ways the states set about doing it. All four of Richard M. Nixon's appointees to the court—Chief Justice Warren Burger, Harry Blackmun, Lewis F. Powell, and William H. Rehnquist—found the death penalty acceptable in theory and application, more or less.

When *Furman* came down, Texas had forty-five prisoners on Death Row and seven others under sentences of death who had not yet been transferred from county jails. All fifty-two of these prisoners became like all the other lifers in the Texas Department of Corrections: their execution numbers were exchanged for ordinary prisoner numbers[1] and they became eligible for parole after twenty years (and, with extra days subtracted from a sentence for a variety of reasons, often far less time than that). Row J-23 in Ellis Unit stood empty—but not for long.

No one had been executed in the United States since Louis Monge had been gassed to death in Colorado on June 2, 1967. No one had been executed in Texas since Joseph Johnson had been electrocuted on July 30, 1964. In part, this dormant period had resulted from a change in the public's attitude toward capital punishment, but more important was the series of lawsuits challenging state death penalty laws and verdicts in individual cases filed by the NAACP Legal Defense Fund and the American Civil Liberties Union. That litigation led to *Furman*,[2] the message of which seemed to be that the states could execute felons if the definitions of death-eligible offenses were objective, discretion was limited, there was appellate review to ensure the trial and sentencing had been conducted and applied correctly, and the process took into account the character and record of the defendant. The court was, in effect, insisting that the states be consistent in their use of the death penalty while simultaneously tailoring the death sentence to the specific crime and defendant.

In retrospect, that attempt to avoid capriciousness seems to have ensured rather than prevented it. This may be one reason why so many capital cases spend more than a decade being processed by the courts, and why several Supreme Court justices—Brennan, Stewart, and Sandra Day O'Connor among them—have at the end of their careers decided that a fair and equitable capital punishment system is impossible to achieve and that the entire killing apparatus operated by state and federal governments should be abandoned.

The states that wanted to retain capital punishment immediately set about redrafting their killing statutes to fit the conditions voiced by the justices in *Furman* who were opposed to *how* the states killed

rather than the *fact* that the states killed. Some of those states had to go through the Supreme Court two or three times before they got to kill anyone, but Texas's reauthorization of capital punishment approved by the state legislature and governor in 1973 has never been successfully challenged in the courts.

In *Furman*, the Supreme Court had limned what it found wrong with current death penalty legislation and practice. In *Gregg v. Georgia*, the court would test Georgia's revised death penalty legislation and determine if that legislation cured the ills listed in *Furman*. *Gregg* was the case in which the court held that the death penalty was not in itself unconstitutional. Along with it, the court decided four other cases addressing particular applications of the holding in *Gregg*: *Profitt v. Florida, Jurek v. Texas, Woodson v. North Carolina*, and *Roberts v. Louisiana*. All five decisions were handed down on July 2, 1976. The court held that the Georgia, Florida, and Texas legislation met the constitutional demands of *Furman*; North Carolina and Louisiana would have to tweak their legislation further before they could execute anyone.

Each of those five cases tested different aspects of death penalty legislation; each had its own citation and opinion. The Louisiana statute, for example, tried to avoid ambiguity by making the death penalty automatic in certain cases; the court said that failed the test of taking into account the individual defendant. Jerry Jurek's brief argued that the Texas death penalty legislation violated the Eighth and Fourteenth Amendments and would lead to arbitrary and "freakish" use of the death penalty. Except for Brennan and Marshall, the court disagreed. "We conclude that Texas' capital-sentencing procedures, like those of Georgia and Florida, do not violate the Eighth and Fourteenth Amendments," Stewart wrote for the majority.

> By narrowing its definition of capital murder, Texas has essentially said that there must be at least one statutory aggravating circumstance in a first-degree murder case before a death sentence may even be considered. By authorizing the defense to bring before the jury at the separate sentencing hearing whatever mitigating circumstances relating to the individual defendant can be adduced, Texas has ensured that the sentencing jury will have adequate guidance to enable it to perform its sentencing function. By providing prompt judicial review of the jury's decision in a court with statewide jurisdiction, Texas has provided a means to promote the evenhanded, rational, and consistent imposition of death sentences under law. Because this system serves to assure that sentences of death will not be "wantonly" or "freakishly" imposed, it does not violate the Constitution.

Later in his career, Justice Stewart would have cause to reconsider and, finally, argue against his own position.

It would be six years after *Gregg* before the Texas law—which, like all laws, is abstract—was actually applied. The killing in Texas began on December 7, 1982, with Charlie Brooks, who had been sentenced to death for kidnapping and murdering a Fort Worth auto mechanic on December 14, 1976. Brooks would be the first person executed in the United States by the new killing technology of lethal injection. By September 29, 2011, Texas had executed 475 men and women in the post-*Furman* era, more than the next seven states combined.

3. Dangerous people

The 1973 revisions in the Texas criminal code and their subsequent refinements set up certain conditions that aggravated the offense of murder and thereby made it capital—which is to say, punishable by death. Capital murder had to be murder connected to another felony (like kidnapping, burglary, robbery, forcible rape, arson, or escaping or attempting to escape from prison), murder for hire, murder as part of a group of connected murders, or murder by someone already serving time for murder or serving a life sentence or ninety-nine years for some other felony. Murder could also be a capital crime if the victim were a child under six or a person that the killer knew was a police officer or fire fighter doing his or her job in a lawful manner.

If someone were convicted of such murder, and if the prosecutor sought the death penalty, there would be a second trial that took place immediately after the conviction with all the same players. In this trial, the jury answered three questions about the defendant's role in the crime and character. A "no" to any of those three questions resulted in a life sentence; a "yes" to all of them resulted in a death sentence.

The jury did not say yes or no to death, only yes or no to the three questions. The judge did not choose life or death; he or she was bound by the jury's vote. So defendants could be sent to their deaths without anyone, technically, having chosen to order them killed.

The three questions have been modified since the reintroduction of the Texas death penalty in 1973, but the key part—the second question—has remained constant: the prosecutor must get the jury to affirm that the defendant is a continuing threat to society. The first and third questions really go to

issues that the jury should have, and probably did, address in its deliberation on guilt or innocence. "It is the prediction of future dangerousness," wrote the authors of a 1989 study evaluating jurors' ability to predict dangerousness, "that is the determining factor between a life and a death sentence in Texas."[3] According to the Texas Defender Service, "Texas is one of only three states in the nation that allows highly speculative, often inaccurate evidence on the possibility of future bad acts to play a crucial role in life and death decisions made by juries."[4]

The determination of future dangerousness is key, but it was and remains something of a joke or game, since the prosecutors can always find someone who will get on the stand and say, "Yeah, this guy is always going to be dangerous." Doyle Skillern was sentenced to death on the basis of testimony about his future dangerousness by the forensic pathologist—a man whose only connection with the case was an autopsy he had performed on the victim.[5] The most famous Texas dangerousness witness was Dallas psychiatrist James Grigson, who testified for the prosecution in more than 160 capital cases and came to be known by the nickname "Dr. Death." He would attest to the dangerousness of defendants he'd never met, people he'd merely looked at through a small window or whose arrest record he'd read in a prosecutor's office.[6] Grigson gave such testimony in the case of Cameron Todd Willingham even though he'd never talked to the man; he made his prediction on the basis of Willingham's tattoos and fondness for heavy metal bands.[7] Grigson "went so far to secure death sentences as to investigate the jurors whom he was going to try to persuade. In one case, Grigson felt a juror was not going to believe his testimony and thus not sentence the defendant to death. Grigson investigated that juror's family and background and, upon finding that the juror had a fourteen-year-old daughter, testified that the defendant was the type of man who would rape and kill a fourteen-year-old girl if given the opportunity."[8] Grigson continued testifying with absolute certainty that capital defendants would be dangerous in prison or out, even after he was shown a 1988 report from the Dallas district attorney's office that followed up on a number of condemned prisoners against whom Grigson had testified previously, nearly all of whom were model prisoners once moved into general population or good citizens once they were released from prison.[9] Because of his consistent predictions of future dangerousness with no scientific basis or significant empirical evidence whatsoever, Grigson was eventually expelled by the American Psychiatric Association and the Society of Psychiatric Physicians.[10] That expulsion, however, did not undo any of the death sentences that resulted from his testimony, nor did it bring back any of the men and women killed because of it.[11]

4. Good time and hard time

More than twenty of the men who were on Death Row when we worked there in 1979 had their sentences reduced to life in 1981 and 1982 as a result of *Estelle v. Smith* and *Adams v. Texas*, Supreme Court cases that addressed problems in the punishment phase of Texas capital trials.

Estelle v. Smith was about one of Dr. Grigson's cases. It did not address the unreliability of his prediction about the defendant's behavior after trial; it was rather about Grigson's professional ethics. On the trial judge's order, Grigson had examined Ernest Benjamin Smith for competency to stand trial; Smith's lawyer was never told of the examination, and Grigson never told Smith that he was going to use what he learned in their meeting as the basis of his testimony against him in a punishment phase, should there be one. The appellate courts held that Smith's Fifth and Sixth Amendment rights had thereby been violated. The other case, *Adams v. Texas*, had to do with prejudicial exclusion of certain jurors in capital cases.

In the criminal justice world, the term "life sentence" is specific to time and place: sometimes it lasts until the person in question is dead, while other times it suggests a far shorter or less-definite period. When these men were sent to Death Row, all Texas convicts sentenced to a term of years became eligible for parole after they had completed one-third of their sentence; for parole purposes, a life sentence was considered as sixty years of time served. In the penitentiary, "time served" is based on prison years, not calendar years. Prison years were the "hard time" or "flat time" (the actual calendar years spent in prison), plus "good time" (which varied depending on security status and disciplinary infractions) and the extra time credited for school attendance and blood donations. In those years, a Texas convict in the top trusty status with a clean record who attended school and donated blood could be paroled out of a life sentence in six years and six months of hard time.

There can be a lifetime of difference between the date a prisoner becomes eligible for parole and the date parole comes, if it ever does. Charles Manson, for example, became eligible for parole in California in 1978; he was turned down then and has been turned down ten times since. In New York, Mark David Chapman, who murdered John Lennon in 1980, became eligible for parole in 2000; he was turned down that year and five times since. Sirhan Sirhan, who murdered Robert Kennedy in 1968, became eligible for parole in California in 1975; he received his fourteenth parole denial in March 2011. And in Texas, the men who got off the Row because of the irregularities marked in *Adams v. Texas* and

Estelle v. Smith became parole eligible in the early 1980s; but, with only a few exceptions, nearly all of them are still doing hard time in Texas prisons.

Beginning in 1991, the Texas legislature began increasing the minimum hard time that had to be served on felony sentences. That is one reason the Texas prison population soared from 50,000 in 1990 to 155,000 in 2009. For capital offenders whose crimes were committed between September 1, 1991, and August 31, 2005, a life sentence resulting from a jury not voting yes to all three questions in the punishment phase or from resentencing was increased to a minimum of forty calendar years. And for crimes committed on or after September 1, 2005, "life" resulting from the vote in the penalty phase of a capital trial has meant natural life—life without parole.

5. The prisoner Jack Smith and the late Excell White

Jack Smith had been on Death Row in Texas for only a few months when we met him there in April 1979. Jack told us that he spent a great deal of time working on his case, but it wasn't easy: because he didn't have any money, it was hard for him to get copies of official court documents, such as old indictments and transcripts. The state law library, he said, charged him five cents a page for the transcripts, which he thought was fair enough, but most of the time it cost more nickels than he had to buy one transcript. The indictments were far shorter than the transcripts, but the Harris County court charged him two dollars each for copies of his old indictments. "Well, if a man don't have the money," he said, "there's no way I can get these indictments."

There was a further problem. Jack couldn't read very well, so once he got the indictments and other transcripts, he couldn't do much of anything with them unless somebody helped him. Texas prisons had a vigorous literacy program, but Death Row prisoners weren't allowed to take part in it or any other education program. Bruce would often see Jack—who lived in cell 18 on one row of J-23—with his left hand through the bars of his cell holding a mirror attached with string to two rolled-up newspapers, which were also held together by string. The mirror on the newspaper tubes let him and Mark Fields in cell 19 look at one another while Fields read to Smith from the transcripts Smith's nickels had purchased from the state law library.

Excell White, who arrived on the Row on August 26, 1974, was the fifth man delivered to J-23 under the penal code that had been revised and passed in 1973. He didn't get to meet the first condemned

prisoner, John Devries, who had arrived on February 15, 1974, one month and fifteen days after the new penal code had gone into effect; Devries had hanged himself with bedsheets on July 1, 1974. The next three arrivals after Devries were Jerry Jurek (sentence reduced to life in 1982, eligible for parole since April 29, 1981, presently on the Coffield Unit), Leonard Freeman (conviction reduced to murder with malice aforethought; resentenced to ninety-nine years in 1983), and James Burns (sentence reduced to life in 1982, eligible for parole since November 22, 1993, presently on the Terrell Unit).

Excell White's prison file says his full name is Robert Excell White, but we never heard anybody call him anything but Excell, and it is by that name he is listed in the Web page the Texas prison system maintains of executed prisoners.[12] By March 30, 1999, the day the state of Texas finally got to kill him, he had been on the Row twenty-four years and seven months—8,854 days.[13]

"Four o'clock one afternoon, I arrived here," Excell said. "Came here and the gloom was—wasn't nothing but just emptiness." Bruce and he were sitting at one of the square steel tables with four welded seats in the dayroom between one row and the small caged exercise yard. Since that day, he said, "It's been more or less filled with loneliness."

The twenty usable cells on one row filled up, as did the twenty usable cells on two row and three row. The condemned men kept coming, so after a while they spilled over to the other side of cell block J—row J-21. Later, they would take over G block and then that whole end of the prison, and after those cell blocks filled up with condemned men, they moved the condemned men to another prison entirely.

6. Terminology

As in most prisons, the word "row" had three different meanings in Ellis. The prison was composed of twelve cell blocks, each designated by a letter. Each block had two sides, which were identified by a number and the letter of the cell block. Those sides of a block were often referred to as "rows," as in, "What row is he in?" "He's in J-21." Each of those rows had three tiers, which were usually called "rows"—one row, two row, and three row were the same as tier one, tier two, and tier three. The cement floor in front of the cells was called the "run," as in, "I was in cell 2 and he was in cell 21 at the far end of the run." And in Ellis, as in every other U.S. prison that holds condemned prisoners, the place where those prisoners were kept, however many blocks or wings or pods or cells it took, was called "Death Row."

What we write here mostly refers to Death Row in Texas in the spring of 1979, because that's the

Row and time we know the most about; but pretty much everything we say applies to that Death Row the rest of the time and to all of the nation's other Rows as well. With only a few exceptions, the states that have a Death Row differ only in small degrees in how they handle prisoners sentenced to death, and those differences are minor compared to what the Rows have in common and what the lives of the people waiting in them have in common. Texas now has what is probably the cruelest Death Row in the nation,[14] but there are other prisons in the United States holding noncapital prisoners that are equally cruel. The defining fact about Death Rows isn't their level of control but the fact that everyone in them is under a sentence of death.

Everyone under sentence of death in Texas in 1979 was male. A woman named Mary Anderson had been under sentence of death earlier, but her conviction had been reduced to murder in November 1978, whereupon she was resentenced to fifty years (she would be paroled in 1991). The first female Death Row inmate in Texas was Emma "Straight Eight" Oliver, sentenced in 1949 and commuted to life two years later; she was housed below what is now the warden's office at The Walls, a block from the Huntsville town square. The first woman in modern times to be executed in Texas was Karla Faye Tucker in 1998; she had been convicted in 1984. Before Tucker, no woman had been executed in Texas since 1863. Mary Anderson had been held in a one-person Death Row at what was then the women's prison, the Goree Unit in Huntsville; women under death sentences now are kept at the Mountain View Unit in Gatesville, midway between Austin and Fort Worth and a little west of Waco. Because of all that, we will, with only a few exceptions, use the male pronoun when we write about Death Row prisoners in these pages.

"Death Row inmate" and "condemned prisoner" contain too many syllables for daily use, so Texas officials have come to refer to them by only two—*D* and *R*. The term is pronounced just like it looks— *dee-ar*—as in: "There's a new DR coming in. . . . I got a DR going out on bench warrant. . . . One of the DRs cut his throat last night."

7. Getting to J

In April 1979 Texas confined all its condemned men in cell block J of Ellis prison farm. There weren't quite enough DRs to populate all 120 habitable cells on the two sides of the block, so the first three cells on one row of J-21 housed the six porters who serviced J-21 and J-23, and fourteen of the cells on three row of

J-21 were occupied by PCs—regular Ellis prisoners in protective custody because other prisoners wanted to kill them. Except for the porters, everyone on block J—both DRs and PCs—was in a one-man cell.

The PCs were housed on the Row because it was the safest place in Ellis other than the punitive isolation cells elsewhere in the building. Punitive isolation—called "solitary" in most places but called "the shitter" in Ellis—had no mattresses, no bookcases, and solid doors. It was at that time the only place in Ellis with solid doors, the only place a prisoner could be kept in total darkness. A few years later, some of the Death Row cells in Ellis would get solid doors, and, after the whole Row was moved to another prison in 1991, all of the condemned prisoners were kept in cells with solid doors.

Ellis was then the strictest prison in the Texas Department of Corrections. It housed multiple recidivists, convicts who had attempted or succeeded in escaping from other units, and convicts who had been so violent that wardens at other units could not or did not want to manage them. The residents of Death Row, many of whom were in prison for the first time, were mostly younger and had far less experience with the criminal justice system than nearly every other prisoner on the unit.

The racial or ethnic distribution on Death Row was very different from that of the state of Texas. According to the count board on J-23, the two sides of the Row held "53 White, 36 Black, [and] 13 Brown" prisoners—51.9 percent, 35.3 percent, and 12.7 percent, respectively. The population of the state of Texas that year was 65.7 percent white, 21 percent Hispanic, 11.9 percent African American, and 1.4 percent other.[15] So blacks were on the Row at triple their presence in the state's population. The percentages were still skewed, but not nearly so much, if you just looked at the big cities, the source of most Death Row prisoners. Houston, for example, was 52 percent white, 27 percent black or African American, 18 percent Hispanic or Latino, 2 percent American Indian/Asian/Pacific Islander, and 1 percent other.[16]

The skewing that is far more difficult to explain or justify has to do with the race of the victims. As far as we could determine, out of the 116 Death Row prisoners (101 on J-21 and J-23 and 15 out on bench warrants), only one—a white man—was there for having murdered a black person.[17] All of the other victims were white. That pattern, to greater or lesser degrees, continues in Texas and in most of the other areas of the country where the death penalty is frequently applied. A 2011 study by Michael L. Radelet and Glenn L. Pierce of 191 recent homicides in one Louisiana parish, for example, concluded that prosecutors sought the death penalty 97 percent more often when the victim was white than when the victim was black.[18]

Ellis had been built in the classic telephone-pole style: a long central corridor with twelve cell blocks

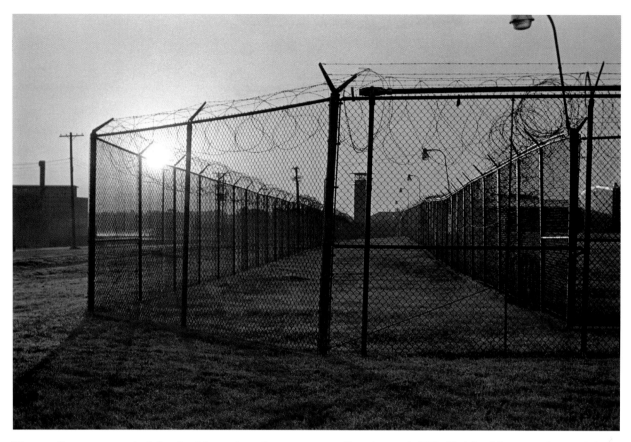

The northern segment of the double cyclone fence surrounding the main Ellis Unit buildings and one of the corner guard pickets.

(six on each side) perpendicular to it at regular intervals, like the tops of telephone poles back in the days when there were telephone poles and they connected wires that ran aboveground. There were larger structures on either side of Ellis's middle: a smaller one in the shape of a quadrangle with an open-air center for the prison's administrative offices and the visiting room, and a larger one on the other side of the central corridor for the dining hall and kitchen. (See appendix 1 for an aerial view of the prison compound.)

The main prison building and most of the convict industries (school bus repair, license plate plant, and so forth) were in a compound surrounded by a double cyclone fence topped with concertina razor

wire and triple-strand straight barbed wire. Guards in the brick towers outside each corner—"pickets" in the prison terminology—could see and have an easy rifle shot at anyone trying to climb the fence. There were two more pickets outside the middle of the two longer segments of the fence, each of them adjacent to one of the two gates through which one might pass through the fences.

Prisoners were brought into Ellis through an open sally port gate behind the dining hall. A sally port is a control device we've seen in every prison and county jail we've ever visited; it is also common in noncarceral high-security areas, such as nuclear-weapons facilities and credit card manufacturing rooms.[19] Two gates control access to an enclosed space, only one of which is ever opened at a time, so people can't rush through because that other gate is blocking their way. When people are being checked, coming or going, both gates are closed, so if anything goes wrong, they have nowhere to go.

Ordinary prisoners coming into Texas prisons would be picked up by one of the prison's buses at the jail of the county where they'd been convicted. The bus would take them to the prison system's diagnostic unit, where they would be examined, interviewed, and, a few days or weeks later, taken by the prison bus to whichever unit they'd been assigned to start their sentence. There was only one place for DRs to go, so when they were sentenced by the counties, the sheriffs immediately drove them directly to Ellis Unit.

When new DRs arrived at Ellis, the sheriff's vehicle transporting them would drive to the back of the prison compound, pull inside the outside sally port gate, and stop. That outside gate would be closed and locked. The vehicle would be checked, and the deputy sheriffs transporting the condemned man would hand the condemned man over to a prison official. Then the second gate, which opened into the prison grounds inside the double cyclone fence, opened, and the DR was taken to the Row.

Texas Rangers working in the area and stopping at the prison for lunch, lawyers, prison staff and officials, and visitors would park their vehicles in the large lot opposite Ellis's front gate. They would cross the road and pass through a sally port in the cyclone fence controlled by the officer in the front picket. That officer would first lower a rope with a hook or box at the end, with which he would collect any firearms that the visitors might be carrying. Except during the Carrasco siege at The Walls (p. 131), there were never any firearms inside the perimeter fence at any Texas prison.

Once inside, you turned left to go to the visiting room and right to go to the prison's administrative offices and into the prison's custody area. To get to the central corridor of Ellis, you went right as far as you could go, turned left, went through an internal sally port, then found yourself just a little bit south of the quarter-mile-long corridor's geometric middle. Across the corridor and a little to the left was the entrance

Main corridor, Ellis Unit,
Texas Department of
Corrections.

to the huge convicts' dining hall and kitchen; behind you was the inside sally port through which you had just passed, which led back to the lobby, the front doors, the outside sally port, and the free world.

If, once in the central corridor, you turned right and walked past the three pairs of facing cell blocks, you came up to the doors of the prison chapel. It had oak pews and a large stained-glass window. If, once in the central corridor, you instead turned left and walked past the other three pairs of facing cell blocks, you came to the doors of the gym. If you turned left at that point, you'd be facing the gates to J-21 and J-23—Death Row.

8. Ellis's yellow line

Like most other Texas telephone-pole prisons, Ellis had two yellow lines painted the entire length of its main corridor. The lines were about three feet from the walls. Ordinary inmates had to walk between a yellow line and a wall. In all Texas telephone-pole prisons except Ellis, only free-world people (including staff) were allowed to walk down the middle of the corridor. In Ellis, two other categories of prisoner also got to walk in the center of the corridor. One category was trusties pushing food carts to and from J-21 and J-23. The other was DRs. Unlike everybody else, DRs never made that walk alone, and they were always put in steel restraints before the cell-block gate opened.

Death Row prisoners got off the Row and were able to walk the central corridor between those yellow lines when they had a visitor or court appearance, when they were called to the chaplain's office for a phone call when a close family member died or was about to die, and when they were being taken for a week or two of lockup in one of Ellis's dark solitary-confinement cells because they'd acted up on the Row in a way officials thought deserved greater punishment than cell restriction. A few years later, one more reason would be added: they got to walk between the yellow lines, bracketed by two guards and wearing handcuffs and a waist chain, when they were being taken to The Walls in Huntsville, twelve miles away, to be killed.

9. Visitors

One reason Death Row prisoners rarely got to see family or friends in the visiting room was that prison officials were determined to completely segregate condemned and regular prisoners (except for the trusties who worked as porters on the Row and as the physician's assistant), so the 2,200 or so regular

prisoners could get visits on Saturdays and Sundays and the condemned men got their visits on week-days. Had their families been wealthy, the week-long visiting schedule would have been luxurious, but nearly all men on J-21 and J-23 were poor, and so were their families. It was difficult enough for poor folks who lived within a few hours' driving distance—Dallas was 171 miles to the north and Houston seventy miles to the south—to take a day off work for a prison visit. For families in El Paso (733 miles, eleven hours) or Amarillo (532 miles, seven hours), it was a two- or three-day round-trip. The practical effect of that was that Death Row prisoners got very few visits from family members.[20] For many con-demned men, the visits got rarer and rarer as the years rolled on, and often they stopped entirely.

Other than an occasional journalist or researcher, the only other people who had occasion to meet condemned prisoners in the visiting room were lawyers, but they came to Ellis prison even more rarely than family members. The drive to and from Huntsville from Houston or Dallas or San Antonio or El Paso was just as long for them as for anybody else, and they could be moving a lot of paper and making a lot of telephone calls during the hours they would be driving a car up and down the interstate just to tell someone something they could tell him equally well in a letter. (This was before cell phones; since cell phones, lawyers can rack up billable hours even if they're in a traffic jam.) So what if the informa-tion took a few days longer getting there? The good lawyers seldom made the trip because they were terribly overworked, and the bad lawyers seldom made it because they weren't interested.

Few trial lawyers stuck with a particular case even through the first round of appeals. Few of the law-yers handling Death Row appeals were paid very much, and many weren't paid anything at all; some didn't even get their out-of-pocket expenses. Consequently, many condemned men never met the last lawyers they would ever have.[21] "I've been down here since July last year and I have never seen my ap-peals attorney," one DR told Bruce. "I just found his name. I just recently got his name and address and I had to do it through another inmate."

10. Counts

Unless he had a reason to walk the rows—to deliver mail, say, or to deal with a problem—the guard on duty on the Row usually sat in the barber chair outside cell 2 or 3 on one row and watched television, or he sat in a straight-back chair at a small wooden desk just to the left of the gate between the Row and the corridor. To his left and at a ninety-degree angle to him was the thick steel door to the dayroom.

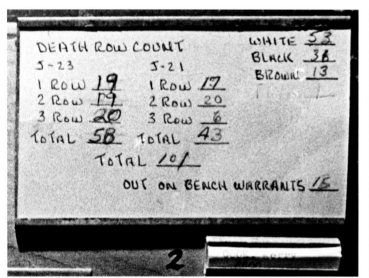

LEFT: Count card on J-23 wall listing Death Row population total by cell occupancy and by race (detail from photograph on p. 4). RIGHT: The J-23 side of Death Row and its exercise cage.

The guard's wooden chair faced a brick wall, to which were attached the count board, the cell map, and a small calendar. This was the only calendar we saw on Death Row.

Slips of paper in the aluminum slots on the count board listed the occupants of every cell in the Row's three tiers. Four vertical index cards listed the names and cell numbers of individuals in the four recreation groups who were on cell restriction for punishment or protection. The horizontal index card gave the total count for the two sides of the Death Row cell block (J-23: 58; J-21: 43; a total of 101 condemned men), the number of men who were out at court on bench warrants (15), and the racial breakdown of the condemned men in residence (white: 53; black: 36; brown: 13). A similar count board was on the wall at the guard's station in every Ellis row.

The occupant map below the count board had fields for all 126 cells on J-23 and J-21. The cell numbers were in a narrow column on the left. Cell 1 in all six rows was unoccupied; it was used for the shower, cleaning supplies, and a mop sink. The first three rectangles in the fourth wide column from the left—representing cells 2 through 5 on row one of J-21—each had two names: the six porters who serviced the two rows. The upper left corner of nearly all the boxes had the prisoner's execution

number, a three-digit number representing the order in which he had arrived on the Row. The lowest execution number belonged to Jerry Jurek in cell 17 of two row on J-23 (508). The highest number (630) belonged to James Buffington in cell 10 of two row on J-23. Most of the names in the far-right column—three row of J-21—were protective custody prisoners. Their boxes had a two- or three-digit number penciled in the upper right corner, so anyone looking at the chart could tell at a glance whether the occupant of the cell was a DR or a PC.

Every time a man moved into or out of a cell, appropriate changes would be made in the count board slots, in the occupant map rectangle, and on the J-23 count board index cards. Those changes were not always consistent. In the detail photograph of the horizontal count card above, for example, the Row had 102 inmates when they're counted by race and 101 when they're counted by occupied cells. The count board has no name slip in cell 2 on one row, indicating that the cell is empty; the occupant map shows that cell to have been occupied by Fred Durrough. In fact, most of the time we were there, cell 2 was vacant, and we used it to store our equipment at night. Late in our visit, Durrough came back from a bench warrant and moved into cell 2, which may have been where he lived before he'd gone to court. So the count board had it right part of the time and the occupant map had it right part of the time, but neither had it right at the same time. The horizontal count card combined the two, with the count by race including Durrough and the count by bodies in cells not including Durrough.

11. Recreation

Prisoners on Death Row got out of their cells but not off the Row for just two things: a shower once a day and recreation in the dayroom and the small exercise cage for three ninety-minute periods every week. The officials didn't want them tracking mud back into the building, so they could go out to the cage only when it wasn't raining and the ground was dry, which some times of the year didn't happen for weeks on end. Neither did officials want them going outside when the weather was too cold for the guard[22] who'd sometimes watch them while sitting in a folding iron chair outside the cage.

The steel door to the left of the guard's desk had a small glass window. At appropriate times, he would call recreation and tell whichever of the four recreation groups he was letting out to get ready, then he'd tell the guard in the hall picket—the three-tier-high cage that spanned the ends of J-21 and J-23 and had a bridge to the cell block across the corridor—which cells on which row of J-23 to open.

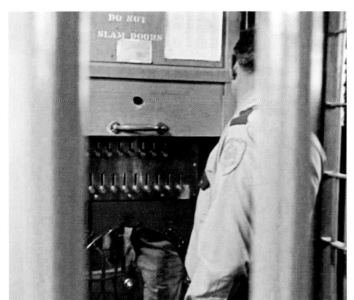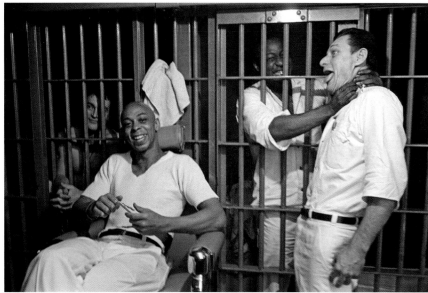

LEFT: Guard Ronnie D. Hodges in front of the cell door locking controls on the first level of the hallway picket of J-23. The pins determine which cell doors will be operated. The large wheel rolls the selected cell doors open or shut. RIGHT: Mark Moore (in the cell) clowns for the camera with night porter John Hayter, while day porter Emery Harvey sits in the barber chair and Andy Barefoot (in cell 3) watches television.

The picket guard would first move to the upper position on a panel in front of him the appropriate stainless steel knobs that connected physically to the pins and locking and rolling mechanism in each cell door to be opened. There were two sets of such knobs in the panel at the end of each row—eleven in the upper group and ten in the lower. Then he would spin an eighteen-inch chrome-plated wheel. The gear box that ran above all the cell doors on the row would groan and crank, and the cell doors corresponding to the knobs he had moved to the upper position would all roll open at once. He could open or close just one or all twenty-one cells on a row with a single spin of that chrome-plated wheel, depending on which pins he had moved. No convicts, not even trusties, were ever allowed in the cage.

The men going to recreation would file out of their cells and walk toward the front of the row if they were on one row or come down the steel stairs if they were on two or three rows. Then they'd turn left at the guard's desk and go into the dayroom, sometimes accompanied by one of the porters. The row guard would lock the door from the outside and wouldn't open it until it was time for the men to go

back to their cells or until something alerted him to a problem. If problems happened but there was no commotion, the door stayed locked until the ninety-minute recreation period was over. If the weather was right, the porter would unlock the steel door between the dayroom and the exercise cage.

The dayroom had a water fountain and three steel tables, each with four welded steel seats. The DRs used the steel tables to play cards and dominoes or just to hang out and talk. Some stood around and talked. The difference between doing that in the dayroom and doing it from the cells was that from the cells, no more than two men could interact at once, and the only way a man could see the person he was playing dominoes with or talking to was with a mirror. In the dayroom, several men could talk or play cards at once, and they could all see one another, just like ordinary people.

The exercise cage had two wooden benches set end to end near the wall. Most of its space was occupied by a volleyball court. When the men played volleyball, the action was often vigorous. The cells were no wider than a man's arms could reach and the ceilings were low, so the exercise yard was the only place an inmate could make a big movement without slamming into brick or steel. Steel I-beams crossed the cage, so the freedom to move was only relative.

The four recreation groups consisted of fifteen men each, but the number that came out of the cells was usually smaller than that. Often one or two prisoners would be on cell restriction as punishment or for protection, and there were always some who just didn't want to come out of the cell that day, or at all.

Billy Hughes, for example, would recreate if he could get outside in the sun but not if he had to spend the ninety minutes in the dayroom, which he said was more boring than staying in his cell with his drawing equipment, typewriter, and books. Gerald Bodde (who would die on the Row of cardiac arrhythmia in 1987) wouldn't come out of his cell for anything but a shower. He had informed on a number of people, both in county jail and on the Row, and he was worried someone might kill him. "They'd all like to get me if they could," he told Bruce. "I'm a prisoner here, on Death Row." After he was raped in the dayroom by James Demouchette and had the words "good pussy" sliced into his buttocks with a piece of glass, Kerry Max Cook wouldn't go to recreation for a long time, either.[23]

Some people didn't have Bodde's and Cook's good reasons for avoiding recreation. They just didn't like coming out of their cells for anything if they could help it, so they just zoned out and slept, day and night, waking up only for food or a shower, and sometimes not even for the food.

Most of the time, everybody was in their five-by-nine-foot cells. They could see people walking by— porters, guards and other officials, and convicts going to and from the shower; the food trays coming

and going three times a day; commissary coming once a week with cigarettes and ice cream and Coke or Dr. Pepper (for those with cash on account). There were brief daily visits from the retired navy medical corpsman who wore a long lime green shirt with four pockets and handed out medications from a plastic fishing-lure box. He wrote down new symptoms to tell the doctor, who visited rarely and whose English was so bad that few of the DRs could communicate with him. On rare occasions, one of the preachers came to the Row, but he never stayed long. Since cell 1 on each row was the shower, the men in cells 2 through 9 saw a lot of people going back and forth, and the men in the double-digit cells saw fewer and fewer the closer that their cell was to cell 21 along the back wall. The men on one row could see a lot of action because the run at that level went all the way to the windows, but the men on two row couldn't see anything happening under the run, and the men on three row couldn't see anything happening on one row at all unless it was happening right against the windows or right under the television sets. If there was a fight on one row, they could hear it but they couldn't see it, not even if, like Jack Smith, they had their mirrors on long holding stems.

12. Porters, floor boys, building tenders

In 1979 three non–Death Row prisoners, all of them trusties, worked on J-23 and three others worked on J-21. All six of them were housed two to a cell in cells 2, 3, and 5 on J-21. Their schedules were staggered, so most of the time, there was just one man in the cell, and during the day, they could come out of the cell, whether they were working or not. Get in good with them and you could get by; get on the wrong side, and the hell that was Death Row got even worse.

The trusties' job was to maintain the Row. Each worked an eight-hour shift, seven days a week, no holidays. They mopped the floors; loaded the food trays, carried them to the cells, and picked them up when they were empty; changed channels on the television sets; delivered commissary; carried things from one cell to another; helped people cope when they were freaking out; and acted as an intermediary between the DRs and the guards, who mostly sat at the front of the Row, handled the mail, and sometimes helped fill the food trays. "They're my legs," one DR said. Some were friendly; some maintained their distance; one was known as the deputy warden's snitch and nobody liked him, not even the other porters. At feeding time, all six trusties worked, no matter what their shift. The three trusties from J-21 came over to help pass out and collect the trays on J-23, then everybody went over to the other side and did the same thing there.

They were referred to as floor boy, floor man, orderly, porter, and building tender. That last term—*building tender*—was passing into disuse in 1979 because the prisoners' rights case *Ruiz v. Estelle* was then in process in Houston. Part of the case challenged the Texas Department of Corrections's use of building tenders as convict guards and administrative thugs. Before *Ruiz*, there were convicts with the job title "building tender" in all Texas prisons. In most of the prisons during the years leading up to *Ruiz*, their job centered around maintenance, but in some they had real power and even control of the tanks or rows. According to the testimony in *Ruiz*, some of the building tenders were brutal, some were sexual predators, and some were pimps. The building-tender system made it possible for Texas to run its prisons on the cheap, since in those units where they were given power over other prisoners, only a few free-world guards (paid) were needed to oversee the convict building-tender force (unpaid) and thereby manage the buildings. But U.S. district court judge William Wayne Justice said that was an unacceptable economy. After his *Ruiz* decision came down in 1980, the building tenders were replaced by free-world guards, and those convicts who remained on jobs in the wings got new job titles and limits on their power to punish, extort, and control.

13. Noise

Except for the few hours between lights-out and the arrival of the breakfast food cart at 5:30 A.M., J-23 was a place of ceaseless, oppressive noise. The kind and intensity varied, so it never settled into monotonous white noise that might be ignored. Some men stuffed cotton in their ears, but that was only partial help at best, and the cotton made it hard for them to hear the things they needed or wanted to hear.

Each cell had a speaker just above the air vent on the back wall between the sink and the toilet. Each speaker had a four-position switch, which accessed a soul radio station (KMJQ, Houston), a white country radio station (WBAP in Dallas), and a rock station (KLOL, Houston) or turned the speaker off. The radios all came on at 6:00 A.M. Since all the speakers and all the air vents on J-23 and J-21 backed on the same pipe chase—the narrow corridor between the two sides of the cell block where the plumbing and electrical lines ran—a jumbled mixture of all three stations came through each cell's air vent whether that cell's speaker was on or off. The loudest speaker other than one's own was the speaker in the parallel cell across the pipe chase on the other side of the block. The pipe chase speaker noise could be reduced by hanging towels or thick paper over the air vent, but then in the warm months, when air temperature on the block was over 100 degrees for days at a time and the humidity wasn't far behind,

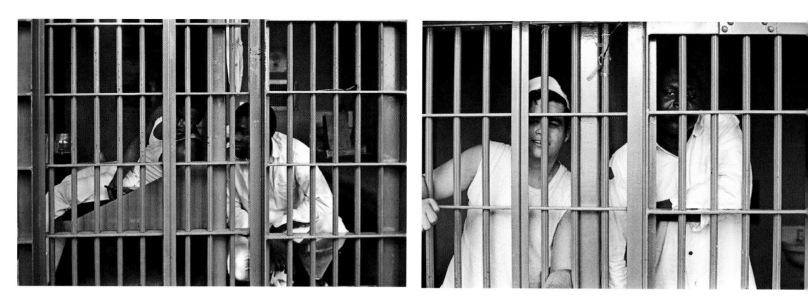

LEFT: Kenneth Davis (cell 6) and Calvin Woodkins (cell 7) in conversation, each leaning close to the bars and the wall separating their cells so people in other cells won't be able to hear them. RIGHT: Donnie Crawford (cell 11) and Wilbur Collins (cell 12) after Brandon smashed the jar on the bars of Donnie's cell.

the cells became unbearable. The sound got in anyway: even if the air vent and speaker in one cell were completely blocked off, it spilled out onto the rows from every other cell in J-23 and then came right in between the bars, along with every other noise constantly roiling the air. "You can't get away from it," Jack Smith told Diane. "In the mornings, immediately at six o'clock, the radios come on, blasting. You cannot, even if you got your radio turned off, you can't help but hear it."

The eight television sets were on from about 9:00 A.M. until lights-out—10:00 P.M. on weeknights and later on weekends (or if something special were on, sometimes as late as 2:00 A.M.). They were all supposed to be tuned to the same channel at any one time—soaps from noon to five, sports or movies at night—but none of them had remotes, so when it was time to go to another channel, a porter had to climb steel rungs bolted to the brick wall and rotate the tuner knob on each of the eight sets. During that period, which was often interrupted because he was called to do other things, as many as four of the television sets would be tuned to different channels from the other four and the noise from the three radio stations, two television stations, and the Row itself was like something scored by composer Charles Ives at his most ludic.

All day long, there would be the clang of cell doors and the groaning of the gear box above the cell doors, the slamming of the steel-barred door to the corridor and the solid steel door to the dayroom, and similar sounds from the cell block across the corridor. Toilets flushed. Cans of tobacco or jars of instant coffee being passed from one cell to another scraped on the concrete floor. At mealtimes, steel trays slapped the concrete and scraped as they were slid under the cell doors full; a few minutes later, the empty trays scraped again, higher in pitch, as they were pushed back onto the run. In between, the trays banged against toilets as they were emptied before pickup by the porters.

There was always the murmur of people talking, sometimes rising as the talking turned into yelling to or at one another or at nothing at all. And then there were the screams, which could come any time but came mostly at night.

14. Night, Brandon, Emily, and George

Thus night—those hours between lights-out and the arrival of breakfast—was precious to almost everyone on J-23. It was the one time a man could think, the one time he might pretend he was alone. The lights at the top of the block were kept on, but the lights just outside the cells were turned off, so all the cells on one row and two row were dark or mostly dark once the television sets were turned off. There were night noises, but with one exception they were brief and bearable: an occasional toilet flushing, snoring, someone talking or yelling or screaming in his sleep, someone getting noisier than he should have while jerking off.

The exception was Thelette Brandon, who lived in cell 13 on one row. Bruce doesn't remember ever seeing Brandon not in motion, except when he was sitting on his bunk or on his toilet eating a meal. He'd hang on the bars and rock back and forth. He'd stand in the middle of his cell and dance. The first day Bruce was on the Row, one of the porters brought him a note, winked, and said, "From Brandon." He pointed at a tall man who was standing close to the bars of his cell, moving his upper body left and right, dancing to a beat neither Bruce nor anyone else could hear, and grinning at him. The porter rolled his eyes.

The note said: "There are things we should talk about. Thelette J. Brandon. Fantastic Dancer of Mind."

Every night after lights-out, Brandon had vigorous conversations with Emily and George, individuals he told Bruce lived in the pipe chase behind his cell. Some nights they wouldn't talk to him, and he'd get very cross with them; other nights they would talk to him, and the conversations—only one side of which was ever heard by anyone else—would quickly degenerate into fierce arguments that went on

for hours. Some nights he sang to them. Everyone else would scream at Brandon to shut the fuck up so they could get some sleep, but the only voices he attended in the dark were the voices of Emily and George. We don't know when or if he slept.

At least six men on the Row told us they'd like to kill Brandon just so they could get some sleep. Others were more sympathetic. Jack Smith, who lived in cell 17 on the same row, said to Diane, "That nut that talks to hisself, three of them jumped him. They beat him up in the dayroom. Then they carried him out in the hall and put him back in his cell and locked him up. You know why they jumped on him? Because he talks day and night down there. Carries on conversations with hisself. Loud. And sometimes he'll scream out real loud. I don't hold it against him. I blame the officials for not doing something for him. Why don't the doctors do something for him? Why don't the psychiatrists do something for him? I can't destroy that man because I know he's not there or he wouldn't be staying up day and night."

Bruce asked Scott Summerfield, one of the guards, why the medical staff didn't do something for Brandon. He shook his head and said, "The unit psychologist, or whatever he is, doesn't particularly like to come to this tank."

One day, Bruce was walking around, and Brandon yelled out, "Hey, Bruce, gimme one of those cigars."

"No," Bruce said.

"Come on," Brandon said.

"I'll give you one if you promise not to argue with Emily and George tonight."

"It's a deal."

"You promise that there won't be any yelling?"

"I promise."

Someone in one of the adjoining cells yelled out, "Don't believe him, Bruce. He's lying. He's always telling people he's not going to do it and then he does it."

"I'll be real quiet," Brandon said. Bruce gave him the cigar.

The next morning, Bruce came on the Row about 6:00 A.M. Before he was past the shower cell on one row, someone yelled out, "The son of a bitch was arguing with them all goddamned night!" Somebody else yelled, "I told you!"

As Bruce passed Brandon's cell, Brandon said, "Hey, Bruce, that cigar you gave me didn't work. Gimme another one and let's try it again tonight."

A few days later, Charles Grigsby, one of the porters, said to Diane, "That wasn't right, what Brandon did with Bruce and the cigar."

"You mean promising not to carry on and then carrying on anyway?"

"No. He can't help that. I mean him saying, 'Gimme one of those cigars.' That's no way to ask for something."

"Bruce says Brandon is kind of crazy."

"Even so," Grigsby said, "that's no way to ask somebody for something."

Bruce was taking a picture of Andy Barefoot, who lived in cell 3 on one row, when he heard smashing glass. By the time he turned and saw where it was, Summerfield had yelled "Roll thirteen!," and Summerfield and two porters—Emery Harvey and Charles Rigsby—had rushed toward Brandon, who was standing in front of cell 11, where Donnie Crawford lived, holding a towel and not doing much of anything. Harvey and Rigsby each took Brandon by an arm, and then Summerfield pushed him from behind. They propelled and steered him at a trot toward his cell. They got there just as Ronnie Hodges, the guard in the hall picket, got the cell door open. They shoved Brandon in. Summerfield again yelled "Roll thirteen!," and Brandon's cell door slammed shut.

Harvey told Bruce that on the way back from his shower, Brandon had smashed his coffee glass—formerly an instant coffee or peanut butter or mayonnaise jar—against the bars of Donnie's cell. "That's how you blind guys," Harvey said. "The jar hits the bars going fast, it explodes and it sends glass flying into the face of anybody who's looking out." He shook his head. "What's weird is, he and Donnie are friends. I never saw anything bad between them."

"The way you get somebody over here," Barefoot said later, "is you heat you up some water boiling, boiling hot. And when he comes by, scald him. Or either take a mayonnaise jar and throw it through the bars and let it cut people up 'cause that glass hitting that bar, and the momentum of it's still going and the sharp edges, will cut you bad." Several other DRs told us the same thing: if you want to get someone, you smash glass against his cell bars or you throw boiling water in his face.

After everything calmed down and was back to normal, Bruce went over to Brandon's cell and asked him, "Why did you try to blind Donnie?"

"I didn't. I was trying to blind Wolf."

"But you smashed the glass on Donnie's bars. Donnie's in eleven, Wolf's in twelve. Why did you do that?"

"I just don't know, Bruce. I really don't."

"So why did you want to blind Wolf?"

Brandon shook his head. "I don't know, Bruce. I just don't know."

The next day, Donnie told Diane that the reason Brandon had smashed the glass against the bars of his cell was that Donnie had reached through the bars and punched Brandon in the head as Brandon was going back to his cell from the shower. Brandon, Donnie said, then rushed to his cell, picked up the jar, came back out and smashed it against the bars of Donnie's cell. Diane asked him why he had punched Brandon in the head. "Because he's driving me crazy yelling all night. I can't get any sleep." Donnie told Diane that a few days earlier, Wolf had jumped on Brandon in the dayroom and punched him a few times for the same reason. Someone else told Bruce it hadn't been just Wolf beating up on Brandon in the dayroom: several guys had gotten in on it, and it had happened more than once. That was probably the same beating that Jack Smith had described to Diane.

"So that's what that was about," Donnie said. "Him not letting us get any sleep."

"He said he didn't know why he smashed the glass on your cell or why he wanted to blind Wolf."

"By now," Donnie said, "he probably doesn't."

15. Violence

That's the only time Bruce saw anything approaching violence on the Row. The film we made and the photographs in this book show men on the Row doing a lot of things, but none of them shows any violence. But we'd hear about it. Billy Hughes told of being in a group moving from the cells toward the dayroom a year earlier when a man repeatedly stabbed the man walking in front of him "who was supposed to be his friend. And for no apparent reason. To this day, nobody knows why it happened or what caused it to happen."

Mark Fields told Diane about Richard Vargas, who would die on the Row of a heart attack in 1981: "He's the one that beat his brains out on the bunk. He had cut his wrists. A person cuts his wrists, there's something wrong with him. I'm not going to cut my wrists, not just for the hell of it to see what's going to happen. I know what's going to happen. Okay, he cuts his wrists. Now they take him out, they bring him back. He bites all this stuff off. The dude's nuts. There's something wrong with him. Okay, they take everything. He lit his bed on fire. They take everything out of the cell. He beats his brains on the

edge of the steel bunk. And beats his head on the bunk till his brains come out. And this is literal, this is not a figure of speech. Brain matter was running out of his head. And they take him down and bandage it up. They bring him back. He starts beating again."

We heard that story from three other men on the Row. Vargas was the prime example of someone freaking out more than once. There was some variation: the time he spent beating his head on the bunk ranged from two hours to two days; the matter that came out of his skull ranged from fluids to brain matter. What everybody agreed upon was that he had given signal after signal that he was losing it, that he had set his cell on fire, that he had cut himself, and that he had finally smashed his own skull against the steel bunk. Vargas was in the hospital the entire time we were at Ellis, so we never got to ask him what he thought or hoped beating his head against the steel bed would accomplish.

Excell White said he never slept with his head close to the bars because he didn't know who might go by in the night or what they might do. And there was Kerry Max Cook getting raped and cut by James Demouchette in the dayroom and later mutilating himself out of frustration because he couldn't get anyone's attention (but we didn't learn of that until years later, first from Kerry's book and later when he told us about it in more detail).

The only reports of ongoing violence we heard had to do with the floor men on the Row before the *Ruiz* trial got under way. Both Excell White and Jerry Jurek, who had been on the Row longer than anybody else, spoke of frequent beatings from those floor men. By the time we did our work on the Row, both of those former floor men had gone to other prisons and were dead, and their regime of control was a thing of the past.

We don't think the photographs fail to be representative because they don't show violence like what James Demouchette did to Kerry Max Cook and to other people in the dayroom, or people freaking out the way Richard Vargas did. The occurrence of such things, at least then, was rare. It was a possibility felt more than an event seen. If you were there for a week or a month, you probably wouldn't have seen anything either. John Thompson (who had arrived on the Row seven months earlier and who would be executed on July 8, 1987) told Diane, "I haven't seen a fight since I've been here. I've heard fights. I'm up on three row. When another group goes to the dayroom, if they get in a fight, you can hear them hassling down there. But we've never had one in our group. We've never had any fights or anything. There's a lot of hollering, cussing each other out. But I think a lot of that is just a put-on, you know. We've got three rows, three tiers, and somebody will get in a hollering fight down on one row with

somebody on three row, and that is just because they don't go out in the same group, you know. They know they're not going to be fighting."

The important thing is that the photographs depict what the Row was like nearly all of the time, but violence was always possible and sometimes happened, which is why some of the guys never came out of their cells except to shower, and many, like Excell, only slept with their heads at the far end of the bunk.

In time, as Texas sent ever more condemned prisoners to Ellis, Death Row would occupy that entire end of the prison. Block J would be the maximum-security condemned prisoner block, and layers of grillwork would be welded to the cell doors, cutting off nearly all light from outside and making the cells even hotter and more airless than they previously had been. For a few years, about a third of the DRs were allowed to take part in a work program making garments and doing the maintenance work previously done by the porters; their living situation was similar to that of other Ellis prisoners.[24] It was in that period, mostly in the cells of the work-capable block, that both rapes and consensual sex increased. "One guy had AIDS," Kerry told Bruce in 2010, "but a lot of guys had sex with him anyway. I said to one, 'How can you do that?' He said, 'I'm gonna die anyway. What difference does it make?'"

16. Craziness and boredom

We now find Thelette Brandon's craziness less freaky than we did at the time. The Row is a crazy place. If there's one thing you have to know about it, that's it: it is a *crazy place*. People spend all day and all night keeping at bay the sure knowledge that the entire judicial machinery of the state is dedicated to killing them. Many of the people surrounding them are capable of exploding at the slightest provocation or at no provocation at all. If you're abused, you're a victim; if you complain about being abused, you're a snitch, and you're further abused for that. Courts spend years responding to the simplest requests, and family members often deal with the tension by acting as if you are already dead. You spend years of your life atrophying in a room narrower than the span of your arms.

In 2009 Kerry Max Cook told Bruce that after he got out, someone asked him how he kept from going crazy. "I'm not sure I didn't," he said.

"We have somebody flip out or get so mad or frustrated that something will happen every week, just about every day, somebody will get mad and yell, somebody will get mad and go screaming about the

television," Billy Hughes said. "We have men here that sleep under blankets continuously, summer and winter, and they sweat all the time and they scream for the windows to be open. And the windows might *be* open. We have men that wake up in the middle of the night and start singing. Some men have something drawn on their wall, an outline of a man, and they start talking to it, scolding it and cussing it, beating it, and beating their legs, beating their bunks just to get some motion, something in their life other than just sitting here. We've had men sit here on the floor and beat their head against the bunks until they were bloody. We've had men try and cut themselves. We've had men that just couldn't tolerate it any more. And nothing was actually happening to them, but that was the thing: the waiting. It's continuously having the same walls. The same bars. The same papers, same books. Nothing changes. Only outside, the light: we have day and we have night, we have day and we have night. The programs are almost always the same if anything comes up on the TV. The mail runs at different times. That makes things a little different. Meals run pretty much the same. One week it might come a little earlier, one week it might come a little later. But the food hardly ever changes."

17. All the things a man might do on the Row

Here is a list of every activity that we think a man living on the Ellis Death Row possibly might have done:

Sleep

Read

Eat

Watch television

Listen to radio

Read and write letters

Weave things out of tobacco wrappers

Roll cigarettes

Smoke cigarettes

Use the toilet

Brush your teeth

Wash something in the sink

Shave

Masturbate

Fuck or be fucked by somebody in the dayroom

Go to recreation

Go to the shower

Cut on yourself

Cut on someone else

Pray

Draw or paint

Play dominoes or chess or checkers with the guy in the next cell

Play dominoes or chess or checkers
or cards or volleyball in the dayroom
and cage

Work on your case

Work on someone else's case

Fight

Go nuts

Commit suicide

18. Sockets and glass

None of the cells on J-23 had any electric outlets or light sockets. That, we were told, was because back in July 1965, when Ellis Unit opened for business and the system's administrators decided to keep all condemned men there until they were moved to the death house at The Walls prison in downtown Huntsville the day before their execution, the state of Texas was executing by electrocution and didn't want anybody cheating the executioner by plugging himself in and zapping himself on his own schedule. A condemned man was allowed to have bedsheets with which, like John Devries, he might hang himself, and a shaving mirror he could shatter and use to cut his own or someone else's throat. There were numerous other ways a clever person might find to do himself or another person in, but 110-volt alternating current wasn't one of them. The rules did not permit that.

By the time Texas had so many condemned men in queue that the Row spilled over to J-21 on the other side of the block, the state had decided it would mothball the electric chair, "Old Sparky," and would instead kill by lethal injection. So all the cells on J-21—which had previously housed ordinary murderers, robbers, arsonists, and rapists—continued to have electric lights and sockets with which one could plug in a fan or a stinger to make instant coffee.

Someone (we could never find out who) decided that if the state wasn't going to kill these guys with electricity, it wasn't going to worry any longer about them killing themselves with electricity, either. Prisoners on J-23 were told they could now run extension cords into their cells from the light sockets outside and above their cell doors, and they too could now heat up their coffee and have electric fans.

There were four other differences in the two sides of cell block J. One was that the exercise cage for J-21 was twice the size of the exercise cage for J-23; no one ever explained why the spillover condemned got twice the volleyball space as the earlier residents, nor was any move made to expand the J-23 cage, which would have been easy to do with all the free labor in the prison.

Another difference was that all the cells in J-23 had one bunk, but all the cells in J-21, like all the

other regular cells in Ellis, had two bunks. DRs were one man to a cell, which meant that DRs on J-21 had a body-sized shelf on which to put things, while DRs on J-23 had only the small bookcase against the wall opposite their bunks.

A third difference was the wall paint. Cells in J-21 were painted the same neutral institutional color as all the other cells in Ellis. But the cells in J-23 had been painted a lunatic variety of colors: Kenny Davis's cell was ochre, Brandon's and Doyle Skillern's were sea blue, Barefoot's was a darker blue, Kerry Max Cook's was lime green, Paul Rougeau's and Pedro Muniz's were snot green, and Billy Hughes's was bright orange. Every time Bruce sat in Billy's cell, he wondered what it was like in that five-by-nine-foot space in the hot and muggy months of June, July, and August. Would the guys in the sea blue and lime green cells be less likely to go crazy or melt than the guys in the orange or ochre cells? Had some loopy prison researcher done this surrealistic paint job as a psychological study, then gone elsewhere before he remembered to return the cells to normal? We couldn't find anyone who could explain the J-23 color scheme.

The other, and perhaps most important, difference had to do with vision: prisoners on J-21 were permitted to see out of their cell block windows; prisoners on J-23 were not.

Some time after Ellis prison opened in 1965, all 3,120 transparent panes of glass in all of J-23's windows were taken out and replaced with frosted panes. The condemned men on J-23 could receive light, but they could not look out. By the time J-21 became part of Death Row, no one in the prison administration could remember why the clear glass panes on J-23 had been replaced with frosted panes, so the 3,120 clear panes on J-21 were left in place. Since no one could remember why J-23 had frosted rather than clear glass, replacement panes on J-23 were thenceforth clear as well.

J-21 faced block G, so the only thing J-21 prisoners could see through their clear class windows were the bricks, windows, and bars of G-19; the I-beams and mesh of the J-21 exercise cage; and, if they stood close to the windows, a small patch of sky.

J-23 was the outer side of the last wing at that end of the prison, so its windows looked through and over the exercise cage onto some grass, the double cyclone fence with concertina razor wire surrounding the entire building, the corner guard picket, and a great deal of sky. Had it not been for the frosted glass, prisoners on J-23 could have seen birds, as well as the small herd of deer that prison officials kept as pets between the parallel sections of the cyclone fence.

This wasn't merely an aesthetic or recreational matter. The practical consequence of the frosted win-

dowpanes was that longtime prisoners on J-23 rarely got to focus their eyes more than a few yards away, and they therefore had far more eye problems than the men on J-21 or any other Ellis row. Almost all of them developed myopia. Since there were no lights inside their cells, they were, on bright days, squinting out into a wall of unspecific bright light created by all that frosted glass, which caused a wide variety of other eye problems—in addition to contributing to the general craziness of the place. "The light is so bad," Andy Barefoot said. "I don't have no light and I'm going blind in here because I can't see good." "It's like being in a cave down there," Billy Hughes said, "it's so dark in there." When a J-23 prisoner shaved, he had to stand at the bars to get enough light to see in his mirror what he was doing, then he had to go back to his sink in the dark back corners of the cell to rinse off the razor before returning to the bars to move the blade across another part of his face.

In 1979 we asked George Beto, who had been commissioner of corrections in Texas from 1962 through 1972, why the clear glass on J-23 had been replaced with frosted glass.

"Somebody did that?" he said.

"Yes," Bruce said.

"I can't imagine why anybody would do that," Dr. Beto said.

19. Nowhere land

The sequestration of electricity and the blurring of the light perhaps strike you as absurd or capricious. They are indeed both. They may also strike you as evidence of bureaucratic cruelty. They are that as well.

Cruel, capricious, brutal, and absurd things occur in other institutions—schools, the military, convents, and mental hospitals, for example. The nature of power in such institutions, as Erving Goffman argued long ago in *Asylums*,[25] is often total. Total power may have reasons for what it does, but it doesn't need them, and neither does it need to tell you what they are; that's one of the ways you know you're dealing with total power. If total power elects to behave in ways that are cruel, capricious, and absurd, it can and will do so.

That doesn't mean these things are without meaning. No behavior or condition that occurs on a regular or continuing basis within complex institutions is meaningless. If a continuing behavior or condition doesn't seem to make sense, the problem may be in our model or idea of what the institution is

doing or should be doing. Behavior that seems eccentric is sometimes the most, rather than the least, important thing we can know about an institution,[26] and what seem the most whimsical or capricious restrictions are perhaps the most powerful articulations of power: *Things done do not have to make sense to you; things are done because we say they will be done; what we say will be done is what we feel like saying ought to be done. There is no negotiation. The lack of an option for negotiation isn't an accident; it is proof of our authority for establishing these conditions.*

The absurdity defines rather than confuses the reality, and in a prison environment, there is nowhere this is truer than on Death Row, which is a place defined only in tautology: Death Row is the place condemned prisoners are kept alive between courthouse and death house.

What happens in court is pretty much what you've seen in all those B movies: the trial ends, the jury renders its verdict, and the judge says something on the order of *You will be taken into custody by the department of corrections and at a date to be set henceforth put to death. And may God have mercy on your soul.* What goes on in the death house on the day of execution is a process comprised of carefully defined, unambiguous steps.[27] Everything that takes place on that final day is specified beforehand. Everything that happens is documented as it occurs: the prisoner's last meal request, the meal that is actually delivered, whether or not it is eaten, the last words, the names of the witnesses, the amounts of various pharmaceuticals used in the killing operation, the official time of death declared by the prison physician.

But on Death Row, there is no process, and virtually nothing is recorded; there is only procedure and stasis. Things, as Billy Hughes said, happen with impeccable and maddening regularity—the food carts come; mail is delivered; showers are taken; the medical assistants make their daily rounds delivering pills and taking reports of symptoms; the cell doors open for brief recreation periods in the dayroom and, if the weather is good and the ground dry, in the exercise cage—but nothing leads to anything else. It is life in the moment. It is limbo time, endlessly cyclical, endlessly repetitive.

That time in limbo is not, however, without use. "Proponents of capital punishment often lament the long period between sentencing and execution," we noted in *Death Row*. "They fail to understand that only that lengthy period permits the clinical killing to take place without anyone having to feel any guilt or personal responsibility at all. The appeals process doesn't exist just to give the condemned a fair chance at correcting errors; it also exists to let the bureaucracy of death function without the burden of sin."[28]

20. Time

Death Row is substantively different from the rest of the prison. Everywhere else in the prison, the fact of being in the prison is the punishment.[29] Being on Death Row has no more to do with the sentence and the punishment—which is death at the hands of public employees—than the make of your automobile has to do with where you start out and where you end up.

Some DRs spend more time on the Row than many murderers serving life sentences spend in prison, but as far as the court is concerned, the limbo time of the condemned does not count so much as a single minute. This is because, from the court's point of view, Death Row doesn't exist. No court in America sentences anyone to Death Row; it is part of no death warrant. The courts only say, "You will be executed." No court sets the conditions of any state's Death Row, and only a few state legislatures (Texas is not one of them) have detailed the specific conditions under which condemned prisoners live. Death Row is a liminal place in which all rules and conditions are ad hoc. It is a peripheral administrative artifact of the killing process.

But the body's clock is ineluctable, merciless, and relentlessly practical. The body cares not at all for bureaucratic classifications and justifications. The official calendar may insist that those years on Death Row have no meaning, but the body testifies otherwise: people age on the Row, they pass their youth there, some grow old there, some die there.

Death Row differs from all other prison situations in this one important regard: with one exception, nothing done by the prisoner while there influences anything but the conditions under which the prisoner resides while there. Behave badly on the Row and you lose recreation privileges or commissary privileges, or you may be sent down the corridor for a few days in the dark cells of solitary or moved to a part of the Row with fewer amenities; but your bad behavior on the Row doesn't affect the sentence of death. Behave like an angel on the Row and the guards and porters will be nicer to you—but it doesn't affect the sentence of death. An ordinary prisoner serving a sentence, even life without parole, may earn modifications in his living conditions by behaving in ways that meet prison administrators' approval. He may be assigned to a cell block or prison with fewer restrictions and more privileges, or if there are prison jobs, he may get one of the best job assignments. For prisoners not serving life without parole, good behavior may even result in a reduced sentence. But prisoners on Death Row are not serving sentences, and they are not doing time. There is no way to reduce a sentence of death because

death is absolute and eternal. DRs are, as more than one prisoner on Death Row said to us, "just in limbo."

Even now, with Texas's Death Row on Polunsky being a place where the condemned have daily contact with no one but their guards (and most of that only through a narrow slit in a steel door), and they are not allowed to put anything on their walls or have any personal possessions or books in sight, the difference in treatment for the prisoners the guards like and approve of and those the guards dislike and disapprove of is an AM radio: if you are a very good Death Row convict, you are allowed to have an AM radio in your cell; if you are perceived as difficult, you are not allowed to have an AM radio. Reception isn't good; sometimes there isn't any reception at all. If you are very difficult, you don't get to have any visits—but few DRs get visits anyway.

Except when a DR dies, is murdered, or commits suicide, death sentences are altered only by things that happen far away from the Row. Lawyers try to convince judges that evidence was withheld or overlooked, the police lied, the court-appointed defense attorney was drunk and slept through the trial, the jury was improperly charged, or that new unimpeachable evidence demonstrates innocence. All of these things happen, and in Texas these things have happened a lot. A DR can write writs and letters urging people on the outside to take up his cause or to reconsider his case. Or the last court in line says "No," the Board of Pardons and Paroles and the governor agree, and the DR is taken one morning into Huntsville and is put to death. All of those decisions about life and death made outside the prison on the basis of work by lawyers or letters or writs by a DR are grounded entirely in events that occurred before the DR came to the Row.

Anywhere else in the prison other than Death Row, if you come upon a convict writing a letter, doing push-ups, reading a book, masturbating, or making a picture frame out of cigarette-pack wrappers and you ask "What are you doing?," you get for an answer something that implies time: *A nickel. . . . A dime. . . . Five-to-twenty-five. . . . I'm doing it all.*

What you *do* in prison is *time*—hence the ubiquitous slang term for serving or having served a sentence: *He's doing time. . . . I was doing time. . . . You're going to do time.* Ask the same question of someone engaging in the same activities on the Row, however, and you get: *Writing a letter. . . . Doing push-ups. . . . Reading a book. . . . Jerking off. . . . Weaving a picture frame. . . . What does it look like, asshole? Don't you have eyes?*

The one exception to the Row being the place in prison where time doesn't count or mean anything

is when the courts or state officials conclude that an individual shouldn't have been sent to Death Row in the first place, that he is guilty of murder or some other felony but not capital murder and so is not a killable killer. Because of some mistake or government misbehavior, the time on the Row was time spent there in error. When that happens, the death sentence is reduced to a term of years or to life. For the few condemned prisoners who get such term sentences, or life with the possibility of parole, the years on the Row count toward parole eligibility.

Whenever we've visited solitary-confinement cells in penitentiaries, we've seen calendars scratched into the walls. In those cells, prisoners with nothing, not even daylight, marked the days. Except when an execution date is set and time is running down, we don't remember anyone on the Row who marked the days. People on the Row fill days or hide from them. They sleep. They work on their case. They draw. They read. They watch soap operas, and many come to identify more with the characters on the screen than with their own families.

Kerry Max Cook, who came to J-23 in 1978 when he was twenty-one years old—and who was exonerated two decades later—recently told us of finding a roll of toilet paper on three row that was full, from the first sheet to the very last, with perfect, tiny writing, words with no spaces between them, like ancient Greek, one word abutting against the next with no punctuation. This went on for sheet after sheet until the writer got to the end of the roll, at which point he had rolled it back up and thrown it away. Sometimes, Cook said, he'd find slips of paper on the run in the same minuscule hand. He'd take the sheets back to his cell and would spend hours trying to make sense of them, being a reader doing the writer's process in reverse. He never learned who the writer was. The unknown writer's words and Kerry's failed attempt to make sense of them were equally with or without meaning.

21. Living space and killing space

In 1998 seven DRs tried to break out of Ellis prison. Six got to the roof of the building but no farther. Only one made it off the grounds: Martin Gurule, who wrapped himself in newspapers and magazines and cut and crawled through the concertina razor wire atop the fence surrounding the Ellis compound. Gurule's was the first successful Texas Death Row escape since Raymond Hamilton, a member of the Bonnie and Clyde gang, back in 1934. Gurule didn't get far or stay free long, however. Two fishermen found his body in nearby Harmon Creek a week after the break. He had a superficial bullet wound in

his back. The coroner said the cause of death was drowning, and he'd been dead just about the whole time he'd been gone. The newspapers and magazines he'd wrapped around his body to protect himself from the razor wire probably got water heavy and contributed to his drowning. He'd been free for as little as fifteen minutes and had traversed less than half a mile.

The prison board decided the condemned needed more severe lockdown, and there were getting to be too many DRs for Ellis, anyway; so the next year, the Row was moved from Ellis Unit, twelve miles north of Huntsville, to the new Terrell Unit (renamed the Polunsky Unit in July 2000),[30] which is forty-three miles east of Huntsville. At the time of the move, 100 of the Row's prisoners were in double cells; Polunsky had room for 504 condemned prisoners in one-man cells.

It turned out that juries weren't as anxious to kill the individuals they convicted of capital murder as they were to keep them off the streets.[31] The Row's peak population was 459 in 2000. There has been a consistent decline ever since—caused partly by court decisions, but also by a decline in death sentences as the result of the state's having adopted life without parole for people convicted in capital cases. As of May 2010, Texas's Death Row held a total of 333 prisoners (including ten women held at the Gatesville Unit).

Since they moved the Row to Polunsky, the condemned, who never had much freedom of movement or many places to move to begin with, now have far less of both. Their only window looking outside is a four-inch slit close to the cell ceiling. There is no group recreation, no television, no group religious services, and no work program.[32] The design of the doors permits no chess or domino games through the bars—or anything else. Each cell door has a horizontal slot and two narrow vertical windows facing the corridor. Those two windows are covered with thick steel mesh, so the prisoners can't see much, and they can carry on conversations with the person in the adjacent cell only by shouting. Only a few DRs are allowed to have radios. It is basically lockdown all day, every day, with brief periods of solitary exercise. Whenever a condemned prisoner goes anywhere outside his cell, he must back up to the door, drop to his knees, and extend his hands backward through the narrow slot to be handcuffed. Then he stands, turns around, and waits for the door to be opened. The whole process of dropping to the knees and extending the arms backward is particularly difficult and painful for the older convicts with arthritis. Food trays and mail come and go through the horizontal slot. The lights never go out.

The description in that paragraph is secondhand, based on letters, conversations, and Web postings by inmates of Polunsky Death Row. Bruce attempted to visit Polunsky in 2010, but the official who was

in control of such visits—Michele Lyons, Texas Department of Criminal Justice director of public information—refused to take or respond to his telephone calls, and neither would she respond to his e-mail requests for assistance. Former Walls warden Jim Willett, who now runs the Texas Prison Museum in Huntsville, was surprised at the official stonewalling. "Ten years ago they let David Isay interview the tie-down team for NPR,"[33] he told Bruce. But Kerry Max Cook said he wasn't surprised that Bruce was stonewalled: "What you saw at Ellis was awful. Polunsky is far worse. If you're a prisoner there, you can't talk to anybody. You don't see anybody. People go crazy there all the time. They don't want anybody to see what it's like in there now. If people like you don't get in, then the world doesn't get in—and what's going on there doesn't get out."[34]

Polunsky is nastier than Ellis, but other than a last ride that is thirty minutes longer than the ride from Ellis, the killing protocol itself is essentially unchanged. The day of the scheduled execution (in years past it was the previous night), the prisoner is brought from Death Row to one of the eight cells in the death house in the Huntsville Unit and placed under deathwatch.

Executions take place at the Huntsville Unit—The Walls. The Row, as we noted earlier, was originally at The Walls but was moved to Ellis when there were too many condemned men for The Walls to manage; overcrowding was also the primary reason for the move from Ellis to Polunsky. But there are two additional reasons why DRs might be kept at one place and killed at another, one of which is personal and the other structural. The personal reason has to do with the sensibilities of the Death Row guards. The guards who handle the condemned on the Row get to know them very well; they spend years living or working in the same small space, a space neither guard nor prisoner can ever adequately describe or explain to friends or family outside.[35] They know things other people do not know or wish to know. But the guards who handle DRs on the final day never met them before. There isn't sufficient time in the few hours between arrival and the final decision whether or not to administer the lethal injection for anybody to become pals, so members of the tie-down team—the crew that straps the condemned prisoner onto the gurney—"are not helping execute people they know."[36] For the guards in the death house, it's just a job, one in which every action is part of a formal procedure, which makes it easier all around, both for those who are about to die and for those who are the state's agents in the killing process.

The structural reason is that, unlike the experiences and conditions of Death Row, everything about the death house and the execution protocol is spelled out in rules and documents and procedures,[37] just

as everything that happened in court so many years earlier. The moment a DR is moved off the Row and begins walking through those two yellow lines on his way to the death house, he is out of limbo and back in time.

22. The death house

Bruce visited the death house in The Walls only once: in 1978, a year before we worked on the Row and four years before the post-*Furman* killing started. About 100 condemned men were then celled at Ellis, but no one had yet been brought to The Walls on a death warrant.

Two large wooden cases were pushed against the wall opposite the row of eight cells in which the condemned had in years past, and would again a few years hence, spend their last hours alive. "That's Old Sparky," Bruce's guide, a building major named A. J. Murdock, told him. "The electric chair. We don't use it any more but we haven't figured out where to put it." They were hoping, Major Murdock said, to get it moved out before they started shipping DRs in from Ellis for execution. The condemned men would, he said, find it depressing even though it wasn't the device with which Texas was going to kill them. Along the same wall were two wooden chairs, a barber chair, a small refrigerator, a wooden table on top of which were two telephones (one with a rotary dial, the other with no dial or buttons) and a three-burner hot plate. Nobody was going to be in the death house long enough to need a haircut: the barber chair was also a holdover from the electrocution days, when they'd shave a monk's circle at the top of the condemned prisoner's head and shave the hair off his left leg so the electrodes would make good contact.

The gurney was in place in the adjacent room, as were the tubes that would carry the sodium thio-pental (sedative, in a nonlethal dose), pancuronium bromide (muscle relaxant to collapse diaphragm and lungs), and potassium chloride (to stop the heart). The devices the executioner would use to control the flow of the killing drugs were in a room on the other side of a wall with three small curtained windows. That room—the site of Old Sparky in the electrocution days—was out of sight of the condemned and the witnesses.

On the wall behind and to the right of the gurney, just a few feet from where the condemned prisoner's head would be once the tie-down team got the restraining straps in place, was the automatic sequencer for the electric chair, which they were either leaving up as a memento or hadn't yet gotten around to

dismantling. It had been installed after what turned out to have been Texas's last execution by electrocution—Joseph Johnson on July 30, 1964—so it had never been used and, now that they killed with pharmaceuticals, never would be. Three hard conduit tubes ran from the box along the wall behind the head of the gurney to the executioner's room. The sequencer had a terrific array of knobs, dials, switches, and lights, as well as what appeared to be a manual timer that went up to a maximum of 150 seconds, not unlike a kitchen egg timer. If you didn't know that it was the control box for the electric chair, you would have thought it was a toy made by a deranged electrician with an abundance of spare parts and time.

The space for witnesses was separated from the space for killing by a horizontal bar and a curtain that, Major Murdock said, would be closed while the condemned was brought in, opened after he or she had been prepared to be killed and kept open for the killing, then closed again after the attending physician announced that the procedure had been successful. There were no chairs. "You should have chairs," Bruce said. "People may get faint." "No," Major Murdock said, "that won't be a problem. It will be very quick. And it will look just like the guy is going to sleep. That's the reason for the thiopental. There won't be time for people to get sick. It will be over in seconds."

He was wrong: some of the executions took quite a bit of time, with the condemned thrashing about and not going quietly to sleep as promised by the vendors of the various poisons and delivery systems. They had particular difficulty with former drug users. According to Michael L. Radelet, who provided notes on forty-two post-*Furman* botched executions, technicians stuck needles in both of Stephen Peter Morin's arms and one of his legs for forty-five minutes before they found a workable vein (March 13, 1985). They spent two hours finding workable veins in Genaro Ruiz Cammacho (August 26, 1998). Joseph Cannon made his final statement and they started the drugs flowing, whereupon the needle came out (April 23, 1998). Cannon said to the witnesses, "It's come undone." They spent fifteen minutes hooking him up again, after which he made a second final statement and the execution continued. Sometimes, as with Raymond Landry (December 13, 1988), things started well enough, but then went haywire. "Two minutes after the drugs were administered," Radelet wrote, "the syringe came out of Landry's vein, spraying the deadly chemicals across the room toward witnesses. The curtain separating the witnesses from the inmate was then pulled, and not reopened for fourteen minutes while the execution team reinserted the catheter into the vein." And sometimes the problem was with the witnesses, about whom Major Murdoch was also wrong. When they executed Stephen McCoy (May 24, 1989), for example, a male witness fainted, knocking over another witness as he fell.[38]

 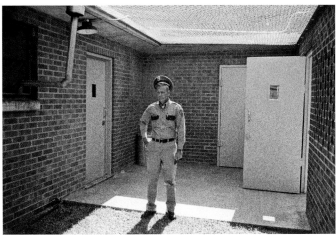

LEFT: The death house in the Huntsville Unit (The Walls)—the cells to which prisoners are taken and held during the day they are scheduled for execution. RIGHT: Major A. J. Murdock in the space between the doors leading from the main yard of the Huntsville Unit on the right and the death house on the left.

But none of the hurly-burly finally mattered. However long it took, whatever happened and whatever commotion took place, the procedure continued to its inexorable conclusion.[39]

23. Getting off the Row

Other than escape, there are only two ways to get off Death Row: a change in legal status or death. Both can come about in several ways.

The best change of legal status is when a judge throws out everything because new evidence provides unmistakable proof of innocence. Judges may do that, but they're not obligated to: the Supreme Court ruled in *Herrera v. Collins*, a Texas case, that the Constitution doesn't prohibit execution of someone who is innocent, so long as the procedures leading up to the execution were proper; Justice Antonin Scalia continued that argument (with concurrence from Clarence Thomas) in a dissent to the 2009 habeas corpus petition of Georgia death row prisoner Troy Davis,[40] who would, as a result, be executed on September 21, 2011.

Courts may decide that misbehavior by the police or prosecution so tainted the case that a fair retrial is impossible. Texas has been forced to release thirty-five condemned men because evidence proved

they weren't guilty or were convicted improperly. On rare occasions, the Board of Pardons and Paroles and the governor commute a death sentence to a life sentence;[41] sometimes courts reduce capital sentences to life sentences; and sometimes a court-ordered new trial results in such a sentence or plea deal rather than the death penalty.[42] When that happens, the individual who had been condemned to death gets a regular prison number and moves into one of the regular prison cell blocks.

Since *Furman*, more than 1,000 men and women have been sentenced to death in Texas. Of these, 303 who were sentenced to be executed got off Death Row by means other than execution: eight committed suicide (six of them after conditions of imprisonment on the Row were made far crueler after the move to Polunsky); three were murdered by other Death Row inmates; twenty-eight died of natural causes or an accident (including one who drowned during an escape attempt); twenty-nine were age seventeen or younger at the time of their offense and had their sentences commuted to life when a court said they were too young to kill; and 235 got off the Row because their sentences were commuted or reversed on legal technicalities, because the part of their trial having to do with the death sentence (as opposed to the part having to do with guilt or innocence) was corrupt, or because authorities realized they were innocent and shouldn't have been in prison at all.

For prisoners on Death Row, death comes in one of four ways:

- Suicide, like Jack Devries (July 1, 1974), Joseph Turner (July 5, 1986), Stephen Mattox (June 26, 1983), James Gunter (August 24, 1997), Deon Tumblin (November 2, 2004), Christopher Britton (February 4, 2005), Michael Johnson (November 19, 2006), Jesus Flores (January 29, 2008), and William Robinson (February 1, 2008).
- Murder, like Edward King (August 28, 1979) and Calvin William (August 26, 1990).
- Natural causes, like Gerald Bodde (cardiac arrhythmia), Carl Napier (hepatitis C and liver disease), Calvin McGhee (dissecting aortic aneurysm), Porter Nelson (cerebral hemorrhage), Jim Vanderbilt (pneumonia), Ramon Mata Jr. (septic shock), Donald Vigneault (lung cancer), and James Dickerson (AIDS).
- Or, as was the case for 467 men and two women in the post-*Furman* era (as of June 1, 2011), including more than a dozen men we talked with in 1979, they are, early on the afternoon of their last day, brought from the Row to The Walls. They spend a few hours in one of the eight cells adjacent to the death chamber, usually the second cell. They talk to a chaplain,

order and have a last meal, and wait for a last-minute stay. If it doesn't come, they walk with the warden into the death chamber shortly after 6:00 P.M. (Executions in Texas used to be at midnight, but in 1995 Warden James Willett moved them to 6:00 P.M. to make it easier for the witnesses—families of the victims, families of the condemned, press, and sometimes a prosecutor.) In the death chamber, they are tied down on the gurney, which is now bolted in place, have the IV lines inserted, and say their last words, if they have any. With only a few exceptions, they're pronounced dead by 6:20.

Executions are, for the most part, swift, but Death Row—limbo—is long, very long, a decade on the average and far longer than that for anyone who has any clutter at all in his trial records or is lucky enough along the way to get a good lawyer interested in his case. Some critics of the death penalty say such delays are cruel and unusual punishment in themselves.[43] Proponents of the death penalty argue that there wouldn't be delays if prisoners didn't keep filing appeals; if they'd just accept the sentence of the court and be done with it, things could move very quickly. The critics respond that courts wouldn't grant delays if there wasn't sufficient evidence that the justice system had behaved improperly, and they point to the large number of condemned prisoners whose sentences are reduced or vacated entirely, which is what happened with "more than 30 percent of death verdicts imposed [in the United States] between 1973 and 2000"[44] and 22 percent of the individuals Texas sent to Death Row between 1974 and 2010.[45]

24. Why execute?

Death Row exists because prison authorities believe they must quarantine condemned prisoners from other prisoners and keep them out of the ordinary routine of the penitentiary during the years the state is deciding whether and when it is going to kill them. Symbolic analysts like René Girard and Michel Foucault might argue that Death Row, particularly as it grows ever more isolating and restrictive, is itself part of the apparatus that makes guiltless killing by the state possible.[46]

The fact that DRs in Texas who are commuted or resentenced to life or a term of years quickly go into population rather than restrictive custody strongly suggests that, as far as prison officials are concerned, the only real difference between them and everyone else in the building is their sentence, not their dangerousness. The fact that former DRs who are resentenced and therefore move into popula-

tion have far fewer disciplinaries than other prisoners serving felony time suggests that most aren't even particularly dangerous anyway, at least not in the prison context.[47] What makes them eligible for the limbo that is Death Row is their sentence of death, which is a legal fact, not the style or measure of their criminality nor anything in their personality that in any way distinguishes them from all the other violent offenders doing ordinary time in the same institutions at the same time.

If there is no inherent difference between the prisoners on Death Row and all the other murderers in the building, then what is it about them or their cases that justifies putting them to death? Why kill them rather than subject them to the same penalties suffered by all other individuals sent to prison for murder?

Nearly all criminal sanctions, from a short stay in a county jail all the way to the death penalty, are justified on the basis of one or more of six considerations:

- Desert: they deserve the pain.
- Retribution: we need to inflict the pain.
- Incapacitation: by locking them up or killing them, we'll keep them from doing whatever it was they were doing.
- General deterrence: by punishing them, we'll send out a warning to everyone else who hasn't done it yet.
- Specific deterrence: by punishing them, we'll encourage them to behave more acceptably in the future.
- Rehabilitation: enduring this punishment and/or treatment will make this individual less likely to behave that way in the future.

Death differs from all other criminal sanctions in that it is absolute. A fine might be rescinded; a person who serves a prison sentence in error might receive compensation from the state. Nothing can amend an execution that is in error; it cannot be undone or mediated. No apology or sum of money compensates the victim because the victim is not able to receive either.

Advocates of capital punishment offer three further arguments to the traditional six considerations: it has symbolic importance; this is the way we have always dealt with our worst offenders; and it saves money. Not one of these justifications withstands serious examination. And none of the justifications for ordinary sanctions withstands an extension to death. The following explains why.

Symbolic Justification. "In 1868," wrote David Grann in a chilling article on what is almost certainly a recent Texas execution of an innocent man, "John Stuart Mill made one of the most eloquent defenses of capital punishment, arguing that executing a murderer did not display a wanton disregard for life but, rather, proof of its value. 'We show, on the contrary, most emphatically our regard for it by the adoption of a rule that he who violates that right in another forfeits it for himself,' he said." For Mill, there was one counterargument that carried weight—"'that if by an error of justice an innocent person is put to death, the mistake can never be corrected.'"[48]

In 1979 political scientist Walter Berns told us Mill needn't have worried.[49] The issue, Berns said, isn't whether or not the death penalty deters crime or can be administered fairly; rather, it is the fact that the death penalty lends majesty to the law because it is the only punishment in the criminal justice armamentarium that is absolute and irreversible. The accidental execution of someone guilty of nothing, said Berns, is a small price to pay for the death penalty's ratification of a procedure that demonstrates the majesty of the law so well.

Berns's argument fails in that his two fundamental justifications are nothing more than assertions. His first assertion is that the criminal justice system lacks majesty if it isn't willing to kill even the innocent; his second is that even if the system is in need of majesty, the death penalty is the only instrument that might provide it. Would you put a knife to someone's throat on the basis of those assertions? Berns gives sophistry a bad name.

Traditional Justification. "We have always had the death penalty," this argument goes. "When Moses comes down the mountain and finds the Israelites adoring the golden calf, he orders, and gets, mass executions of the guilty. And there have been executions in America since colonial times. So why should we abandon it now?"

Unless the argument is that anything once done must be forever done, declaring that capital punishment was accepted in previous cultures is a historical observation, not a justification for killing or anything else. Recollection of actions in the past is never sufficient, in and of itself, to legitimize action in the present. For most of the history of this country, women and blacks could not vote or own property; there were schools, clubs, and hotels that were proud to let the world know they did not admit Jews or Catholics; there were hospitals in which people who behaved oddly were treated with lobotomies, electroshock, and ice baths. The Supreme Court has long used evolving standards of decency as the rationale for changing a long-standing practice that comes to be seen as barbaric or is taken as offensive or

understood as harmful to society. Until *Furman*, many states, including Texas and California, executed for rape.

Incapacitation Justification. "Killing the killer," some argue, "will keep the killer from doing it again." Yes, but so will a lifetime of strict lockup (as at Polunsky), which also is far cheaper than capital punishment; and in the rare (but not unknown) case of error, lockup allows the possibility of at least some recompense. No absolute punishment should be embraced without considering Occam's razor: if something simpler will serve the same end, or serve it better, why complicate things? The decrease in death penalties in jurisdictions where life without parole is introduced as an option suggests, as we noted earlier, that many jurors aren't interested in killing defendants so much as they are in keeping them off the streets. And the relative lack of violence by commuted and paroled condemned prisoners suggests they're not that likely to do it anyway. "While incapacitation may have been a legitimate rationale in 1976," Justice John Paul Stevens wrote in 2008, "the recent rise in statutes providing for life imprisonment without the possibility of parole demonstrates that incapacitation is neither a necessary nor a sufficient justification for the death penalty."[50]

Desert, Vengeance, and Sanitation Justification. Vengeance is grounded in a vague notion of *lex talionis*: the offender shall be punished in kind. Desert means you deserve it, so we're going to do it to you. Basing punishment on desert rather than vengeance has a nicer tone to it—"This isn't something we're doing; it's something you earned"—but it is essentially the same thing.

One of the men on J-23 put the sanitation argument this way: "There are people that need to be killed just 'cause they were mean son of a bitches. That's the way I feel about it. It doesn't have anything to do with deterrence or with morals or religion. It's the fact that the son of a bitch ought to knew better."

One problem with vengeance and sanitation as justifications for execution is inequity: if the punishment of a long prison sentence or life without parole for murder is reasonable and just for 99 percent of the people convicted of murder, why should 1 percent whose crimes differ in no substantial way be put to death? Death for an extremely small and mostly random—and partly racially targeted—subset of that group is proof of the system's capriciousness, not its fairness or justness. So is the preference for white victims over victims of color and the difficulty poor defendants have getting adequate representation at trial. What kind of sanitation are we getting if hardly anyone in the category is ever subject to it? Why is sanitation by death preferable to sanitation by life in prison? Do we want to be in the "social sanitation" business?[51] Who is getting the vengeance? The guards who handle the condemned prisoner in

the death house, the technicians who turn the valves letting the poison into the veins, the warden who makes sure the process takes place according to the rules—they are all insulated from any connection with the crime, the victims, and the condemned. If they have any direct connection to the case, they are excused; they are specifically precluded from the role of avenger. The killing occurs years after the event. Does the victim's family get to own the vengeance? Are victims with family owed more vengeance than victims without? (A study published in 2011 indicates that jurors who view victim-impact evidence in the punishment phase are far more likely to vote for the death penalty.[52]) What about a victim who had no family to give victim-impact information? If there's nobody other than a prosecutor asking for vengeance by death for a particular murder victim, why are we doing it?

Money Justification. This rationale goes, "It's cheaper to kill them than to support them for the rest of their lives." But this is not true; the death penalty is more expensive than the longest prison term. It might be cheaper if prisoners were marched out of court after sentencing, put up against a wall, and shot, or perhaps forced to their knees and beheaded, as is the practice in some places. But that is not the way it is done here, nor will it ever be. The way it is done here may get polished or tuned, but it is not going to change substantially in the foreseeable future: there will be appeals, several of them, and they will take years; and while they are taking their slow turn through the courts, the condemned will spend years in prisons that are not only far different from any other but also far more expensive to maintain than any other. Their cases will involve more resources of the courts, prosecutors, public defenders, and the entire criminal justice bureaucracy than the cases of ordinary defendants on trial for crimes that differ from theirs in no substantial way. According to a 2009 Death Penalty Information Center report, the forty-four executions the state of Florida carried out between 1976 and 2000 cost the state $24 million each; North Carolina death penalty cases cost the state $2.16 million more per execution than non–death penalty cases leading to sentences of life imprisonment; and Texas executions cost three times as much as "imprisoning someone in a single cell at the highest security level for forty years."[53] The annual cost of maintaining a capital inmate in California is three times the $44,000 California spends each year on ordinary state prisoners.[54] These aren't optional costs, or costs that can be eliminated by better management. As long as we continue doing capital trials and giving the condemned even a semblance of the access to the courts the rest of us have, these costs are mandatory. Killing by the state is and will be very expensive.

Deterrence Justification. It is impossible to count things that do not happen, let alone supply, with

confidence, the reasons unknown events did not occur. Is anyone deterred from performing murder by a death penalty that takes years to come about who would not be equally or more deterred by a prison sentence that began immediately at the end of a trial? The burden is on those who would kill to show that individuals are so deterred, and no such studies have been accomplished.

Economist Isaac Ehrlich claimed to show by statistical analysis that an execution can result in a decrease in murders for a period of time after the execution is made public, but scholars have found his work faulty in all major regards and essentially without meaning.[55] Ehrlich's claims that each execution might prevent eight new homicides and the arguments demolishing them were summarized by Justice Thurgood Marshall in his dissent in *Gregg v. Georgia*. Marshall concluded his critique of Ehrlich's work: "The Ehrlich study, in short, is of little, if any, assistance in assessing the impact of the death penalty." (The text of Marshall's dissent appears in appendix 3 of this book.) Ehrlich's pseudoscience has, however, been frequently quoted in arguments justifying executions. Writing of the failure of academic economists to cope with or understand the 2008–9 fiscal crisis, Nobel laureate Paul Krugman wrote, "As I see it, the economics profession went astray because economists, as a group, mistook beauty, clad in impressive-looking mathematics, for truth."[56] This could be said of Isaac Ehrlich's death penalty work. Studies far more reliable than Ehrlich's have shown again and again that swiftness is far more effective as a deterrent than severity. The death penalty is the most delayed, interrupted, and reversed criminal sanction of all, so it is, in all likelihood, the least effective criminal sanction of all for those contemplating murder.

"Despite 30 years of empirical research in the area," wrote Justice Stevens in *Baze v. Rees*, "there remains no reliable statistical evidence that capital punishment in fact deters potential offenders. In the absence of such evidence, deterrence cannot serve as a sufficient penological justification for this uniquely severe and irrevocable punishment."

25. Equity: *Callins v. James*

The fact that the major grounds for capital punishment are easily refuted hasn't kept thirty-four states and the federal government from deciding they want to be able to put people to death. This isn't a public issue on the order of building a new expressway or raising or lowering the school budget. It isn't a project where there can be some realistic estimate of the financial costs and social consequences. Rather, it goes to belief. We know of no other issue in criminal justice, not even treatment of sex offend-

ers, that is so firmly grounded in belief. People discuss the death penalty the way they discuss abortion: most begin with a conclusion that is already beyond the reach of reason. Not beyond argument, just beyond reason. Arguments can be made, but the discussion always ends in, "Yes, but . . ." or "But I believe. . ." There is no successful argument to an a priori conclusion because the conclusion is accepted before any evidence or reasoning can enter the argument. When evidence is offered that contradicts the conclusion, it is taken as error in the evidence, not the conclusion.

Which is why the most compelling arguments have addressed equity, or lack of it, in the administration of the death penalty rather than the legitimacy of the death penalty itself. Opponents of capital punishment rarely argue why and how the reasons for it are faulty (the supporters just come up with other reasons, since they "know" beforehand it is right in principle), but why it cannot be applied fairly. Opponents have argued that the death penalty is used disproportionately against the poor; that defendants with retained counsel are far less likely to get the death penalty that defendants with court-appointed counsel;[57] that it is used extortionately by prosecutors ("Plead guilty to murder or we'll file capital murder against you");[58] that it is used more often when the victim is white than when the victim is nonwhite (widely documented,[59] but the Supreme Court has thus far refused to deal with the data[60]); or that every industrialized European country has gotten rid of the death penalty, and every one of them has greater public safety than we have ("See: they don't need the death penalty, but we do"). Defenders say: "You're right. That's terrible. We have to fix that sort of thing."

Perhaps the best and most informed statement on the impossibility of applying the death penalty fairly was in a dissent by Justice Harry A. Blackmun (who had voted with the minority to keep the death penalty in *Furman*) in a case in which the Supreme Court declined to review the death sentence of Bruce Edwin Callins, who was about to be executed by Texas.[61] The following is the opening section of Justice Blackmun's eloquent dissent.[62]

On February 23, 1994, at approximately 1:00 A.M., Bruce Edwin Callins will be executed by the State of Texas. Intravenous tubes attached to his arms will carry the instrument of death, a toxic fluid designed specifically for the purpose of killing human beings. The witnesses, standing a few feet away, will behold Callins, no longer a defendant, an appellant, or a petitioner, but a man, strapped to a gurney, and seconds away from extinction.

Within days, or perhaps hours, the memory of Callins will begin to fade. The wheels of justice

will churn again, and somewhere another jury or another judge will have the unenviable task of determining whether some human being is to live or die. We hope, of course, that the defendant whose life is at risk will be represented by competent counsel—someone who is inspired by the awareness that a less-than-vigorous defense truly could have fatal consequences for the defendant. We hope that the attorney will investigate all aspects of the case, follow all evidentiary and procedural rules, and appear before a judge who is still committed to the protection of defendants' rights—even now, as the prospect of meaningful judicial oversight has diminished. In the same vein, we hope that the prosecution, in urging the penalty of death, will have exercised its discretion wisely, free from bias, prejudice, or political motive, and will be humbled, rather than emboldened, by the awesome authority conferred by the State.

But even if we can feel confident that these actors will fulfill their roles to the best of their human ability, our collective conscience will remain uneasy. Twenty years have passed since this Court declared that the death penalty must be imposed fairly, and with reasonable consistency, or not at all, see *Furman v. Georgia*, 408 U.S. 238 (1972), and, despite the effort of the States and courts to devise legal formulas and procedural rules to meet this daunting challenge, the death penalty remains fraught with arbitrariness, discrimination, caprice, and mistake. This is not to say that the problems with the death penalty today are identical to those that were present 20 years ago. Rather, the problems that were pursued down one hole with procedural rules and verbal formulas have come to the surface somewhere else, just as virulent and pernicious as they were in their original form. Experience has taught us that the constitutional goal of eliminating arbitrariness and discrimination from the administration of death can never be achieved without compromising an equally essential component of fundamental fairness—individualized sentencing.

It is tempting, when faced with conflicting constitutional commands, to sacrifice one for the other or to assume that an acceptable balance between them already has been struck. In the context of the death penalty, however, such jurisprudential maneuvers are wholly inappropriate. The death penalty must be imposed "fairly, and with reasonable consistency, or not at all."

To be fair, a capital sentencing scheme must treat each person convicted of a capital offense with that "degree of respect due the uniqueness of the individual." That means affording the sentencer the power and discretion to grant mercy in a particular case, and providing avenues for the consideration of any and all relevant mitigating evidence that would justify a sentence less than

death. Reasonable consistency, on the other hand, requires that the death penalty be inflicted evenhandedly, in accordance with reason and objective standards, rather than by whim, caprice, or prejudice. Finally, because human error is inevitable, and because our criminal justice system is less than perfect, searching appellate review of death sentences and their underlying convictions is a prerequisite to a constitutional death penalty scheme.

On their face, these goals of individual fairness, reasonable consistency, and absence of error appear to be attainable: courts are in the very business of erecting procedural devices from which fair, equitable, and reliable outcomes are presumed to flow. Yet, in the death penalty area, this Court, in my view, has engaged in a futile effort to balance these constitutional demands, and now is retreating not only from the Furman promise of consistency and rationality, but from the requirement of individualized sentencing as well. Having virtually conceded that both fairness and rationality cannot be achieved in the administration of the death penalty, the Court has chosen to deregulate the entire enterprise, replacing, it would seem, substantive constitutional requirements with mere aesthetics, and abdicating its statutorily and constitutionally imposed duty to provide meaningful judicial oversight to the administration of death by the States.

From this day forward, I no longer shall tinker with the machinery of death. For more than 20 years, I have endeavored—indeed, I have struggled—along with a majority of this Court, to develop procedural and substantive rules that would lend more than the mere appearance of fairness to the death penalty endeavor.

Rather than continue to coddle the Court's delusion that the desired level of fairness has been achieved and the need for regulation eviscerated, I feel morally and intellectually obligated simply to concede that the death penalty experiment has failed. It is virtually self-evident to me now that no combination of procedural rules or substantive regulations ever can save the death penalty from its inherent constitutional deficiencies. The basic question—does the system accurately and consistently determine which defendants "deserve" to die?—cannot be answered in the affirmative. It is not simply that this Court has allowed vague aggravating circumstances to be employed, relevant mitigating evidence to be disregarded, and vital judicial review to be blocked. The problem is that the inevitability of factual, legal, and moral error gives us a system that we know must wrongly kill some defendants, a system that fails to deliver the fair, consistent, and reliable sentences of death required by the Constitution.

Blackmun adds a footnote at this point.

> Because I conclude that no sentence of death may be constitutionally imposed under our death penalty scheme, I do not address Callins' individual claims of error. I note, though, that the Court has stripped "state prisoners of virtually any meaningful federal review of the constitutionality of their incarceration." Even if Callins had a legitimate claim of constitutional error, this Court would be deaf to it on federal habeas unless the state court's rejection of the constitutional challenge was so clearly invalid under then-prevailing legal standards that the decision could not be defended by any reasonable jurist. That a capital defendant facing imminent execution is required to meet such a standard before the Court will remedy constitutional violations is indefensible.

Justice Blackmun concludes his dissent:

> Perhaps one day this Court will develop procedural rules or verbal formulas that actually will provide consistency, fairness, and reliability in a capital sentencing scheme. I am not optimistic that such a day will come. I am more optimistic, though, that this Court eventually will conclude that the effort to eliminate arbitrariness while preserving fairness "in the infliction of [death] is so plainly doomed to failure that it—and the death penalty—must be abandoned altogether." I may not live to see that day, but I have faith that eventually it will arrive. The path the Court has chosen lessens us all. I dissent.

Justice Antonin Scalia responded to Blackmun anecdotally, appealing not to reason or to law, but to emotion.

> Justice Blackmun begins his statement by describing with poignancy the death of a convicted murderer by lethal injection. He chooses, as the case in which to make that statement, one of the less brutal of the murders that regularly come before us, the murder of a man ripped by a bullet suddenly and unexpectedly, with no opportunity to prepare himself and his affairs, and left to bleed to death on the floor of a tavern. The death-by-injection which Justice Blackmun describes looks pretty desirable next to that. It looks even better next to some of the other cases currently before us, which Justice Blackmun did not select as the vehicle for his announcement that the

death penalty is always unconstitutional, for example, the case of the 11-year-old girl raped by four men and then killed by stuffing her panties down her throat. How enviable a quiet death by lethal injection compared with that!

Yes, but so what? The question raised by *Callins* wasn't whether the method the state chose to put him to death was more or less ugly or vile than what transpired in Scalia's allusion to what four men may have done to an eleven-year-old girl, but whether the state should be putting Callins to death at all, whether evidence of *innocence* wasn't sufficient reason for the state to be made to stop a procedure that was, in all its technical aspects, correct. Scalia sidesteps that question entirely and instead offers a lurid analogy rather than reason.

There is no answer in law to Scalia's majority opinion in *Callins* because Scalia isn't arguing from law. None of the arguments for the death penalty, in fact, are made from law. Law looks at the process of killing—with some justices, such as Scalia, insisting the process can be made fair enough, given the bad things some people do; and other justices, such as Blackmun and John Paul Stevens, insisting in cases very late in their careers that the process can never be made fair enough because, when it comes to killing by the state, it is the *state's* reasons and behavior that are in the dock, not the condemned prisoner's—and, says Blackmun, when the state elects to kill, however methodically and ploddingly, no amount of tuning can ever make that killing right.

26. Giving up on death

Justice Stevens, who wrote the majority opinion in *Jurek v. Texas*, announced in his opinion in *Baze v. Rees*, a Kentucky case challenging the constitutionality of the lethal cocktail used in current executions, that he had decided to renounce the death penalty. It took him a long time getting there, and a lot of people died while he was in the process of changing his mind, but change his mind he did. The Supreme Court's "decisions in 1976 upholding the constitutionality of the death penalty," he wrote, "relied heavily on our belief that adequate procedures were in place that would avoid the danger of discriminatory application identified by Justice Douglas' opinion in *Furman* . . . of arbitrary application identified by Justice Stewart . . . and of excessiveness identified by Justices Brennan and Marshall." But the opposite has happened: capital defendants, he says, have less protection than ordinary offenders. Their juries are skewed against them. The cases are so charged with emotion that the risk of error is

greater than ordinary cases. The penalty is racially skewed, far more likely to be applied when the victim is white and the murderer black. The imposition of the death penalty, he concludes, represents "the pointless and needless extinction of life with only marginal contributions to any discernible social or public purposes. A penalty with such negligible returns to the State [is] patently excessive and cruel and unusual punishment violative of the Eighth Amendment." The death penalty, he decided at the end of his long career, simply could not be applied fairly and justly.

27. Trends

Since 1974, when executions resumed in the United States, more than 1,200 men and women have been put to death, over half of them in three southern states: Texas, Virginia, and Oklahoma. Harris County in Texas accounted for more executions than any state—except Texas itself.

After reaching a high of ninety-eight executions in 1999, the rate of killing slowed considerably, with fifty-two in 2009 and forty-six in 2010. Texas had more executions in 2010 than any other state—seventeen—but that was down from twenty-four a year earlier. The number of new inmates receiving death sentences in the United States has seen a similar decline: 234 in 2000, 112 in 2009, and 114 in 2010. There has been a corresponding, though not so dramatic, drop in the number of people presently in prison under sentences of death: 3,652 in 2000, 3,297 in 2009, and 3,261 in 2010. Public support for the death penalty has also declined: 66 percent favor it now, down from 78 percent twenty years ago. New Jersey repealed capital punishment in 2007, and New Mexico followed in 2009. There has been a moratorium in Illinois since 2000, when, in response to evidence that more than a dozen innocent people had been sent to Death Row, Governor George Ryan commuted the sentences of all of the state's 167 condemned prisoners.

In January 2011, the Illinois Senate and House both voted to abolish the state's death penalty. A week later, U.S. senator Dick Durbin (Illinois) announced that he had changed his life-long support of the death penalty: "There are many people who commit heinous crimes, and I'd be the first to stand up with emotion and say they should lose their lives. But when I look at the unfairness of it, the fact that the poor and people of color are most often the victims when it comes to the death penalty, and how many cases we've gotten wrong now that we have DNA evidence to back us, I mean, it just tells me life imprisonment is penalty enough."[63] Illinois governor Pat Quinn had until March 11 to choose among

four options: veto the bill (killing it), amending the bill (killing it, since it had been passed in the previous legislative session and would therefore have to go through both houses of the Illinois legislature in amended form), sign the bill (in which case it would become law), do nothing at all (in which case it also would become law). Quinn extracted a huge amount of press coverage from his meetings with citizens' groups, prosecutors, and journalists, as well as from his public release of the letters he received from Desmond Tutu and Sister Helen Prejean urging him to sign. He drew it out until March 9, at which point he signed the bill, abolishing capital punishment in Illinois as of July 1, 2011.

We've noted that a major reason for the decline in death sentences has been the increasing availability of sentences of life without parole. Another important reason for the change in sentencing may be the weakened economy: death penalty cases cost as much as ten times the amount of ordinary murder cases. Many prosecutors decide to seek life without parole not just because juries like it better than death, but rather because their budgets are tight.

28. Records

Jack Smith, who was received on the Row on October 10, 1978, is still there at this writing, more than thirty-two years later. Jack was born on December 23, 1937, which makes him the oldest man ever to serve on Texas's Death Row; if they execute him, he'll also be the oldest man executed by the state of Texas. He has, so far as we know, exhausted all his appeals, but on Death Row, there are always surprises. Jack has seen a lot of DRs come and go.

David Powell, who arrived on Death Row the same day as Jack Smith, was executed on June 15, 2010. Ronald Chambers, who arrived almost two years earlier, on January 8, 1976, died of natural causes in the Dallas county jail on November 12, 2010. Four other Death Row prisoners have been there longer than Jack Smith: Clarence Jordan and Anthony Pierce, both of whom arrived earlier in 1978; Harvey Earvin, who arrived in late 1977; and Raymond Riles, who arrived on February 4, 1976.

It's still too early to know which, if any, of them will be the next record holder for time on the Row before execution, or time on the Row before dying of natural causes, or time on the Row before dying of suicide, or time on the Row before getting a commutation, or time on the Row before getting murdered. At the end, it didn't matter to Excell White. It doesn't really matter to anyone: records, like everything on Death Row, mean nothing.

PART III
Working

1. Avoiding the Row

Bruce avoided Death Rows for seventeen years. The opportunities were always there, but he didn't take them. During Bruce's first field trip to a prison (Indiana State Prison at Michigan City in 1961), the warden offered to show him the electric chair and let him talk to condemned prisoners. He declined. The following summer, the warden of the Missouri State Prison in Jefferson City made a similar offer, though this time the instrument of execution was a gas chamber. Bruce said no to him too. Both prison officials expressed surprise; both said the death house was almost always high on the list of things outsiders wanted to see.

During the years he did research in Texas prisons, which began in July 1964 and continued through the rest of that decade, Bruce could have visited the Row at any time. Dr. George Beto, who was director of the Texas Department of Corrections (TDC) from 1962 through 1972, thought Bruce's inquiries were worthwhile, so he instructed the prison staff to let Bruce go anywhere he wanted and talk with anyone he wished.

Bruce thought it reasonable to talk to people about their lives in crime and their adjustments to the world of prison, and he spent a great deal of time doing interviews and recording prisoners' songs and stories.[1] But he thought the situation of the men on the Row was so precarious and painful that his own academic curiosities were trivial in comparison. He could justify to himself a conversation with a long-term convict about the technology of safecracking or his day-to-day life or getting by in the prison cotton fields or the building, but he couldn't justify such a conversation with someone waiting for the state of Texas to run several thousand volts of electricity through his body, thereby boiling the liquid in his eyes and veins and so overcooking his brain that smoke poured from the black cloth covering his head—which is how they did it in the days before they killed using medically certified pharmaceuticals.

2. An invitation

In the early 1970s, our prison visits focused on Cummins prison farm in Arkansas, the first prison in the United States to have been found unconstitutional in federal court.[2] In 1978 George Beto, by then retired from the prison system and a professor in the Criminal Justice Center at Sam Houston State University, invited Bruce to be the Center's visiting distinguished lecturer. Bruce was to give a talk titled "The Bureaucratic Crisis in Public Institutions" and meet with several graduate and undergraduate

classes. During that visit, he met for the first time James Estelle, who had replaced Dr. Beto as director of the TDC. They had a cordial meeting, in the course of which Bruce told Estelle that he was no longer doing prison research. Estelle said that if Bruce ever wanted to take up his prison research again, the place was still open to him. Bruce could, Estelle said, have the same freedom to work without observation or supervision that Dr. Beto had accorded him when he'd done his work there a decade earlier. Bruce thanked him, but he had no intention of or interest in taking him up on the offer, which he was sure Estelle knew as well as he did.

While Bruce was in Huntsville, Dr. Beto invited him to a barbecue at the Goree Unit of the TDC, which was where women prisoners were housed. "A lot of people you know will be there," he said. Bruce went. He saw Carl Luther McAdams, longtime warden of Ellis, known everywhere in the prison (but never to his face) as "The Bear" or "Beartracks." He saw D. V. "Red" McCaskle, who would, after Estelle resigned under fire in a few years, become acting director of the system. He saw Oscar "Slim" Savage, whom he'd known as an Ellis field major and who would become a highly respected warden. And he saw Billy Macmillan, whom he'd met on his first visit to the Texas prisons in 1964 when Macmillan was a field sergeant at Ramsey Unit, one of the prisons on the Brazos River southwest of Houston. The last time Bruce had seen him had been in 1967, when Macmillan had been a field major on Ellis. He was now an assistant director of the prison system.

Macmillan said the TDC was presently going through a massive lawsuit. He asked Bruce if he would be willing to testify in federal court about changes in the prison system since he first did research there in 1964 and about how the TDC compared to other state prison systems he'd visited.

Billy knew that Bruce's politics were far to the left of anybody they knew in common and that he had written articles criticizing prison administrations in the *Atlantic Monthly*, the *New York Times Magazine*, *The Nation*, and other such publications. He also knew that Bruce had testified as an expert witness in criminal cases in federal court, always for the defense.

Bruce said he'd do it if he could visit all the prisons again so he wasn't talking in the abstract. He hadn't been in Texas prisons for nearly a decade. Billy said arrangements would be made for him to visit any place he wanted to see for as long as he liked.

Bruce said, "If I testify, I'll say what I think is wrong with the place too."

"As long as you say what you've seen," Macmillan said, "I don't care what you say." Bruce hadn't a doubt that Billy Macmillan meant that, so he said he would do it.

3. Building tenders

And so in 1978, Bruce began visiting Texas prisons once again. He had long thought TDC prisons were at once the most repressive and the safest of American prisons: prisoners there had the least freedom and the greatest chance of serving their sentences without physical harm. He never thought that TDC prisons were safe places—no prison is a safe place, and he'd never been in a prison where some people didn't brutalize and exploit other people. It was only that he thought there had been less of it in TDC prisons in the years he did research there than he'd found or heard about in prisons he'd visited in Indiana, Missouri, New York, California, Arkansas, and Washington.

The system had two more units in operation than it had when Bruce had done his research in the 1960s—fifteen rather than thirteen separate prisons. It also had more than twice the convict population—25,000 rather than 12,000.[3] The plaintiffs in the pending court case *Ruiz v. Estelle* argued that repressive measures and the increasing overcrowding were so extreme that they were unconstitutional. They also argued that the building-tender system—the prison's use of inmates to control other inmates in the buildings and thereby keep costs to a minimum—led to a wide range of abuses, such as beatings, sexual exploitation, and extortion.

Bruce had heard stories of building-tender abuses when he'd done his earlier research in the TDC, but he'd never seen any of it. That didn't lead him to discount the stories, any more than the fact that he'd never seen a policeman beat anyone up on the streets led him to discount stories about policemen sometimes beating people up. Officials who engage in such behaviors tend to be careful about when and where they engage in them and about who gets to see them doing it. Bruce had had conversations with Dr. Beto about the building-tender system in which he'd said that he thought it was a critical part of the actual, if informal, structure of the institution. The building tenders appeared in no organizational charts, but the prison couldn't get through a day without them. Dr. Beto told Bruce that the role of the building tenders was the most recalcitrant structural problem he had to deal with, one of the few things he'd never been able to get control over. A promising sociology graduate student at Texas A&M spoke with Bruce several times while he was trying to find a Ph.D. thesis topic. Bruce urged him to look at the building tenders. He studied the correctional officers instead, and it remained for *Ruiz v. Estelle* to look into the Texas building-tender system and finally blow it, and the entire prison system, apart.

4. Documenting the Row

One of Bruce's 1978 visits was to Death Row on the Ellis Unit, twelve miles northeast of Huntsville. He saw very quickly how the Row differed from the rest of the prison. None of the usual prison markers of behavior mattered there because the Row was the single place where the rhetoric of rehabilitation was meaningless (one was there waiting to die, not to be improved), the rhetoric of punishment was inappropriate (the punishment was not time served on the Row but execution), and nobody there spoke of "doing time" (because nobody there was doing time).

When Bruce came home from that trip, he said to Diane that someone should do a study of life on the Row: How did the men survive? What were the ways in which they made existence meaningful? What were the relationships between the condemned men and their guards? How did the prison officials justify this set of prison conditions that differed so radically from the conditions in the regular cell block directly across the hall? What did the Row look like? Someone should research those things—though not him. He'd moved on.

That July, the two of us took part in a conference put on by the Institute for the American West and the Sun Valley Institute of Arts and Humanities. At a reception for the participants in Ketchum, Idaho, we met Carey McWilliams, who in 1971 had gotten Bruce to start contributing articles on prison problems to *The Nation*, which McWilliams then edited. Bruce had never met him before that conversation in Ketchum, but he'd long held him in high regard as a journalist and editor. Bruce told McWilliams about his recent visits to the Row and said that he thought someone should document it, maybe even film it.

"Right," Carey said. "When are you going to do it?"

"No," Bruce said. "It's too depressing. And I don't want to be a voyeur."

"Don't be silly," Carey said. "For one thing, it ought to be done. For another, you've got the access. So go do it."

"I don't *want* to do it," Bruce said. Carey scowled. Bruce said he was a writer, not a filmmaker; writers work alone, filmmakers have to work with other people. It was a different kind of work entirely. Cary would have none of it. He again said the key line: "You've got the access."

So the following spring, the two of us went and did it.

We knew we had to do both a film and a book. The film would show what the rhythm of the place

was like and what the people who lived there were like; the book would provide the space for discourse that film can't afford.

Neither of us had ever made a film before, but we'd been marginally involved with another film that same year, so we had an idea of what things cost and how film budgets looked and the sort of work that had to be done. At the time (1978), the accepted rough guideline for 16mm color documentary film production was $1,500 per minute. We couldn't afford that, so we decided to do a thirty-minute, black-and-white film. On the basis of the Death Row project description and some video footage Bruce had shot with a Sony Portapak videotape machine in the Arkansas penitentiary a few years earlier, Bruce was awarded a $10,000 Independent Filmmaker's grant by the American Film Institute. The two of us received a grant for the book portion of the work from the Fund for Investigative Journalism. We asked one New York foundation interested in criminal justice matters for $65,000 for the film; they said no. It was a nice no, so we wrote again and asked for $25,000; they again said no and told us how much the rejection pained them. We wrote back and said it pained us far more, so how about $8,500? We threatened that if they didn't give us the money, we wouldn't ask any more. They gave it to us, but made us promise we wouldn't use their name in the credits (we didn't). The Polaroid Corporation gave us two cases of SX-70 film so we could give everyone on the Row snapshots to send home without having to wait for Bruce to make prints in his darkroom back home; the SX-70 snapshots would be useful to us because we could use a set of the Polaroid images to keep the names straight. The Levi Strauss Foundation contributed a few thousand dollars, and so did the Playboy Foundation. In all, we had grants for about $25,000, so we decided to make a sixty-minute color film. We were $65,000 short of the accepted production minimum, but we had enough to do the location work and get the film processed.

We figured the rest of the money would come in later. Anyway, those $1,500 budgets were based on films with lots of people, all of whom got paid. No one except the cameraman got paid for working on *Death Row*; the two of us would do all the other work ourselves. In retrospect, knowing what we later learned about the costs of film production and the complexity of film editing, we were hugely naïve.

We wrote letters to everyone on the Row explaining our purpose and saying we thought the work would give them an opportunity to tell the outside world what they thought about where they were. If the Row was the place most isolated from outside eyes, it was also the place insiders were most cut off from outside conversations. We weren't going to argue anything in our film, we told them; we were just

going to show people a place about which they knew nothing. Three men wrote us back saying they'd be happy to help out however they could. That seemed enough for a start.

Jerry Puglia (our cameraman), Gary McDonald (a volunteer grip from the media services department at Sam Houston State University), and Bruce arrived at Ellis early on a Tuesday morning in late March. Diane was to arrive the next afternoon. Our plan at first was that the three of us would work on the filming while Diane did long interviews elsewhere in the prison. As it turned out, her interviews not only suggested things that Bruce should film and conversations he should have on camera on the Row, but they also became the major part of our book about the Row.[4] And often things people said to Bruce in interviews or in conversation on the Row became substantial elements in Diane's much longer conversations with those same people later.[5]

We had several reasons for Diane doing her interviews in another space. If the prison authorities had agreed to let us film with her on the Row, they would have insisted on having guards around while we were working, and that would have ruined the interviews and changed the mood. Even with all the access we had, it was still rural Texas in 1979, and there was no way in the world they would have let a woman walk around Death Row without a lot of official protection. Only five years had passed since Fred Carrasco, Ignacio Cuevas, and Rudolfo Dominquez took fourteen hostages at The Walls in an escape attempt that resulted in the deaths of Carrasco, Dominguez, and two women hostages and the placement of Cuevas on Death Row.[6] We couldn't have worked in the cells, and if she'd done her interviews in the dayroom, that would have interfered with the ordinary recreation schedules. In addition, the toilets in the cells face out to the runs; like just about every other place in a penitentiary, there is no privacy on Death Row. Had Diane been there all day long, new and uncomfortable constraints would've been placed on the residents.

5. Bona fides

The first day was a disaster. Our reception was icy and hostile. Hostility on Death Row is like hostility in few other places. Someone on one row said to Bruce, "We hear you're a witness against the convicts in *Ruiz*."

Death Row is a noisy place in the day—toilets flush, the eight television sets are on constantly, radios blare, people call back and forth to each other, cell doors roll open and shut, the hallway door rattles open and clangs shut. Even so, he had the feeling that men all the way up to three row heard the question and were listening for the answer.

"I'm testifying about what I've seen here over the years. I'd say the same thing if I was testifying for the plaintiffs."

"My lawyer wrote me that I could be in the film," another said, "but he told me I shouldn't do it unless he's here while you're doing it."

"Where is he?"

"He lives in New York."

The lawyer's name was Joel Berger. He had written the same letter to many other inmates on the Row. He hadn't told them not to talk to us at all, but he was going to make it as difficult as he could for us anyway. The following week, one of the prisoners told Bruce that Berger was in the visiting room. Bruce found him there and asked why he hadn't at least let us know he was writing that letter, since he knew we were coming down from upper New York State with a film crew. "I'm a lawyer," Berger said. "I'm a very busy person. I don't have time to be writing letters to people."

"But if you had shown me the letter, we could have worked something out."

"I told you: I'm a lawyer. I'm too busy for that."

Paul Rougeau, who was in cell 15 on one row, showed Bruce Berger's letter and said, "I want to be in the movie. I don't like somebody in New York thinking I'm too stupid to know what I can say and what I can't say in a movie." We filmed him. We filmed Thomas Andrew Barefoot getting a haircut and shaving in his cell and talking about rules. Barefoot also talked about the letter and said he didn't like being told whom he should and shouldn't talk to.

In the moment, Bruce was furious at Berger. The three of us had friends in common in the New York civil rights legal community. He could, Bruce thought, have shown a little collegiality. But Bruce was, in fact, thinking far too much about our project and far too little about the perilous situation of the prisoners we hoped to interview. In a recent conversation about this incident, Billy Sothern, a New Orleans death penalty lawyer, said, "Joel Berger was right to warn them against talking to you or anybody else without a lawyer there. I would have told them the same thing. They have everything to lose. *Everything.* Often my clients would say damaging things, given the opportunity to say them. The guys who are there are frequently there because they had stunningly bad judgment. There were enormous stakes for them in saying anything to you guys at all."

Even though we'd filmed Andy Barefoot and Paul Rougeau, the mood on the Row still seemed cold and suspicious. Bruce was in despair: after all those years of *not* doing anything about the Row and all

those months of scuffling for the money to get started, it looked like he might as well pack up, cut the losses, and go home. The crew did some filming, and Bruce taped some interviews and took some photographs, not working too close to anybody.

While Jerry and Gary were packing up the gear for the day (they had one shot set up for the next morning; if things didn't pick up after that, we were through), Bruce walked along the three tiers of the cell block, talking to anyone who wanted to talk. There weren't many who did. On the third tier was Larry Ross, who was in cell 3 between Kerry Max Cook and Raymond Riles. Larry had written us an enthusiastic letter saying he looked forward to participating in the film, but that morning on the Row, he'd said that he'd be happy to give us advice, but he certainly couldn't be in the film. "You may think I misled you," he'd said, "and you'd be right. But I happened to change my mind, you see." Bruce suppressed several things he thought would be fine responses, nodded, and started to move on. Ross called Bruce back. He wanted to chat. He said that he was into theosophy. He asked what kind of books Bruce wrote. Bruce said it was difficult to describe them. He asked to see one.

Diane had urged Bruce to bring a few of his prison books along on this trip.

"What's the point of that?" he'd said. "They'll just add weight and take up space."

"Bring them anyway," she'd said, "you never know."

Bruce went down to one row and took from one of the bags a copy of *Killing Time*, which consists of photographs and bits and pieces of conversations he had gathered during his eight visits to Cummins prison in Arkansas from 1971 through 1975, and a copy of *In the Life*, a book of observations on working in crime and living in prison from interviews he'd done in Massachusetts, Indiana, Illinois, Texas, and a few other places from 1962 through 1971. He left the two books with Ross on the third tier and went to the motel. Jerry and he didn't talk about the state of things during the drive back to Huntsville. Jerry didn't understand how precarious the situation was; he was still getting over the shock of realizing where this film was being made and who was taking part in it. His previous filming experience had mostly been with commercials.

When Bruce, Jerry, and Gary got back to the Row at 6:30 the next morning, the books were in cell 21 of one row. Bruce later learned that they had been handed from cell to cell all along the twenty inhabited cells of three row (the first cell of each row is the shower), whereupon someone got the J-23 night porter, John Hayter, to bring them down to two row, where they made the same passage; Hayter then carried them down to one row, where they passed through the whole row a third time. Bruce fetched

the two books from Billy Woods (who would be executed on April 14, 1997) in cell 21 of one row, sixty cells from where he'd passed them through the bars to Larry Ross. People said hello cheerily. People chatted. Someone on three row said, "I read them books. You don't tell the convicts' side and you don't tell the man's side. You just tell your side. Can't ask for more than that. I'll be in your movie."

"Me too," said the man in the adjacent cell.

Bruce and Jerry set to work, and the day was a good one. Some men on the Row were still distant, but there seemed to be none of the hostility or coldness of the previous day. The crew filmed, did interviews, took photographs.

6. "I'd like to cut your fuckin' throat"

About 11:00 A.M., while we were filming on one row, Gerald Bodde called down from cell 4 on two row and said he wanted to be interviewed. We had enough shots set up for the rest of the day, so we told him we'd interview him right after lunch on Thursday. About every hour for the rest of that day and two or three times Thursday morning, Bodde called down and reminded us about the interview. Bruce finally told him that if he asked one more time, we wouldn't do it. Actually, Bruce didn't mind at all having him call down like that because he thought it would encourage others to take part more enthusiastically.

He had things exactly backward. The interview with Bodde Thursday nearly brought everything to a dead stop.

Bruce and Jerry began the interview a little after noon. They spent perhaps an hour filming in the dayroom. Bodde told about being gang-raped in the county jail, and how he'd been an informer there and then on the Row.

In Texas in those years, and in many other states as well, men who took the role of being penetrated sexually in prison only were called "punks"; those who were gay in the free world as well were called "queens." Queens had much higher status than punks because, as we've heard many convicts put it, "They're man enough to admit what they are." Punks were seen as submitting out of weakness and fear, and prison is a place where strength and weakness (or the appearance of either) count for a great deal. Being an informer in prison is worse than being a punk. Being an informer isn't nearly as bad as being *known* as one. There are many times when a regular convict might decide that informing is moral or practical—to prevent a killing that would result in tighter restrictions on everyone, for example, or to cut out new competition in one of the prison hustles. Being a punk is always bad, and being an informer is

bad if done for the wrong reasons; being known as both a punk and a snitch is about as bad as it can get as far as inside roles go.

Bodde said he didn't look forward to having his sentence commuted to life because if he were ever sent into population, he'd be killed. "They'd all like to get me if they could," he said. They finished the interview, Bodde returned to his cell, and Bruce and Jerry moved the camera back out to one row to film the afternoon's commissary run.

While Jerry and the grip were setting the lights, Bruce went to see someone on two row. As he walked along the run, Excell White in cell 6 said in a low voice, "You lousy cocksucker, I'd like to cut your fuckin' throat."

"Me too," said John Quinones in cell 7.

Under the best of circumstances, that would not be a good thing to hear. On Death Row, it's unnerving.

The guard called group two out for recreation. Group two included everyone in the last five cells on one row and the first ten cells on two row. The cell doors of those men in group two who weren't on restriction rolled, and the men who wanted to go to recreation came out onto the run and filed along the narrow iron corridor and down the tier of iron stairs, past the guard's desk and into the dayroom. White and Quinones were in group two. Bruce knew that if he didn't get this cleared up, we were finished working on Death Row, so he followed the group into the dayroom.

"Knock when you want to come out," the guard said as he closed the door and locked it from the other side.

On Death Row, the guard stays out of the dayroom. At that time, recreation was the only time more than one Death Row prisoner was allowed out of his cell at the same time. The guards avoided risk by locking all members of the recreation group in the dayroom and checking through the small peep window every now and then. If they noticed trouble, they would call other guards from other wings before venturing inside. So when the steel door slammed and Bruce heard it lock from the other side, he realized that what he was doing perhaps hadn't been very well thought out. But by that point, there was nothing to do but carry through on it.

He walked directly to Excell White, who was standing with four or five other men. "Why did you talk to me like that?" Bruce asked. "I haven't done anything to you."

Excell scowled at Bruce for a minute; the men around him stared at Bruce in silence. He heard the dull murmur of conversation from the far side of the room. The conversation was slow; it seemed to be

too slow. No one else was looking at them, but he was certain everyone else in that room was paying careful attention to what was going on. You don't have to look at someone to watch him.

Excell said, "You know what you did? You *know* what you did?"

"What did I do?"

"You filmed *Bodde*!"

"I'm aware of that. So what?"

"Do you know what he *is*? Have you any idea what he *is*?"

"Yeah," someone else said, "do you know what he is?"

"He's a punk and a snitch," Bruce said. "So what?"

"So what!" Excell yelled, leaning close. "What kind of image is *that* to give the world of Death Row?"

Bruce's first impulse was to laugh, but he didn't. Instead, he let himself get as angry as Excell was. "You know what *you* did?" he shouted. "Do you know what *you* did?" One of them backed up a step.

Now the entire room was silent and the other groups weren't pretending not to watch. "I'll *tell* you what you did. You listened for two days while he yelled to me and yelled to me about filming this interview and you never said one word. I walked by your house a dozen times, and you never said one word about it. You waited until I had used up a thousand dollars' worth of film and processing and wasted two hours and then afterward you got me convicted and sentenced. You did the same thing to me you probably say the cops did to you: you set me up. You're not a reasonable person and I don't want to talk to you anymore."

"Now wait a minute," Excell said.

"No. I don't want to talk to you. Anyway, what do you think people out there would think of a film about Death Row if it showed everyone as nice and sweet and gentle? They'd think it was just a bullshit film, that's what they'd think."

"Wait a minute," Excell said.

"No," Bruce said. "You're not a rational person."

Bruce knocked on the door and signaled the guard. He waited there for what was probably only a few seconds but seemed a very long time while the guard found the key and fumbled with it in the lock. Bruce's back was to the room and everyone in it.

He found Jerry, and they went back to filming on one row. A little while later, the group in the dayroom came out and returned to their cells. Bruce could see, at the periphery of his vision, Excell

White standing close to the bars of his cell on two row. After a while, Emery Harvey, one of the porters, brought Bruce a note. "From Excell White on two row," he said. Bruce saw Excell watching Harvey hand him the note. He put the note into his shirt pocket and went on with the shot. He could have read it then, but he didn't want to. He was really angry by that time. Being angry was probably his way of coping with the understanding that he shouldn't have gone into the dayroom after Excell's threat.

After a while, Bruce went under the tier of the walkway, out of sight of two row, and read the note. It said: "It is important that I talk to you immediately. Please come to my cell," followed by Excell's signature and cell number. He put the note back in his pocket and went back to work. A few minutes later, where Excell could see him, he took the note out, read it, then looked up and nodded. He was still standing at the bars. When they finished the shot, Bruce went up to the cell.

"Look," Excell said, "about what I said before. I was wrong, okay? We talked about it after you left. If we want this movie to tell people what Death Row is like, we've got to work on it with you. You guys can't do it by yourselves."

Bruce nodded.

"So can I be in the movie?" he said.

"Yes," Bruce said.

"Me too," said John Quinones in the next cell.

7. Trust

That was it. After that incident, the only people we asked to be in the movie or on tape or in photographs who said no were men who for specific reasons couldn't afford to have themselves documented. One was Ronald Clark "Candyman" O'Bryan, convicted of spiking his eight-year-old son's Halloween candy with cyanide for the insurance; he felt he'd had too much publicity already and had hopes of a new trial. (He didn't get it; on March 31, 1984, Candyman became the third post-*Furman* execution in Texas.) Another said his seventy-five-year-old mother thought he worked in another part of the country; his brother remailed his letters to her so she wouldn't know where he was. "If she found out I was down here," he said, "it would kill her. But I'll be happy to talk to Diane about anything you two like." And he did. He also said he would let Bruce take photographs of him if Bruce promised not to show them to anyone; Bruce took the photos and, since he's still there doing a life sentence, we haven't shown them

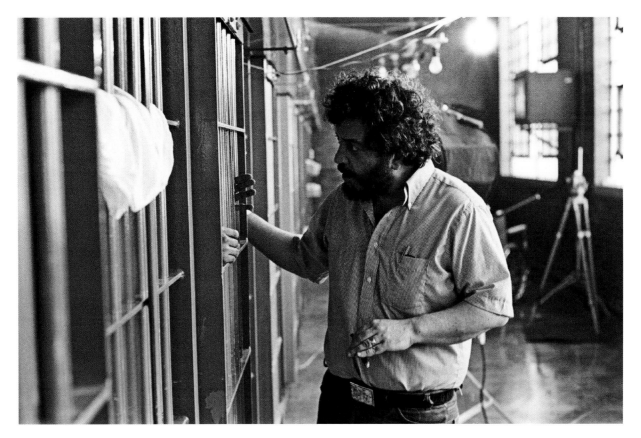

Bruce talking with Donnie Crawford (cell 11) during the filming of *Death Row*. Behind him is some of the equipment used during the filming: a 1,500-watt Lowell Softlight, the camera tripod, and a wheelchair Bruce had borrowed from the prison infirmary to do the film's tracking shots. *Photograph by Clyde Byars.*

to anyone. A third was a former college teacher on the Row for his involvement in the murder of his girlfriend's parents for the insurance. We don't know what his reasons were because he never talked to us at all, except to comment on the weather. He spent a lot of time doing exercises in his cell: push-ups on the floor, chin-ups on the bars. In 1987 he got a reversal. Then the key witness in his first trial said she wouldn't testify in a second trial, the prosecutor dropped the case, and the charges against him were dismissed. As far as we know, there was only one other resident of J-23 who still hung back.

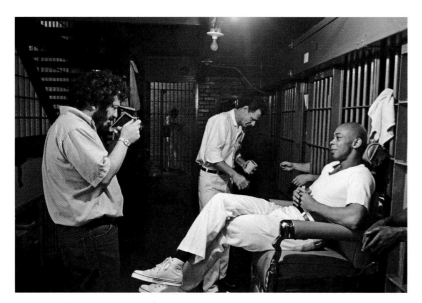
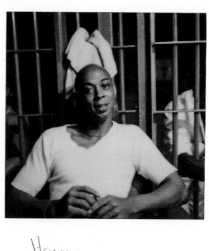

Harvey

LEFT: Bruce making a Polaroid of day-shift porter Emery Harvey while night-shift porter John Hayter talks with Andy Barefoot in cell 3. *Photograph by Clyde Byars.* RIGHT: A black-and-white scan of one of the Polaroids of Harvey.

But it wasn't just our efforts that got people to talk to us and to trust us. It was also things neither of us knew anything about until later. Porter John Hayter, who had spent most of his life in Texas prisons, told Diane that he had been on Ramsey Unit when Bruce had done research there in the 1960s, and he had read an article Bruce had published in *Texas Monthly*[7] about Ellis prison farm a few months before we came down there in April 1979. "I keep telling these guys," he told Diane, "this man don't tell nobody's story but his own." He told her that he'd told them that no heat had come down on anyone for anything anyone had said to Bruce on Ramsey, and that he thought the *Texas Monthly* article nailed Ellis prison better than anything he'd seen. "I'd go down them runs," he said, "and tell them, 'Talk to that man.'"

And they did. Even though some could never accept the notion that anyone who walked around and sat in the cells shooting pictures and making recordings without any guard nearby could be doing it unless he was an agent of the state, most men on the Row, to a smaller or larger measure, decided to trust us, and for that, the two of us remain grateful to this day.

Our conversations, though in different parts of the prison, constantly informed one another. Things would turn up in Diane's long conversations that Bruce knew nothing about, and at night in the motel,

when we were reloading the film magazines and charging the batteries for the cameras and recorders, she would tell Bruce about people he hadn't yet met whom she thought he should seek out, and she suggested things he should talk to them about. Sometimes Bruce would film or tape someone on the Row, then Diane would interview the same person at length and would later ask Bruce, "Did so-and-so tell you about——?" If Bruce said no, Diane would say, "If you have time, you should film him again and ask him about that." And the next day, Bruce would do it. Sometimes it went in the other direction: people would say to one of us something they knew the other one was interested in. Diane would have a long conversation with someone about a certain subject, and the next day on the Row, someone else would mention to Bruce that he knew a lot about that subject and maybe Diane would like to call him down for a chat. Or someone would suggest that Diane tell Bruce to ask him about a particular subject later, and Bruce would.

Once the Death Row community decided we were reasonable people, the work was worthwhile, and participation was in their interest, we had a new problem: it was impossible to film or interview or photograph everyone who wanted to be filmed or interviewed or photographed. "Bruce had not enough the first day," Charles Rigsby told Diane, "and too many now. Everybody wants to talk to him." People would say to Bruce, "When's your wife going to call me out to talk?" The filming, photographing, and interviewing became—for the time we were there—part of life on the Row.

It wasn't just rapport with the Death Row prisoners that was necessary. We also had to seem reasonable and the project had to appear useful to the convict trusties who worked on the Row, as well as to the guards and other staff, even the medical technician. Only two staff members wouldn't talk to us: the doctor, whose English wasn't very good and who didn't talk very much to anybody, and the Baptist minister.

8. Why talk?

What we've just written tells you how we remember having gotten around an impediment to conversation and filming on the Row, but it doesn't tell you why those men talked to us and let us film and photograph them. What if there had been no problem about Bruce's status or his interviewing of Bodde. Why would they have bothered talking to us then?

Some men on the Row would have talked to us because they thought there was always a chance we might help them in their cases. They didn't know how or if we could help, but Death Row is a place where almost every other avenue of aid has failed or been exhausted. Why *not* talk to us? Once they

decided we weren't harmful, they concluded there was nothing to lose by dealing with us as if we might be helpful. In that, as Billy Sothern pointed out, we were all naïve: someone could have said something that might have harmed his case if it had gotten out. We count ourselves fortunate that nothing like that ever happened.

Some men talked because they wanted people outside to know what the place was like. Some talked because we gave them a chance to vent their grievances against the criminal justice system or the prison administration or other residents of the Row. Some talked because they thought the film might do some real good.

Some men talked to Bruce only because they liked Diane. She'd interview someone for a few hours down the hall, and that man would say to a friend, "You should go talk to that lady," and he'd give reasons, and the friend would do just that. Then the friend would decide Bruce was all right because he was married to Diane.

And one more reason—one that we think was of major importance to many of the men who took part in the film, talked to Diane in connection with the book, and chatted with Bruce while he photographed them or the objects in their cells—was discussed by Rosalie Wax in reference to her research in Nisei Relocation Centers during World War II. "While I would like to think that the data I obtained there bear some relationship to my personal skill," Wax wrote, "it would be gross self-deception not to admit that many informants talked to me week after week partly because there was nothing more interesting to do."[8]

9. Punishing Diane

We wrote earlier that the whole time we were at Ellis, Diane worked down the corridor so she could have extended conversations with people without being disturbed, and so she wouldn't disturb the life of the Row by being a woman in a place in which women were hardly ever seen or whose presence would evoke a disruptive bureaucratic protection response. All along, we planned that on the last day we were there, she would come down to the Row to see where everybody lived and to join me in saying goodbye. We were counting on it, and the men on the Row were counting on it. Even in a few weeks, you make real connections with people.

So that last day came. We were both emotionally burned out. Death Row is like the terminal-cancer ward: it is a place where everyone works at being alive, but everyone, staff and inmate alike, is aware of

very powerful—in all likelihood ineluctable—forces waiting and working to kill. The Row is all about death, and everyone there knows it. The people who live and work there deal with it every day, and they have ways of doing that. Some of them can't keep the façade up, and, as we noted earlier, they do things to themselves, or they go inside themselves to places other people cannot reach, or they talk all night long to people who live in the pipe chase, or they simply bang their head again and again against the steel edge of the bunk bolted to the cement wall of their cell.

Our solution was to go home, back to Buffalo with our reels of 16mm film negative, our audiotapes, our photographic negatives, our Polaroids, our notes. On that last day, Clyde Byars, the old lifer who'd been our assistant the whole time we'd been there, helped Bruce load up all the equipment into two laundry carts. Bruce went up to the front sally port to get Diane to bring her back down to the Row. All the men she'd talked to were waiting to say goodbye, as were some who hadn't met her but who had wanted to and who had been told that on this day, they would. A few women reporters had done brief interviews in the dayroom previously, and some had done interviews in the visiting room, but none had come every day for two weeks, having long and interconnected conversations about daily life on Death Row.

It was a Saturday afternoon. Warden Bob Cousins, who'd been helpful to us in every way he might, was off that day, so his assistant warden, Eli Rushing, was sitting at Cousins's desk. We went in and told him we were all set to go, so we wanted to go down to the Row now to say goodbye.

"Well," Rushing said, looking at Bruce, "you can go, but she can't. I can't let her go down there."

"Why not?" Bruce said.

"Security," he said.

"What are you talking about?" Bruce said. "It's Saturday afternoon. The place is totally locked down. There's nobody in the corridor but COs and building tenders."

"Yeah, but one of those convicts might yell something nasty from one of the dayrooms."

"So what?"

"We couldn't have that," he said. He leaned back in Cousins's chair, his boots on the desk.

"Why would they do that?" Bruce said. "I've never heard anybody yell out here." That was true: Ellis was a very tight prison then, the tightest prison Texas had. And the dayrooms were separated from the corridor by frosted glass blocks: even if someone in one of them yelled, you couldn't see him or hear him anyway.

"They might. Couldn't have that with a lady."

"I can deal with it," Diane said.

"Sorry," he said, smiling. "Security, you know?"

He was lying. He was getting even for something. Who knows for what? Maybe because Diane had gotten close to some of the DRs. Maybe he didn't like women. Maybe he didn't like Bruce. Maybe he didn't like the idea of outsiders coming in and having the run of the place, and he couldn't do a damned thing about it. He couldn't go after Bruce. So he punished Diane. And he punished the guys on the Row waiting to say goodbye to her. Rushing had been warden on Eastham prison farm, another prison, and now he was somebody else's assistant: maybe he was just pissed off in general and getting even with everybody. Maybe he was just doing it because he could.

Diane went out to the car and Bruce went down to the Row, where Clyde was waiting. They got the gear and went out to the corridor. At the last moment, Bruce turned, looked back, and saw mirrors sticking out from the cells the whole length of one row, from cell 2 all the way down the run to cell 21. Faces in those mirrors—Fred, Andy, Pete, Kenny, Skeet, Moses, Donnie, Wolf, Paul, Billy, Jack, and all the others—all down the run, watching him go. He thought to take a picture of it, but he couldn't see to focus, so he didn't.

As they walked up the hall, Clyde started to chat, caught Bruce's mood, and went quiet. He went with Bruce as far as the corridor sally port, where someone else helped him the rest of the way through the front entryway and through the outside sally port to the car.

Bruce got in the car and told Diane about the mirrors. He told her that Clyde tried to talk to him as they went up the corridor, but he couldn't talk to Clyde because he was weeping. She didn't say any-thing; before he moved the car out of the lot, he looked at her and saw that she was weeping too. "That son of a bitch," she said, "that lousy fucking son of a bitch. He did it because they *talked* to me." She didn't say, but we both knew, that the capricious and arbitrary bit of cruelty Rushing had come up with a little while earlier was something the men on the Row lived with, in larger and lesser measure, every day of their lives.

10. Testifying

That summer and fall, we worked on the film and the book. We took a few days off work when Bruce went down to Houston to testify in *Ruiz*. He was testifying for the state but had a lot of friends in common with the lawyers for the plaintiffs, so their lead attorney, William Bennett Turner, asked us if we would join his team for dinner the night before Bruce went on the stand. Ed Idar, the Texas assistant attorney general handling the case for the prison, wasn't happy about it, but Bruce told Turner we'd be happy to join them so long as nothing any of us said became ammunition the following day. Turner said that was fine with him, and he'd make sure his associates understood the condition. (One of his associates violated that promise during Bruce's cross-examination. Bruce looked at Turner, who was sitting at the plaintiff's table. Turner quickly shut his associate down.)

During the dinner, Turner asked Bruce, "With what you're saying, why aren't you testifying for our side?"

"I would have," Bruce said, "but you never asked. I wish there were some way I could just go in and say what I knew without belonging to one side or the other."

"You can't do that in court," Turner said.

"I know," Bruce said.

He asked Bruce what he thought was the biggest change in the TDC since he'd worked there ten years earlier. Bruce told him it was the overcrowding, and that he thought some of the most severe problems he'd seen resulted from that. The overcrowding was terrible. "I hope you guys ask me some questions about it when you cross-examine tomorrow." Turner said he certainly would.

As it turned out, not one of the three lawyers who examined Bruce asked him about overcrowding. Ed Idar, the prison's attorney, didn't because it wasn't his job to put information detrimental to their case in the record; Turner didn't, perhaps because he thought Bruce was setting them up, or maybe he already had enough in his case about overcrowding and didn't need Bruce adding to it.

It didn't matter. The plaintiffs won anyway, and they won big. Judge William Wayne Justice accepted nearly every aspect of the plaintiffs' complaint, and it resulted in massive changes in the way the prison operated. The management system that used convict trusties as intermediaries between convicts and authorities was abolished. The legislature grew so fond of its prison system that it built more and more prisons and made sentences longer and longer, so Texas now has more people locked up than any other state except California—indeed, more than most countries. And the Texas Department of Crimi-

nal Justice has also become one of the nation's most violent and dangerous prison systems.[9] The safest and most restrictive place in all of the more than 100 public and private prisons in Texas is now, as it was when we did this work, Death Row.

11. Screening *Death Row*

The first screening of the film was on the Row itself on the afternoon of December 13, 1979. The lab that made the film prints for us also made several U-Matic video copies (bulky cassettes with three-quarter-inch tape that were used for broadcast at that time). Someone at the prison got a U-Matic deck and fed it into the sixteen television sets bolted to the walls of J-21 and J-23.

This time, Diane made it down to the Row. Assistant Warden Eli Rushing was nowhere about, and Warden Bob Cousins did everything he could to make the visit simple for everybody.

We were scheduled to premiere the 16mm film in the large auditorium at the Sam Houston State College Criminal Justice Center that night. We both worried what the people who lived and worked on the Row would think of it. It was, as Excell White had said after our encounter in the dayroom months earlier, their story, not ours. So we agreed that if the Row didn't like the film, we'd throw it out. We just wouldn't show it to anybody else.

We watched it on J-23. Diane sat in a folding iron chair, and when Bruce wasn't taking pictures, he sat in the barber chair. Some of the porters and guards who worked the Row watched it with us. There were other porters and guards watching along with the prisoners over on J-21. The DRs all watched from their cells.

Other than occasional laughter and a bit of yelling at Brandon, the only time anybody made any noise during the fifty-nine-minute screening was when Bodde said, "They'd all like to get to me if they could." He was talking about the people he thought wanted to kill him because he was a punk and a snitch. Someone up on three row yelled, "Who wants you, you son of a bitch?" We were both very embarrassed for Bodde and thought he must feel awful.

As the film played out, Bruce saw one thing after another wrong with it, one point after another we hadn't made or hadn't made well enough. He thought it was a disaster. When it was over, everybody clapped and yelled. The two of us visited everybody in all the Death Row cells on both sides. Bodde, as it turned out, was delighted: "See," he said, "I told you they didn't like me." Maybe the first time Bruce felt really comfortable about it was when Excell looked at us through the bars and just nodded, and a

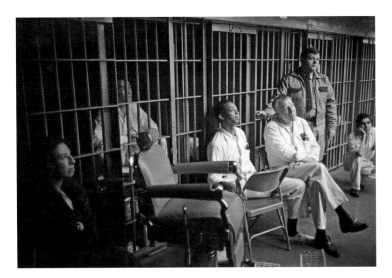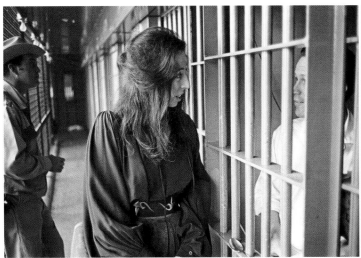

LEFT: Diane watching the premiere of *Death Row* on one of the Row's TV sets. To the right of her are Andy Barefoot in cell 3, Emery Harvey, Clyde Byars (a trusty who was a grip on the film), and a guard and trusty from another row who'd come over to see the film. RIGHT: Diane talking to Fred Durrough on J-21 after the screening; the building major who stayed close to her during her visit to the Row leans against the wire mesh.

moment later a guard we didn't know said, "I'm gonna make my wife come to that screening tonight at the college so she'll finally know what I've been talking about the last two years."

Brandon had been moved over to two row on J-21. "He was excited about your coming today," the building major said, "so they gave him a whole bunch of tranquilizers to make sure he was all calmed down."

When we got to Brandon's cell, he was at the bars and bouncing back and forth the same way he always did. He'd been on cell restriction after he smashed the jar on the bars of Donny Crawford's cell, so he and Diane had never met when we'd worked on the Row the previous spring. He looked at her, grinned, and said, "So you're Diane. You're one beautiful mama. I want to shake your hand."

There was dead silence on the run and everybody knew what everybody else was thinking. The building major, who was standing next to Diane, went absolutely rigid. Brandon kept grinning at all of us. Diane said, "Thank you," and put her hand in front of the bars. Brandon took it in his. Brandon was a very large man, and Diane's hand just about disappeared from sight. We all knew that, if he wished, Brandon could pull Diane's arm out of its socket in an instant.

All he did was hold her hand a moment longer, smile again, and let it go. Everyone relaxed. Then he said, "And Bruce, my man, now I want to shake your hand." He grinned again, knowing exactly what everyone was thinking this time too.

Bruce put his hand out. Brandon took it in his, gently pulled it inside the bars, looked at Bruce, looked at Diane, looked a long time at the building major who was in a condition we thought close to panic, and then he shook Bruce's hand, held it a long time, and finally said, "It's good to see you." And so it was.

12. Brent Bullock Jr. and Norman Mailer

The screening at the college that night was a disaster. The large auditorium was filled with an audience composed of prison workers and their families, faculty and students, and some family members of prisoners. Someone introduced us and the film, the room was darkened, it grew quiet, the film started, and the room stayed quiet. Dead silent.

There wasn't a sound from the soundtrack. Bruce yelled out, "This is a talkie!" Nothing happened. The film rolled on. Bruce went to the projection booth and tried the door. It was locked from the inside. Bruce knocked. No one answered. He pounded. No one answered. He yelled and pounded. No one answered. He went back to his seat. About ten minutes into the film, the sound came on, only it was distant and thin. We later found out that when the projectionist couldn't get the sound to work properly, instead of stopping the film and fixing the problem, he had put a microphone close to the projection-room monitor's speaker and piped that into the auditorium.

When it was over, there was polite applause, but we didn't know if anyone there had made out a word. George Beto, former director of both the prison system and the Criminal Justice Center, came over and said, "If I were still director of this center, that man in that booth would already be looking for his next job." We were furious and disappointed, but also happy because, if things had to go wrong at one of the two places, we both preferred that they go wrong outside the wire.

We were staying at the hotel that was part of the huge Criminal Justice Center operation. After the reception, we went to our room and muttered for hours. The next morning, before heading down to Houston to catch our plane back to Buffalo, we had breakfast in the hotel's dining room.

A friendly young man at another table introduced himself to us and said he had been at the screening the previous evening and liked the film.

"Could you make out any of the words?"

"Enough of them," he said.

He told us that his name was Brent Bullock Jr., and that he was an investigator in the Provo, Utah, sheriff's office. He was in Huntsville for a workshop at the Criminal Justice Center. He told us he had worked as an investigator on the Gary Gilmore case in Provo and had been present at Gilmore's execution by firing squad on January 17, 1977.

He asked us if we knew Norman Mailer. Bruce said he'd met Mailer once, but he hardly knew him. "Did you read *The Executioner's Song*?" Bullock asked. That was Mailer's recent thousand-page book on Gilmore and his execution. Bruce had finished reading it on the plane coming down two days earlier. We asked him what he thought of it.

Bullock critiqued the book, mostly in terms of things he thought Mailer had gotten wrong about some of the people he'd spent time with in Utah. Then he went on to talk about several other Mailer books he'd read in years past. We remember him saying very smart things about *The Naked and the Dead* (which he liked and had reread), *Marilyn* (which he thought exploitative and cheap), and *An American Dream* (which he thought silly). He hadn't read them in connection with a class or anything like that; he was just a cop in the American Southwest, and he liked to read books and think about them. Going over that part of the conversation later, we agreed that his comments on the books were right up there with our smartest graduate students. Brent Bullock Jr. was the kind of reader most writers dream about: someone who reads out of interest and responds to the words and ideas.

"You're not a friend of his?" he asked us again. We said we weren't. Then he told us about Mailer's research in Provo. Mailer, he said, had come in after Lawrence Schiller had done a lot of preliminary interviews for the Gary Gilmore book. Schiller had bought the rights to Gilmore's story, and he'd hired Mailer to do the book. Mailer had come to their office one day, told them his name, and said that he was a world-famous writer there to write a book about Gary Gilmore. "We said, 'Okay, we'll help you.' We would have said that to anybody."

"Did he know you'd read his books?" Diane said.

"No. He never asked, so I never said. A lot of people in the office had read his books. They never said anything either."

"So how did it go?" Bruce asked.

"He interviewed everybody and looked through the files. We gave him whatever he needed." He paused.

"What?" Bruce said.

"Every morning, when he got to the office, he'd ask for whoever he wanted to see, and the receptionist would push down a button and say into her phone, 'Mr. Mailer is here to see——.' And she'd say the name. Then she'd say to Mailer, 'I'm sorry, but he's in conference right now. He said to have a seat, and he'll be with you soon.' Mailer would have a seat, and exactly fifteen minutes later she'd say, 'He can see you now, Mr. Mailer, please go right in.' The thing was, when she made that call when he got there, it wasn't to anybody in particular. It was to the office PA. It was the announcement for the morning coffee break. Whenever Mailer got there, we took our morning coffee break. That went on for months."

"Did he ever catch on?" Diane asked.

"No," Bullock said. "He never knew we had a sense of humor."

Then his tone changed. He told us some things about working on Gilmore's two murders and attending the execution at the state penitentiary two years earlier. "I believe in the death penalty," he said, "and I had no regrets at all when Gary Gilmore was executed. But there's something I have to tell you. After I saw that film last night, I thought about it a lot. That film disturbed me more than seeing Gary Gilmore die. There's no reason a civilized society should have a place like that. It's just not right. It's not."

13. *In This Timeless Time*

After we edited our film and wrote our book about Death Row in Texas, Bruce still wanted to do something with the photographs he'd taken there. They are images of the same place and experience, but they tell a different story, just as the film and the earlier book are about the same place but tell different stories. A book of words is infinitely expandable; it grows to whatever size it has to be. A film, as Andrei Tarkovsky liked to say, is a work in time. A book of photographs with captions and commentary—which the first part of *In This Timeless Time* is—is a combination of moments seized and limited in space and time. There is no visual information beyond a photograph's border, no time before or after the moment the shutter closed. But such images are linked to memories and reflections and subsequent understandings, and when partnered with words, photographs can tell another kind of story. We've learned a lot about Death Row since we first encountered and documented it. It took us until now to understand that this book is the third part of what the two of us undertook thirty-two years ago in that place where time was, so far as all the power of the state could make it, without meaning.

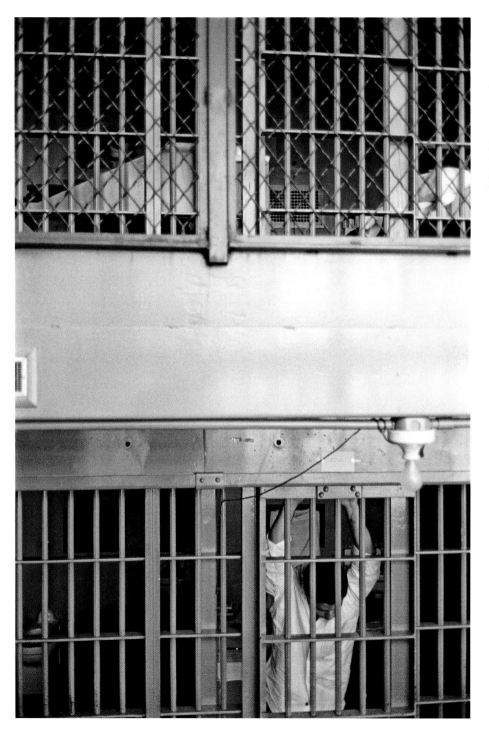

Pedro Muniz in cell 5 of one row hanging from the crossbar atop his cell door, as he often did; above him, in cell 4 of two row, is the face of Gerald Bodde in the cell he never left except for showers and in which he would, a few years later, die of cardiac arrhythmia.

APPENDIX 1

Layout of Ellis Unit inside the Fence

1. North side of J row (J-23), Death Row
2. South side of J row (J-21), Death Row
3. Front entrance
4. Visiting room
5. Administrative offices
6. Corridor leading from front lobby to prison interior; location of internal sally port and count room
7. Main corridor, running from the chapel at the southern end to the gym at the northern end
8. Chapel
9. Gym
10. Dining hall
11. Kitchen
12. Staff and visitors' dining room
13. Back-fence sally port gate
14. Back sally port picket, armory for field officer's weapons
15. Front picket; visitors' firearms held here
16. Front gate through the fence, controlled by guard in front picket
17. General parking lot
18. Guards' dormitory
19. Guards' dormitory parking lot
20. Concertina razor wire and triple-strand barbed-wire-topped double cyclone fence surrounding the entire building area; the only two openings are at the front gate (16) and rear sally port (13)
21. Corner pickets; there is one more just out of the frame at six o'clock
22. School bus repair building, license plate factory, and other prison industries
23. Infirmary, dental lab (all the prison system's dental plates were made at Ellis)
24. Building major's office, disciplinary hearing office

APPENDIX 2

The DR Three-Ring Binder

Somewhere on the unit—perhaps it was in the count room in the corridor between the front lobby and the main corridor—they kept a three-ring binder with one page on each DR. We'd heard about the binder while we were there but never found time to look for it. That sort of thing is all computerized now, but if you go to the Texas Department of Criminal Justice Death Row Information page (http://www.tdcj.state.tx.us/stat/deathrow.htm), you will find photocopies of those sheets for all the executed offenders and offenders still on the Row, like Jack Smith.

The two sets of sheets follow the same format, except the sheets for most people put to death have a penciled notation at the top giving the date of execution and which execution they were in the current series. Ronald Clark "Candyman" O'Bryan's sheet, for example, has "#3, 3-31-84" written at the top, meaning he was the third man to be executed and that it happened on March 31, 1984. In the computerized entries there is, of course, a field for the death date. The sheets have basic information, such as date of birth, date of the offense, date received at the prison, prior criminal activity, codefendants, and a photograph.

When Bruce looked through the online documents for men we knew, one photograph was particularly bothersome: the one for Doyle "Skeet" Skillern. It was the face of a man who looked very different and much older. Skeet was put to death six years after we met him, and Bruce found it hard to believe that his face had changed so much. Then he noticed that the number on the mug shot on Skeet's sheet wasn't his number but the number of his fall partner, Charles Victor Sanne, the man who actually did the killing in another car. So not only did Skeet get executed for a murder he hadn't done or ever intended to do, but the state of Texas marked that execution by affixing to his record the photo of the actual killer in the place where Skeet's photo should have gone. Some errors by other people follow you to the grave.

Here are four of those sheets, two for men who appear in this book and who were executed (Skeet and Candyman); one for a man who appears in this book and who is still there (Jack Smith); and one for a man we never met and who was, in all likelihood, executed for a crime that never occurred (Cameron Todd Willingham).

NAME: Doyle Skillern D.R.# 518
DOB: 04/08/36 RECEIVED: 03/03/75 AGE: (WHEN REC'D)
COUNTY: Lubbock DATE OF OFFENSE: 10/23/74
AGE AT TIME OF OFFENSE: RACE: White HEIGHT:
WEIGHT: EYES: HAIR:
NATIVE COUNTY: STATE:
PRIOR OCCUPATION: EDUCATION LEVEL:
PRIOR PRISON RECORD:

SUMMARY: Skillern was convicted of Capital Murder for the October 23, 1974 shooting death of Texas Department of Public Safety Narcotics Officer Patrick Allen Randel during an undercover drug buy near the town of George West.

CO-DEFENDANTS: Charles Victor Sanne #312300 DOB: 02/11/33, Life

RACE OF VICTIM(S):

NAME: Ronald Clark O'Bryan D.R.# 529
DOB: 10/19/44 RECEIVED: 07/14/75 AGE: 31 (WHEN REC'D)
COUNTY: Harris DATE OF OFFENSE:
AGE AT TIME OF OFFENSE: RACE: White HEIGHT:
WEIGHT: EYES: HAIR:
NATIVE COUNTY: STATE:
PRIOR OCCUPATION: EDUCATION LEVEL:
PRIOR PRISON RECORD: None

SUMMARY: Convicted of murdering his son, Timothy O'Bryan, by poisoning his Halloween candy with cyanide.

CO-DEFENDANTS: None

RACE OF VICTIM(S): White male

Name: Jack Harry Smith D.R.# 615

DOB: 12 / 23 / 37 Received: 10 / 9 / 78 Age: 40 (when rec'd)

County: Harris Date of Offense: 1 / 7 / 78

Age at time of offense: 40 Race: white Height: 5-6

Weight: 145 Eyes: blue Hair: brown

Native County: Galveston State: Texas

Prior Occupation: welder Education level: 6 years

Prior prison record:
 TDC #133858, received 5-30-55 from Harris Co. with 7-year sentence for
 larceny and robbery by assault, paroled to Harris Co. on 10-9-58.
 TDC #154244, received 1-13-60 from Harris Co. with life sentence for
 robbery by assault, paroled to Harris Co. on 1-8-77.

Summary: Convicted in the January 1978 shooting death of Roy A. Deputter
during a robbery. Deputter was shot twice with a .38-caliber pistol while
attempting to stop Smith and accomplice Jerome Lee Hamilton from robbery
Corky's Corner convenience store in Pasadena. Deputter walked in the back
door of the store while the robbery was in progress and was shot after
pulling a pistol on the robbers. Smith and Hamilton fled with an un-
determined amount of money. They were arrested the same day at Hamilton's
apartment, where Deputter's pistol was recovered.

Co-Defendants: Jermone Lee Hamilton #282479, W/M, DOB: 7-2-39. Rec. 8-1-78
 from Harris Co. with life sentence for murder W/deadly weapon.

Race of Victim(s): white male

Name: Cameron Todd Willingham D.R. # 999041

DOB: 1 / 9 / 68 Received: 8 / 21 / 92 Age: 24 (when rec'd)

County: Navarro Date of offense: 12 / 23 / 91

Age at time of offense: 23 Race: white Height: 5-9

Weight: 177 Eyes: brown Hair: brown

Native County: Carter State: Oklahoma

Prior Occupation: auto mechanic Education level: 10 yrs.

Prior prison record:
 Reportedly sentenced to boot camp program at Oklahoma State Prison in
 1989. Released in 1990.

Summary: Convicted in the deaths of his three young children in a house
fire. Killed in the house fire at 1213 West 11th St. in Corsicana were
Amber Louis Kuykendall, 2, and twins Karmon Diane Willingham, 1, and
Kameron Marie Willingham, 1. The defendant told authorities that the
fire started while he and the children were asleep. An investigation,
however, revealed that it was intentionally set with a flammable
liquid. He was arrested and charged in the deaths on January 8, 1992.

Co-Defendants: None

Race of Victim(s): Three white females

APPENDIX 3

Justice Thurgood Marshall's Dissent in *Gregg v. Georgia,* 428 U.S. 153

The full text of Justice Marshall's dissent contains nineteen citations to legal and other sources. Notations indicating their placement are included in the text that follows. The notes themselves are available online at http://www.law.cornell.edu/supct/html/historics/USSC_CR_0428_0153_ZD1. html#428_US_153ast2).

CERTIORARI TO THE SUPREME COURT OF GEORGIA

No. 74–6257 Argued: March 31, 1976—Decided: July 2, 1976.

MR. JUSTICE MARSHALL, dissenting.

In *Furman v. Georgia*, 408 U.S. 238, 314 (1972) (concurring opinion), I set forth at some length my views on the basic issue presented to the Court in these cases. The death penalty, I concluded, is a cruel and unusual punishment prohibited by the Eighth and Fourteenth Amendments. That continues to be my view.

I have no intention of retracing the "long and tedious journey" *id.* at 370, that led to my conclusion in *Furman*. My sole purposes here are to consider the suggestion that my conclusion in *Furman* has been undercut by developments since then, and briefly to evaluate the basis for my Brethren's holding that the extinction of life is a permissible form of punishment under the Cruel and Unusual Punishments Clause.

In *Furman*, I concluded that the death penalty is constitutionally invalid for two reasons. First, the death penalty is excessive. *Id.* at 331–332; 342–359. And [p232] second, the American people, fully informed as to the purposes of the death penalty and its liabilities, would, in my view, reject it as morally unacceptable. *Id.* at 360–369.

Since the decision in Furman, the legislatures of 35 States have enacted new statutes authorizing the imposition of the death sentence for certain crimes, and Congress has enacted a law providing the death penalty for air piracy resulting in death. *49 U.S.C. §§ 1472(i), (n) (1970 ed., Supp. IV)*. I would be less than candid if I did not acknowledge that these developments have a significant bearing on a realistic assessment of the moral acceptability of the death penalty to the American people. But if the

constitutionality of the death penalty turns, as I have urged, on the opinion of an informed citizenry, then even the enactment of new death statutes cannot be viewed as conclusive. In *Furman*, I observed that the American people are largely unaware of the information critical to a judgment on the morality of the death penalty, and concluded that, if they were better informed, they would consider it shocking, unjust, and unacceptable. 408 U.S. at 360–369. A recent study, conducted after the enactment of the post-*Furman* statutes, has confirmed that the American people know little about the death penalty, and that the opinions of an informed public would differ significantly from those of a public unaware of the consequences and effects of the death penalty. [n1]

Even assuming, however, that the post-*Furman* enactment of statutes authorizing the death penalty renders the prediction of the views of an informed citizenry an [p233] uncertain basis for a constitutional decision, the enactment of those statutes has no bearing whatsoever on the conclusion that the death penalty is unconstitutional because it is excessive. An excessive penalty is invalid under the Cruel and Unusual Punishments Clause "even though popular sentiment may favor" it. *Id.* at 331; *ante* at 173, 182–183 (opinion of STEWART, POWELL, and STEVENS, JJ.); *Roberts v. Louisiana*, post at 353–354 (WHITE, J., dissenting). The inquiry here, then, is simply whether the death penalty is necessary to accomplish the legitimate legislative purposes in punishment, or whether a less severe penalty—life imprisonment—would do as well. *Furman, supra* at 342 (MARSHALL, J., concurring).

The two purposes that sustain the death penalty as nonexcessive in the Court's view are general deterrence and retribution. In *Furman*, I canvassed the relevant data on the deterrent effect of capital punishment. *408 U.S. at 347–354.* [n2] The state of knowledge at that point, after literally centuries of debate, was summarized as follows by a United Nations Committee:

> It is generally agreed between the retentionists and abolitionists, whatever their opinions about the validity of comparative studies of deterrence, that the data which now exist show no correlation between the existence of capital punishment and lower rates of capital crime. [n3]

The available evidence, I concluded in *Furman*, was convincing that "capital punishment is not necessary as a deterrent to crime in our society." *Id.* at 353.

The Solicitor General, in his amicus brief in these cases, [p234] relies heavily on a study by Isaac Ehrlich, [n4] reported a year after *Furman*, to support the contention that the death penalty does deter murder. Since the Ehrlich study was not available at the time of *Furman*, and since it is the first

scientific study to suggest that the death penalty may have a deterrent effect, I will briefly consider its import.

The Ehrlich study focused on the relationship in the Nation as a whole between the homicide rate and "execution risk"—the fraction of persons convicted of murder who were actually executed. Comparing the differences in homicide rate and execution risk for the years 1933 to 1969, Ehrlich found that increases in execution risk were associated with increases in the homicide rate. [n5] But when he employed the statistical technique of multiple regression analysis to control for the influence of other variables posited to have an impact on the homicide rate, [n6] Ehrlich found a negative correlation between changes in the homicide rate and changes in execution risk. His tentative conclusion was that, for the period from 1933 to 1967, each additional execution in the United States might have saved eight lives. [n7]

The methods and conclusions of the Ehrlich study [p235] have been severely criticized on a number of grounds. [n8] It has been suggested, for example, that the study is defective because it compares execution and homicide rates on a nationwide, rather than a state-by-state, basis. The aggregation of data from all States—including those that have abolished the death penalty—obscures the relationship between murder and execution rates. Under Ehrlich's methodology, a decrease in the execution risk in one State combined with an increase in the murder rate in another State would, all other things being equal, suggest a deterrent effect that quite obviously would not exist. Indeed, a deterrent effect would be suggested if, once again all other things being equal, one State abolished the death penalty and experienced no change in the murder rate, while another State experienced an increase in the murder rate. [n9]

The most compelling criticism of the Ehrlich study is [p236] that its conclusions are extremely sensitive to the choice of the time period included in the regression analysis. Analysis of Ehrlich's data reveals that all empirical support for the deterrent effect of capital punishment disappears when the five most recent years are removed from his time series—that is to say, whether a decrease in the execution risk corresponds to an increase or a decrease in the murder rate depends on the ending point of the sample period. [n10] This finding has cast severe doubts on the reliability of Ehrlich's tentative conclusions. [n11] Indeed, a recent regression study, based on Ehrlich's theoretical model but using cross-section state data for the years 1950 and 1960, found no support for the conclusion that executions act as a deterrent. [n12]

The Ehrlich study, in short, is of little, if any, assistance in assessing the deterrent impact of the death penalty. Accord, *Commonwealth v. O'Neal*,_____Mass._____, 339 N.E.2d 676, 684 (1975). The evidence I reviewed in *Furman* [n13] remains convincing, in my view, that "capital punishment is not necessary as a deterrent to crime in our society." 408 U.S. at 353. The justification for the death penalty must be found elsewhere.

The other principal purpose said to be served by the death penalty is retribution. [n14] The notion that retribution [p237] can serve as a moral justification for the sanction of death finds credence in the opinion of my Brothers STEWART, POWELL, and STEVENS, and that of my Brother WHITE in *Roberts v. Louisiana, post*, p. 337. See also *Furman v. Georgia*, 408 U.S. at 394–395 (BURGER, C.J., dissenting). It is this notion that I find to be the most disturbing aspect of today's unfortunate decisions.

The concept of retribution is a multifaceted one, and any discussion of its role in the criminal law must be undertaken with caution. On one level, it can be said that the notion of retribution or reprobation is the basis of our insistence that only those who have broken the law be punished, and, in this sense, the notion is quite obviously central to a just system of criminal sanctions. But our recognition that retribution plays a crucial role in determining who may be punished by no means requires approval of retribution as a general justification for punishment. [n15] It is the question whether retribution can provide a moral justification for punishment—in particular, capital punishment—that we must consider.

My Brothers STEWART, POWELL, and STEVENS offer the following explanation of the retributive justification for capital punishment:

> The instinct for retribution is part of the nature of man, and channeling that instinct in the administration of criminal justice serves an important purpose in promoting the stability of a society governed [p238] by law. When people begin to believe that organized society is unwilling or unable to impose upon criminal offenders the punishment they "deserve," then there are sown the seeds of anarchy—of self-help, vigilante justice, and lynch law.

Ante at 183, quoting from *Furman v. Georgia, supra* at 308 (STEWART, J., concurring). This statement is wholly inadequate to justify the death penalty. As my Brother BRENNAN stated in *Furman*,

[t]here is no evidence whatever that utilization of imprisonment, rather than death, encourages private blood feuds and other disorders.

408 U.S. at 303 (concurring opinion). [n16] It simply defies belief to suggest that the death penalty is necessary to prevent the American people from taking the law into their own hands.

In a related vein, it may be suggested that the expression of moral outrage through the imposition of the death penalty serves to reinforce basic moral values—that it marks some crimes as particularly offensive, and therefore to be avoided. The argument is akin to a deterrence argument, but differs in that it contemplates the individual's shrinking from antisocial conduct not because he fears punishment, but because he has been told in the strongest possible way that the conduct is wrong. This contention, like the previous one, provides no support for the death penalty. It is inconceivable that any individual concerned about conforming his conduct to what society says is "right" would fail to realize that murder is "wrong" if the penalty were simply life imprisonment.

The foregoing contentions—that society's expression of moral outrage through the imposition of the death penalty preempts the citizenry from taking the law into its [p239] own hands and reinforces moral values—are not retributive in the purest sense. They are essentially utilitarian, in that they portray the death penalty as valuable because of its beneficial results. These justifications for the death penalty are inadequate because the penalty is, quite clearly I think, not necessary to the accomplishment of those results.

There remains for consideration, however, what might be termed the purely retributive justification for the death penalty—that the death penalty is appropriate not because of its beneficial effect on society, but because the taking of the murderer's life is itself morally good. [n17] Some of the language of the opinion of my Brothers STEWART, POWELL, and STEVENS in No. 74–6257 appears positively to embrace this notion of retribution for its own sake as a justification for capital punishment. [n18] They state:

[T]he decision that capital punishment may be the appropriate sanction in extreme cases is an expression of the community's belief that certain crimes are themselves so grievous an affront to humanity that the only adequate response may be the penalty of death.

Ante at 184 (footnote omitted). [p240] They then quote with approval from Lord Justice Denning's remarks before the British Royal Commission on Capital Punishment:

> The truth is that some crimes are so outrageous that society insists on adequate punishment because the wrongdoer deserves it, irrespective of whether it is a deterrent or not. *Ante* at 184 n. 30.

Of course, it may be that these statements are intended as no more than observations as to the popular demands that it is thought must be responded to in order to prevent anarchy. But the implication of the statements appears to me to be quite different—namely, that society's judgment that the murderer "deserves" death must be respected not simply because the preservation of order requires it, but because it is appropriate that society make the judgment and carry it out. It is this latter notion, in particular, that I consider to be fundamentally at odds with the Eighth Amendment. See *Furman v. Georgia*, 408 U.S. at 343–345 (MARSHALL, J., concurring). The mere fact that the community demands the murderer's life in return for the evil he has done cannot sustain the death penalty, for as JUSTICES STEWART, POWELL, and STEVENS remind us, "the Eighth Amendment demands more than that a challenged punishment be acceptable to contemporary society." *Ante* at 182. To be sustained under the Eighth Amendment, the death penalty must "compor[t] with the basic concept of human dignity at the core of the Amendment," ibid.; the objective in imposing it must be "[consistent] with our respect for the dignity of [other] men." *Ante* at 183. See *Trop v. Dulles*, 356 U.S. 86, 100 (1958) (plurality opinion). Under these standards, the taking of life "because the wrongdoer deserves it" surely must [p241] fall, for such a punishment has as its very basis the total denial of the wrongdoer's dignity and worth. [n19]

The death penalty, unnecessary to promote the goal of deterrence or to further any legitimate notion of retribution, is an excessive penalty forbidden by the Eighth and Fourteenth Amendments. I respectfully dissent from the Court's judgment upholding the sentences of death imposed upon the petitioners in these cases.

ACKNOWLEDGMENTS

We want to thank Carey McWilliams, Bruce's editor at *The Nation*, who talked us into undertaking the Death Row project. George Beto, director of the Texas Department of Corrections (TDC), gave Bruce free run of the system when he was researching African American convict work songs in the 1960s and then other aspects of prison life. He also supported our book and film about Death Row and declared his opposition to the death penalty. We regard him as a reformer and a moral force.

Dr. Beto's successor, James Estelle, in a 1978 conversation, offered Bruce the opportunity to return to the TDC whenever he wished to do research under the same conditions he'd been afforded by Dr. Beto.

We have benefited greatly from the generosity of the Harvard University Society of Fellows, which, from 1963 through 1967, underwrote Bruce's fieldwork and other research, including his first visits to the TDC. We are also grateful to the American Film Institute, the Playboy Foundation, the Polaroid Foundation, the Fund for Investigative Journalism, and the other organizations that contributed to the Death Row fieldwork in 1979.

We owe a debt of gratitude to the University at Buffalo for grants while we were doing the fieldwork and editing the film, and also for Bruce's endowed chairs and the supplementary grants from the Baldy Center in Law and Society that continue to provide support for the Death Row project today.

Many friends looked through an earlier set of these images, read an earlier version of this text, and made important suggestions or talked us through parts of it. We particularly appreciate the vital contributions of Howard S. Becker, Kerry Max Cook, Bill Ferris, Rick Halpern, Doug Harper, Jack Kyle, Philippe Lemonnier, Mike Desmond, and Jim Willett.

We particularly want to thank Bonnie Campbell for her editorial counsel and her superb design work, which brought this complex project to a state where readers can encounter the images and the words as the separate, but interlocked, conversations we intended them to be. And we also want to thank David Perry, editor-in-chief at the University of North Carolina Press; UNCP staffers Zachary Read, Beth Lassiter, and Jay Mazzocchi; and our good friend Tom Rankin at Duke's Center for Documentary Studies, as well as CDS Books editor Iris Tillman Hill and everyone else at CDS involved in this project.

We are especially grateful to Billy Sothern for his careful reading of the manuscript, for his many astute suggestions, for his counsel, and for continuing to fight the good fight, even though the odds are ever more highly stacked against him.

Most of all, we want to thank the condemned men and the TDC employees who trusted us to get their story right.

NOTES

Preface

1. *Death Row* (Documentary Research, 1979); Bruce Jackson and Diane Christian, *Death Row* (Boston: Beacon Press, 1980). The film is currently available in DVD format from Documentary Educational Resources, Boston (http://www.der.org).

2. David Grann, "Trial by Fire," *New Yorker*, September 7, 2009, 42–63.

3. See the "Cases" section of this book for full citations of all court cases mentioned in the text.

Part II

1. Texas Department of Criminal Justice, "Death Row Facts," http://www.tdcj.state.tx.us/stat/drowfacts.htm (September 19, 2009).

2. Jon Sorensen and Rochy Leann Pilgrim, *Lethal Injection: Capital Punishment in Texas during the Modern Era* (Austin: University of Texas Press, 2006), 2.

3. James W. Marquart, Sheldon Ekland-Olson, and Jonathan R. Sorensen, "Gazing into the Crystal Ball: Can Jurors Accurately Predict Dangerousness in Capital Cases?," *Law Society Review* 23, no. 3 (1989): 451.

4. Texas Defender Service, *Deadly Speculation: Misleading Texas Capital Juries with False Predictions of Future Dangerousness* (Houston and Austin, 2004), xii.

5. Ibid., 15.

6. Lisa Belkin, "Expert Witness Is Unfazed by 'Dr. Death' Label," *New York Times*, June 10, 1988. See also Texas Defender Service, *Deadly Speculation*, 17.

7. See David Grann, "Trial by Fire," *New Yorker*, September 7, 2009, 42–63.

8. Texas Defender Service, *Deadly Speculation*, 18.

9. Ibid., 18–20. The report appears as the "Appendix," 55–60.

10. "James Grigson: Expert Psychiatric Witness Was Nicknamed Dr. Death," *Dallas Morning News*, June 14, 2004.

11. Grigson isn't an isolated case; he's just the most egregious. Another is Dr. Richard Coons, who testified in more than fifty death penalty cases and consulted for prosecutors on many more. See Steven Kreytak, "Longtime Expert Witness Unreliable Court Says," *Austin American-Statesman*, October 18, 2010, http://www.statesman.com/news/texas-politics/longtime-expert-witness-unreliable-court-says-979494.html.

12. See http://www.tdcj.state.tx.us/stat/executedoffenders.htm.

13. This record stood until June 15, 2010, when Texas executed David Lee Powell, who had been on the Row since November 6, 1978—thirty-one years and seven months, or 11,578 days.

14. See Dave Mann, "Solitary Men," *Texas Observer*, November 10, 2010, http://www.texasobserver.org/coverstory/solitary-men (February 24, 2011).

15. Susan Combs, Window on State Government, http://www.window.state. tx.us/specialrpt/workforce/demo.php (August 30, 2009).

16. "Population by Race/Ethnicity, City of Houston, 1980, 1990 and 2000," http://www.houstontx.gov/planning/Demographics/demograph_docs/2000census_race.pdf (August 30, 2009).

17. According to the "Executive Summary" of the 2003 Texas Defender Service report *A State of Denial: Texas Justice and the Death Penalty*, "The death penalty is used more often to punish those convicted for murdering white women, the least likely victims of murder." The summary also notes that "[w]hile a 1998 study indicates that 23% of all Texas murder victims were black men, only 0.4% of those executed since the reinstatement of the death penalty were condemned to die for killing a black man." It further notes: "Conversely, as of 1998, white women represented 0.8% of murder victims statewide, but 34.2% of those executed since reinstatement were sentenced to die for killing a white woman." In addition, Texas capital juries "are far 'whiter' than the communities from which they are selected." All of this is documented in detail in the report's fourth chapter (46–61).

18. Glenn L. Pierce and Michal L. Radelet, "Death Sentencing in East Baton Rouge Parish, 1990–2008," *Louisiana Law Review* 71 (2011): 647–73.

19. Those who took the S-Bahn from West Berlin to East Berlin during the

Cold War will remember the sally port at the Friedrichstrasse station. After getting off the train from West Berlin, travelers would, one by one, go into the very small sally port, where a security officer would check his or her passport for a very long time before (hopefully) passing it back through the slot and pushing the button that opened the second steel door.

20. The visitation structure hasn't changed. In 2010 Death Row prisoners could have one or two two-hour visits per week, depending on their security classification. Visitation hours were from 9:00 A.M. to 5:00 P.M. Monday through Friday for both men and women, 5:30 P.M. to 10:00 P.M. on Saturday for men, and 5:30 P.M. to 9:30 P.M. on Saturday for women. On holidays that fell Monday through Friday, condemned prisoners were allowed no visits. So prisoners' family members who might manage a weekday visit because they were off work for a holiday could not visit on that day at all. Non–Death Row prisoners' visitation occurred Saturday and Sunday from 9:00 A.M. to 5:00 P.M.

21. The problem was not unique to Texas then, nor is it unique today. One of the key reasons for backlogs in handling death penalty cases is the lack of lawyers with enough experience even to give the appearance of doing a competent job, as well as a lack of funds to pay and provide case support for the few lawyers that are available, competent or not. California, for example, has what the *Los Angeles Times* calls a "glut" of lawyers, but so

few are available for capital cases that condemned prisoners currently have to wait ten to twelve years before being assigned one. Maura Dolan, "Lack of Funding Builds Death Row Logjam," *Los Angeles Times*, November 27, 2010, http://articles.latimes.com/2010/nov/27/local/la-me-death-lawyers-20101201 (February 20, 2011).

22. The formal term for people with this job is "correctional officer," but since there is no pretense of correction of any kind on Death Row, it seems a euphemism. We refer to them by what they do rather than how they're listed in the prison system's organizational chart.

23. In August 1983 Demouchette murdered Death Row inmate Johnny E. Swift by stabbing him sixteen times in the chest in the dayroom. Demouchette received a life sentence for that murder, which was mooted out or served in full, depending on your point of view, by his execution in 1992 for the 1976 double murder that put him on the Row in the first place. Kerry Max Cook has written an astonishing memoir of his imprisonment and ultimately successful struggle for vindication in *Chasing Justice: My Story of Freeing Myself after Two Decades on Death Row for a Crime I Didn't Commit* (New York: William Morrow, 2007).

24. James W. Marquart, Sheldon Ekland-Olson, and Jonathan R. Sorensen, *The Rope, the Chair, and the Needle: Capital Punishment in Texas, 1923–1990* (Austin: University of Texas Press, 1994), 139–40.

25. Erving Goffman, *Asylums: Es-*

says on the Social Situation of Mental Patients and Other Inmates (New York: Anchor, 1961).

26. That is, in part, what Thomas Kuhn's *The Structure of Scientific Revolutions* (Chicago: University of Chicago Press, 1962) is about: observations that are not explained by the model or are the result of faulty measurement indicate a defect in the model itself.

27. See appendix C, "Post-1974 Department of Corrections Procedures for the Execution of Death-Sentenced Inmates," in Marquart, Ekland-Olson, and Sorensen, *The Rope, the Chair, and the Needle*, 234–40. The document covers everything from transportation of the condemned to the Huntsville Unit and the options for the last meal to media relations and the shower the condemned prisoner takes shortly before execution.

28. Bruce Jackson and Diane Christian, *Death Row* (Boston: Beacon Press, 1980), 31.

29. Which is why, when prison conditions become too brutal, the courts often step in and take control away from the state—as was the case, for example, in Arkansas in *Holt v. Sarver I* and *Holt v. Sarver II* (1969 and 1970), in Mississippi in *Gates v. Collier* (1972), and in Texas in *Ruiz v. Estelle* (1980).

30. The prison opened in 1993 as the Terrell Unit, named for former Texas prison board chairman Charles Terrell Sr. When prison officials started moving condemned prisoners to the unit, Terrell requested that his name be taken off of it, so in 2001 the Texas Board of Criminal Justice renamed it

in honor of Allan Polunsky, who had been the board chairman until a few months earlier.

31. Similar patterns have emerged elsewhere. In North Carolina, for example, capital trials and death sentences have both declined steadily over the past decade. When a jury voted life without parole to multiple murderer Samuel J. Cooper in 2010, the president of the North Carolina Conference of District Attorneys said: "If you can't get the death penalty in that case, gee, what case are you going to get the death penalty in?" See "Death Penalty Cases Dwindle," *Raleigh News and Observer*, May 2, 2010, http://www.newsobserver.com/2010/05/02/463263/death-penalty-cases-dwindle.html (May 10, 2010).

32. There were no religious services on Death Row in 1979. During the entire time we were there, the only man of the cloth to show up was the Baptist minister, who visited the Row twice, about five minutes each time. We asked him to talk about the Row and his work there, but he refused. One of the inmates said, "That's because all he does down here is play dominoes or get the Bible freaks reading certificates." While the work program was going, there were some group religious services in the dayrooms.

33. David Isay, "Witness to an Execution," http://www.soundportraits.org/on-air/witness_to_an_execution/.

34. Texas ACLU prisoners' rights attorney Yolanda Torres has posted on the Internet photos of the Polunsky Death Row that she obtained through a Freedom of Information lawsuit:

http://picasaweb.google.com/yolandamtorres/PolunskyUnitLivingston-Texas#5318817798046201042.

35. Kerry Max Cook's *Chasing Justice*, noted above, describes in harrowing detail life on Texas's Death Row from a point of view that no outsider or prison employee could ever achieve. Jim Willett's *Warden: Prison Life and Death from the Inside Out* (Albany, Tex.: Bright Sky Press, 2004), written with Ron Rozelle, details the last few days from the point of view of a prison official charged with carrying out the death sentence. David Isay's audio essay, "Witness to an Execution," documents the killing process itself.

36. Sara Rimer, "Working Death Row: A Special Report; In the Busiest Death Chamber, Duty Carries Its Own Burdens," *New York Times*, December 17, 2000, http://www.nytimes.com/2000/12/17/us/working-death-row-special-report-busiest-death-chamber-duty-carries-its-own.html (May 4, 2010).

37. Marquart, Ekland-Olson, and Sorensen, "Post-1974 Department of Corrections Procedures for the Execution of Death-Sentenced Inmates," in *The Rope, the Chair, and the Needle*, 234–40.

38. Michael L. Radelet, "Some Examples of Post-*Furman* Botched Executions," September 16, 2009; posted on the Death Penalty Information Center website, http://www.deathpenaltyinfo.org/some-examples-post-furman-botched-executions (April 25, 2010).

39. Major A. J. Murdock died of a stroke in 1982, a few months before Charlie Brooks Jr., #592, became the

first man to be executed in Texas in the post-*Furman* era on December 7, 1982.

40. See *In re Troy Anthony Davis on Petition for Writ of Habeas Corpus*, 2009.

41. So many Illinois capital cases out of Chicago were contaminated by police misbehavior that on January 12, 2003, Governor George Ryan commuted the sentences of all 156 prisoners on the state's Death Row. Death Penalty Information Center: "Illinois Death Row Inmates Granted Commutation by Governor George Ryan on January 12, 2003," http://www.deathpenaltyinfo.org/node/677 (February 25, 2011).

42. Texas governors have commuted thirty-nine death sentences. Twenty-nine of these were in 1995 of individuals who were seventeen years old at the time of their offenses. Another thirty-six died or were killed while on Death Row.

43. See, for example, the statement of Justice Stevens, joined by Justice Breyer, in the certiorari petition *Cecil C. Johnson v. Phil Bredesen, Governor of Tennessee, et al.* (2009). See also the 1993 Privy Council appeal in the case of Earl Pratt and Ivan Morgan, who had been awaiting execution since 1979 (http://www.privy-council.org.uk/files/other/PRATTJ~1.rtf).

44. Justice Stephen Breyer in *Thompson v. McNeil* (2009).

45. See the exchange between Justices Thomas, Breyer, and Stevens in *Thompson v. McNeil*, a denial of cert to a Florida inmate who argued that his thirty-one years on Death Row violated his Eighth Amendment rights. They argued the issue again in another failed

application for cert, *Johnson v. Bredesen* (2009). That case involved a Tennessee inmate who had struggled against execution for twenty-nine years.

46. In particular, see Girard's analysis of sacrifice in *La violence et le sacré* (Paris: Grasset, 1972) and the opening section of Foucault's *Surveiller et punir: Naissance de las prison* (Paris: Gallimard, 1975).

47. Marquart, Elkland-Olson, and Sorensen, "Gazing into the Crystal Ball"; Texas Defender Service, *Deadly Speculation*, 55–60.

48. See Grann, "Trial by Fire," which has to do with the 2004 execution of Cameron Todd Willingham, convicted of having started a fire that killed his three children. Fire experts who examined the evidence after the trial was over concluded there was no arson at all; the fire was almost certainly the result of faulty wiring. The Texas Board of Pardons and Paroles and Governor Rick Perry ignored all of those reports and permitted Willingham's execution to go forth. Perry subsequently fired the chairman and two other members of the state board that was looking into that evidence of Willingham's innocence, and he replaced them with people he found more congenial. Subsequent attempts to seriously reexamine this execution have all been shut down by state officials.

49. Walter Berns, *For Capital Punishment: Crime and Morality of the Death Penalty* (New York: Basic Books, 1979).

50. *Baze v. Rees* (2008).

51. Hitler's T-4 Euthanasia Program was described as a social sanitation project.

52. Ray Paternoster and Jerome Deise, "A Heavy Thumb on the Scale: The Effect of Victim Impact Evidence on Capital Decision Making," *Criminology* 49, no. 1 (February 2011): 129–61.

53. Death Penalty Information Center, "Facts about the Death Penalty," updated May 26, 2011, http://www.deathpenaltyinfo.org/documents/FactSheet.pdf (May 30, 2011).

54. Carol J. Williams, "California Sentences More Prisoners to Die While Executing None," *Los Angeles Times*, December 29, 2010, http://www.latimes.com/news/local/la-me-executions-20101229,0,6086757.story (February 25, 2011).

55. Citations for Ehrlich's initial paper, the key critique of it, Ehrlich's attempt to justify his work, and a key critique of that are listed in the "Sources and Further Information" section of this book. Justice Thurgood Marshall's critique appears as appendix 3.

56. "How Did Economists Get It So Wrong?," *New York Times Magazine*, September 6, 2009, 37.

57. "One study by the Research Department of the Texas Department of Corrections revealed that seventy-three percent of those charged with capital murder and represented by court-appointed attorneys were sentenced to death, but only thirty-five percent of those charged with capital murder and represented by retained counsel were sentenced to death" (Jackson and Christian, *Death Row*, 37–38). The problem of incompetent lawyering in appeals is documented in-depth in the Texas Defender Service report *Lethal*

Indifference: The Fatal Combination of Incompetent Attorneys and Unaccountable Courts in Texas Death Penalty Appeals (Austin and Houston: 2002). Men on the Row complained more about bad and indifferent lawyering than about anything else. "When you ain't got no money to fight your case your ass is down," Paul Rougeau said. "That judge told my lawyer two or three times, 'You sit down. You be quiet. All of this is not necessary.' This was the first death penalty case he ever tried. It was the first criminal case he ever tried."

58. In March 2011 several prosecutors urged Illinois governor Pat Quinn not to sign a bill abolishing the death penalty in the state. They didn't argue that it was just or served as a deterrent. They wanted it as a "bargaining chip," as a device to use extortionately to terrify defendants into pleading guilty when they might otherwise seek a jury trial. They also argued that they received more money from the state for capital cases than for ordinary murder cases and they wanted to keep the income source. See John Hanlong, "'Bargaining' Chip a Poor Rationale for Death Penalty," *Illinois State Journal-Register*, March 5, 2011, http://www.sj-r.com/opinions/x1174969903/In-My-View-Bargaining-chip-a-poor-rationale-for-death-penalty.

59. As, for example, in the Louisiana study cited earlier showing that prosecutors sought the death penalty 95 percent more often when the victim was white than when the victim was a person of color. Glenn L. Pierce and Michal L. Radelet, "Death Sentenc-

ing in East Baton Rouge Parish, 1990–2008," *Louisiana Law Review* 71 (2011): 647–73.

60. The key case here is *McClesky v. Kemp* (1987), in which the court acknowledged the "racially disproportionate impact" of the death penalty in Georgia but concluded that that fact was not in itself sufficient to show that the *purpose* of the death penalty was discriminatory.

61. *Callins v. James* (1994).

62. Blackmun's dissent is full of legal citations. For readability here, we have cut nearly all of them. The full decision can be found online at http://caselaw.lp.findlaw.com/cgi-bin/getcase.pl?court=US&vol=000&invol=U10343.

63. Death Penalty Information Center, "Senator Durbin of Illinois Changes Stance on Death Penalty," http://www.deathpenaltyinfo.org/new-voices-senator-durbin-illinois-changes-stance-death-penalty, February 23, 2011.

Part III

1. Some of Bruce's books resulting entirely or in large part from that field research are: *A Thief's Primer* (New York: Macmillan, 1969); *In the Life: Versions of the Criminal Experience* (New York: Holt, Rinehart and Winston, 1972); *Wake Up Dead Man: Afro-American Worksongs from Texas Prisons* (Cambridge: Harvard University Press, 1972); and *"Get Your Ass in the Water and Swim Like Me": Narrative Poetry from Black Oral Tradition* (Cambridge: Harvard University Press, 1974).

2. The case had two parts. In 1969, in *Holt v. Sarver I*, Judge J. Smith Henry found some aspects of the Arkansas prison system unconstitutional; a year later, in *Holt v. Sarver II*, he said the entire system violated the prisoners' constitutional rights. Bruce's work in Arkansas resulted in three photographic exhibits and three books: *Killing Time: Life in the Arkansas Penitentiary* (Ithaca: Cornell University Press, 1977); *Cummins Wide: Photographs from the Arkansas Prison* (Durham: Center for Documentary Studies; and Buffalo: Center for Studies in American Culture, 2008); and *Pictures from a Drawer: Prison and the Art of Portraiture* (Philadelphia: Temple University Press, 2009).

3. Those are minor increases compared to what has happened since. At the end of the 2009 fiscal year, the Texas Correctional Institutions Division (the current name for what was called the Texas Department of Corrections in years past) operated fifty-one prisons and forty-five other facilities. The 28,642 employees in those institutions managed 155,079 prisoners. Texas Department of Criminal Justice (Austin), *Annual Review 2009*, July 2010, 23.

4. Bruce Jackson and Diane Christian, *Death Row* (Boston: Beacon Press, 1980).

5. *Death Row* was shown on American, French, and German public television; in many film festivals and conferences; and at the Museum of Modern Art, Arsenal (Berlin), and many other such places. It has frequently been exhibited by Amnesty International and is still in circulation from Documentary Educational Resources, Boston.

6. William T. Harper, *Eleven Days in Hell: The 1974 Carrasco Prison Siege at Huntsville, Texas* (Denton: University of North Texas Press, 2004).

7. Bruce Jackson, "Hard Time," *Texas Monthly* (December 1978): 139–42, 255–63.

8. "Reciprocity in Field Work," in *Human Organization Research: Field Relations and Techniques*, ed. Richard N. Adams and Jack J. Priess (Homewood, Ill.: Dorsey Press, 1960), 92.

9. See, for example, Meredith Simons and Robert Gavin, "Texas Has Worst Record of Prison Sex Abuse," *Houston Chronicle*, April 5, 2010, http://www.chron.com/disp/story.mpl/metropolitan/6944075.html(May 31, 2010).

SOURCES AND FURTHER INFORMATION

The best source of factual information on capital punishment on the Internet is the Death Penalty Information Center (**DPIC**): http://www.deathpenaltyinfo.org. **DPIC** opposes capital punishment. Perhaps the primary voice for the proponent side is the Criminal Justice Legal Foundation: http://cjlf.org/deathpenalty/DPinformation.htm.

The Texas Department of Criminal Justice maintains a website that details Texas Death Row population, executions, former residents, and more: http://www.tdcj.state.tx.us/stat/deathrow.htm.

David Carson's Texas Execution Center website (http://txexecutions.org) contains up-to-date reports on executions, summaries of Texas executed offenders' cases since mid-1999, and a short primer on the capital process from trial through appeal to final resolution.

The Clark County, Indiana, prosecuting attorney's office maintains a Web page with the most up-to-date list of U.S. executions, as well as information on all other U.S. executions going back to 1976: http://www.clarkprosecutor.org/html/death/usexecute.htm.

The Texas Defender Service (http://www.texasdefender.org) offers a group of solidly researched publications that document and analyze problematic issues in administration of the death penalty in Texas. These publications—*Deadly Speculation: Misleading Texas Capital Juries with False Predictions of Future Dangerousness*; *Lethal Indifference: The Fatal Combination of Incompetent Attorneys and Unaccountable Courts*; and *A State of Denial: Texas Justice and the Death Penalty*—are all available online at http://www.texasdefender.org/publications.

Kerry Max Cook wrote about his ordeal—twenty-one years on the Row for a crime done by someone else—and the struggle that resulted in his release in *Chasing Justice: My Story of Freeing Myself after Two Decades on Death Row for a Crime I Didn't Commit* (New York: William Morrow, 2007).

We present selections from the conversations we had with inmates and staff on the Row in *Death Row* (Boston: Beacon Press, 1980).

James Willett has written (with Ron Rozell) a fascinating memoir of his years as a warden in Texas prisons, many of which were spent at The Walls, where he oversaw executions: *Warden: Prison Life and Death from the Inside Out* (Albany, Tex.: Bright Sky Press, 2004).

Don Reid, longtime editor of the *Huntsville Item*, started writing about executions at The Walls as a bit of extra work for the Associated Press when he was a young reporter. In the course of thirty-five years, Don observed 189 executions and went from a disinterested observer to a fierce and articulate critic of capital punishment. He wrote (with John Gurwell) about his experiences in *Eyewitness* (Houston: Cordovan Press, 1973; reprinted as *Have a Seat, Please* by Texas Review Press, 2001).

James W. Marquart, Sheldon Ekland-Olson, and Jonathan R. Sorensen have written a history of capital punishment in Texas: *The Rope, the Chair, and the Needle: Capital Punishment in Texas, 1923–1990* (Austin: University of Texas Press, 1994).

Jon Sorensen and Rochy Leann Pilgrim have documented Texas capital punishment in the post-*Furman* era: *Lethal Injection: Capital Punishment in Texas during the Modern Era* (Austin: University of Texas Press, 2006).

David Isay's audio essay, "Witness to an Execution," documents the killing process itself. He and his Sound Portraits team recorded Warden Willett, the tie-down team, the death-house chaplain, and a former corrections officer who attributes his mental breakdown to his participation in too many executions. The Peabody Award–winning program, which originally aired on *All Things Considered* on October 20, 2000, can be heard online at http://www.soundportraits.org/on-air/witness_to_an_execution/.

Sara Rimer has written about the execution process from the point of view of the warden and the tie-down team: "Working Death Row: A Special Report; In the Busiest Death Chamber, Duty Carries Its Own Burdens," *New York Times*, December 17, 2000, http://www.nytimes.com/2000/12/17/us/working-death-row-special-report-busiest-death-chamber-duty-carries-its-own.html (May 4, 2010).

Joseph T. Hallinan, in *Going up the River: Travels in a Prison Nation* (New York: Random House, 2001), analyzes the recent huge increase in American prison populations, with particular focus on the Texas expansion and the transformation of prisons in America from social agencies to business enterprises.

Ken Light visited the Death Row on Ellis in 1994, fifteen years after we did our work there and seven years before the condemned were moved to Polunsky. His photos appear in *Texas Death Row* (Jackson: University Press of Mississippi, 1997). The Row he visited in 1994 occupied more cell blocks than the one we visited in 1978 and 1979. In 1994 the condemned prisoners had graduated security levels, some of them were allowed into a work program, and some of the cells had grilles and separators added to the doors. Even so, we doubt the Death Row he visited was more than superficially different from the one we knew.

The most recent study of capital punishment in America is David Garland's *Peculiar Institution: America's Death Penalty in an Age of Abolition* (Cambridge: Harvard University Press, 2010). Garland, who emigrated to the United States from Scotland ten years ago, assembles a great deal of factual information, but he spends so much time arguing with Michel Foucault (mostly over things Foucault never said or implied) that his book often seems more an attempt to trump Foucault than apply an outsider's point of view to a troublesome American institution.

The campaign that led to the 1981 abolition of capital punishment in France offers an interesting counterpoint to what went on in the United States during the same years and what has happened since. Perhaps the best book on that is Robert Badinter, *L'Abolition* (Paris: Fayard, 2000). His speech to the National Assembly the day before the vote is one of the great abolitionist arguments: *"Demain, vous voterez l'abolition de la peine de mort": Discours de Robert Badinter devant l'Assemblée nationale, 17 septembre 1981* (Paris:

Editions Points, 2009). At one point, Badinter notes that capital punishment has disappeared in the democracies of the West. One of the deputies, Claude Marcus, interrupts, saying, "Pas aux État-Unis" (Not in the United States). Badinter responds that he was speaking of the European democracies, but in any case, the United States was the exception (29).

Isaac Ehrlich's first salvo in his attempt to convince the rest of us that executions reduced murders was "The Deterrent Effect of Capital Punishment: A Question of Life and Death," *American Economic Review* 65, no. 3 (1975): 397–417. After that article was shredded by critics, he wrote several more articles defending and restating his work, including Ehrlich and Joel C. Gibbons, "On the Measurement of the Deterrent Effect of Capital Punishment and the Theory of Deterrence," *Journal of Legal Studies* 6, no. 1 (1977): 35–50; Ehrlich, "The Deterrent Effect of Capital Punishment: Reply," *American Economic Review* 67, no. 3 (1977): 452–58; Ehrlich, "Capital Punishment and Deterrence: Some Further Thoughts and Additional Evidence," *Journal of Political Economy* 85, no. 4 (1977): 741–88; and Ehrlich: "The Deterrent Effect of Capital Punishment: Ehrlich and His Critics: Rejoinder," *Yale Law Journal* 85, no. 3 (1976): 368–69.

Some of the scholarly articles that marked the fatal errors in Ehrlich's work, the crippling problems in his methodology, and the illegitimacy of his conclusions are Jon K. Peck, "The Deterrent Effect of Capital Punishment: Ehrlich and His Critics," *Yale Law Journal* 85, no. 3 (1976): 359–67; Peter Passell and John B. Taylor, "The Deterrent Effect of Capital Punishment: Another View," *American Economic Review* 67, no. 3 (1977): 445–51; David Baldus and James W. L. Cole, "A Comparison of the Work of Thorsten Sellin and Isaac Ehrlich on the Deterrent Effect of Capital Punishment," *Yale Law Journal* 85, no. 2 (1975): 170–86; and William J. Bowers and Glenn L. Pierce, "The Illusion of Deterrence in Isaac Ehrlich's Research on Capital Punishment," *Yale Law Journal* 85, no. 2 (1975): 187–208.

Sorenson and Pilgrim devote a chapter of *Lethal Injection* to the question of deterrence ("Deterrence: Does It Prevent Others from Committing Murder?" [20–48]). After examining all the major studies through 2007, they conclude the answer is no—capital punishment does not deter other possible murderers. They look at Ehrlich's work particularly in a section appropriately titled "Voodoo Economics" (37–39).

Perhaps the most important critique of Ehrlich's work was Justice Thurgood Marshall's 1976 dissent in *Gregg v. Georgia*. Unlike the items in the previous two paragraphs, Marshall's opinion wasn't an academic response to Ehrlich's academic exercise but was instead a real attempt to keep real people from really getting killed in a manner justified by pseudoscience. The body of Marshall's dissent is presented in appendix 3.

CASES

Adams v. Texas, 448 U.S. 38 (1980).

Baze v. Rees, 553 U.S. 35 (2008).

Callins v. James, denial of petition for a certiorari decided February 22, 1994.

Cecil C. Johnson v. Phil Bredesen, Governor of Tennessee, et al., 558 U.S.____(2009).

Estelle v. Smith, 451 U.S. 454 (1981).

Furman v. Georgia, 408 U.S. 238 (1972).

Gates v. Collier, 501 F. 2d 1291 (5th Circuit, 1972).

Gregg v. Georgia, 428 U.S. 153 (1976).

Herrera v. Collins, 506 U.S. 390 (1993).

Holt v. Sarver I 300, F. Supp. 825 (1969).

Holt v. Sarver II 309, F. Supp. 362 (1970).

In re Troy Anthony Davis on Petition for Writ of Habeas Corpus, 557 U.S.____(2009), no. 08–1443, decided August 17, 2009.

McCleskey v. Kemp, 481 U.S. 279 (1987).

Profitt v. Florida, 428 U.S. 242 (1976).

Roberts v. Louisiana, 428 U.S. 325 (1976).

Ruiz v. Estelle, 503 F. Supp. 1265 (S.D. Texas 1980).

Thompson v. McNeil, 129 S. Ct. 1299 (2009).

Woodson v. North Carolina, 428 U.S. 280 (1976).

A TECHNICAL NOTE

With five exceptions, all of the photographs reproduced in this book were made with a Nikon F2 or a Leica M4 using Kodak Tri-X film, exposed at EI 1200 and developed in Acufine.

The exceptions are the aerial view of Ellis prison (p. 218), Kenneth Davis folding Marlboro wrappers in his cell (p. 68), the cell door locking pins (p. 5), guard Ronnie D. Hodges in the J block hallway picket (p. 152), and the Polaroid of Emery Harvey in the barber chair (p. 206). The aerial view of Ellis and the picture of Kenneth Davis are from Ektachrome slides processed and scanned normally, then converted to greyscale in Photoshop CS4. The photos of the cell door locking pins and Hodges are screen captures from the DVD version of the film *Death Row*, also converted to greyscale in Lightroom 3. Bruce took the aerial photo in the spring of 1978; all the other photos were taken in April and December 1979.

All original 35mm negatives and slides were scanned at 4000 dpi using a Nikon Super Coolscan 9000ED. The TIFF files used for this book, and the publishing reference prints, were made from those scans using Photoshop CS5 and Lightroom 3.

All the original negatives for the images in this book, a copy of the digital files used for production of all images in this book, along with all the rest of Bruce Jackson's fieldwork negatives, will be part of the Bruce Jackson collection at the American Folklife Center at the Library of Congress.

INDEX

Adams v. Texas (1980), 140, 238
Anderson, Mary, 143
Aranda, Arturo, 88, 89, 90

Badinter, Robert, 236
Barefoot, Thomas Andrew, vii, 8, 12, 13, 28, 30, 31, 86, 87, 112–15, 159, 165, 166, 199, 206, 213
Baze v. Rees (2008), xiii, 180, 182, 187, 238
Berger, Joel, 199
Berns, Walter, 179
Beseda, Elizabeth, 131
Beto, George, 166, 193–95, 214
Bill Clements Unit (TDC, Amarillo), 78
Bird, Jerry, 42, 48, 49
Blackmun, Harry A., xiii, 136, 183, 186, 187
Bodde, Gerald, 153, 176, 201–3, 207, 212, 217
Brandon, Thelette, 60–62, 156–60, 162, 165, 212–14
Brennan, William, 136, 137, 187, 226
Breyer, Steven, 232 (n. 45)
British Royal Commission on Capital Punishment, 228
Britton, Christopher, 176
Brock, Kenneth Albert, 126, 127
Brooks, Charlie, 138
Buffington, James, 151
Building tender, 155, 195
Bullock, Brent, Jr., 214–16
Burger, Warren, 136, 183
Burns, Donald, 12, 13, 142
Burns, James, 142
Byars, Clyde, 205, 206, 209, 210, 213
Byrd, Alton, 423

Callins, Bruce Edward, 183, 186

Callins v. James (1994), 186, 187, 234 (n. 61), 238
Cammacho, Genario Ruiz, 174
Cannon, Joseph, 174
Capital murder, 138
Capital punishment, 178–82, 226–28
Carrasco, Fred Gomez, 131, 146, 198
Cases, material, 176, 238
Chambers, Ronald, 106, 189
Chasing Justice: My Story of Freeing Myself after Two Decades on Death Row for a Crime I Didn't Commit (Cook), 82, 231 (n. 23), 235
Coffield Unit (TDC), 142
Collins, Wilbur ("Wolf"), 74–78, 156, 159, 160
"Continuing danger to society," 108, 138, 139
Cook, Kerry Max, 92–95, 108, 153, 161, 162, 165, 170, 200, 235
Coons, Richard, 230 (n. 11)
Court-appointed lawyers, xii, 183
Cousins, Bob, 209, 212
Crawford, Donnie (Muriel), viii, xiii, 49, 51, 90, 91, 156, 159, 160, 205, 213
Cuevas, Ignacio, 130, 131, 198

Davis, Kenneth, 56, 57, 66–71, 86, 87, 156, 165
Davis, Troy, 175
Death house, 164, 172, 173
Death penalty, xii, xiii; unfair and capricious application of, xiv, 135–44, 184; problems with, 179–89, 226–28
Death Row, xi–xv; as differing from other prisons, xiii, 142, 143, 162, 167, 168; legal

limbo of, xi; moved from Ellis to Terrell/Polunsky, 171, 231–32 (n. 30); murders on, 176; as being "outside" time, xiii, 168, 169, 177; pictures of Bruce Jackson and Diane Christian at, 205, 206, 213; suicides on, 176
Death Row (book), xiv, 230 (n. 1)
Death Row (1979 film), xiv, 230 (n. 1), 234 (n. 5); first screening of, 212
Death Row count board, xii, 3, 4, 144, 150
Demouchette, James, 153, 161, 231 (n. 23)
Denning, Lord Justice, 228
Devries, John, 142, 164, 176
Dickerson, James, 176
Dominquez, Rudy, 131, 198
Douglas, William O., 136, 187
DRs (Death Row inmates), 143, 146, 148, 149, 153, 154, 165, 168, 169, 171, 173, 177, 189, 212
Durbin, Dick, 188, 234 (n. 63)
Durrough, Fred, 72, 73, 151, 213

Earvin, Harvey, 189
Eastham Unit (TDC), 210
Ehrlich, Isaac, 182, 224–26, 233 (n. 55)
Electric chair ("Old Sparky"), 17, 101, 164, 173, 174
Ellis Unit (TDC), xi, 2, 116, 135, 142, 144–49, 161, 162, 165, 170–72, 194, 196, 198, 206, 208, 209, 218, 219
Estelle, James, 194
Estelle v. Smith (1981), 140, 141, 238
Executions, xi; botched, 174

Exercise cage, 34–40, 153, 164, 167
Exonerated, The (Jensen and Blank play), 92

Fearance, John, 128, 129
Fields, Mark, 78, 79, 81, 84, 141, 160
Flores, Jesus, 176
Freeman, Leonard, 142
Furman v. Georgia (1972), xii, 59, 81, 135–37, 173, 176, 180, 183, 184, 185, 187, 204, 223, 224, 226, 228, 238

Garcia, Moses, 46, 49, 51, 54, 55, 62–65, 86, 87
Gates v. Collier (1972), 231 (n. 29), 238
Gatesville Unit (Mountain View), 143, 171
Gilmore, Gary, 215, 216
Goree Unit (TDC), 143, 194
Granviel, Kenneth, 42
Gregg v. Georgia (1976), xiii, 59, 137, 138, 182, 223, 238
Grigsby, Charles, 8, 11, 24, 159
Grigson, James ("Dr. Death"), 139, 140
Gunter, James, 176
Gurule, Martin, 170

Hamilton, Raymond, 170
Harvey, Emery, 8, 10, 152, 159, 204, 206, 213
Hayter, John, 152, 200, 206
Herrera v. Collins (1993), 175, 186, 187, 238
Hodges, Ronnie D., 152, 159
Holt v. Sarver I (1969) and *Holt v. Sarver II* (1970), 231 (n. 29), 234 (n. 2), 238
Hughes, Billy, 17, 116–21, 135, 153, 160, 163, 165–67

Huntsville Unit (TDC). *See* Walls, The

Idar, Ed, 211
Innocence Project, 92
In the Life (Jackson), 200
Isay, David, 172, 232 (nn. 33, 35), 236

J-23 and J-21 (Ellis Death Row), ix, xiv, 2–6, 8, 16–18, 20–27, 78, 97, 136, 141–44, 148, 150, 151, 154, 155, 164–66, 170, 205, 212
Johnson, Joseph, 136, 174
Johnson, Michael, 176
Jones, Jessie, 42
Jordan, Charles, 46, 47, 49, 50, 51, 86, 87, 189
Jordan, Clarence, 58
Jurek, Jerry, 58, 59, 137, 142, 151, 161
Jurek v. Texas (1976), 137, 187
Justice, William Wayne, 155, 211

Killing Time (Jackson), 200
King, Edward, 176
Krugman, Paul, 182

Landry, Raymond, 174
Lethal injection, 101, 138, 164, 173, 174, 177, 183, 186
Life sentence, 140
Livingston, James, 44, 45
Lyons, Michele, 172

Macmillan, Billy, 194
Mailer, Norman, 214–16
Marshall, Thurgood, 136, 137, 182, 187, 223–28
Mata, Ramon, 176
Mattox, Stephen, 176
McAdams, Carl Luther ("The Bear," "Beartracks"), 194
McCaskle, D. V. ("Red"), 194
McCoy, Stephen, 174
McDonald, Gary, 198

McGhee, Calvin, 176
McMahon, Billy, 52, 53, 71
McWiliams, Carey, 196
Monge, Louis, 136
Moore, Mark, 13, 80, 81, 86, 87, 152
Morin, Stephen Peter, 174
Muniz, Pedro ("Lobo"), 28, 30, 31, 33, 56, 57, 86, 87, 122–25, 165, 217
Murdock, A. J., 173–75, 232 (n. 39)

Napier, Carl, 176
Nelson, Porter, 176

O'Bryan, Ronald ("Candyman"), 106, 107, 204, 220, 221
O'Connor, Sandra Day, 136, 183
Oliver, Emme ("Straight Eight"), 143

Parole, 140
Picket, 2, 5, 145, 146, 151
Pierce, Anthony, 189
Pierce, Glenn L., 144
Polunsky Unit (TDC, formerly Terrell Unit), 41, 169, 171, 172, 176, 180, 231 (n. 30), 232 (n. 34)
Population (non–Death Row prisoners), xii, 177
Powell, David Lee, 189, 230 (n. 13)
Powell, Lewis F., 136, 183, 226–28
Prejean, Sr. Helen, 189
Prison doctor, 14, 15
Profitt v. Forida (1976), 137, 238
Puglia, Jerry, 198

Quinn, Pat, 188, 189, 233 (n. 58)
Quinones, John, 202, 204

Radelet, Michael L., 174
Ramsey Unit (TDC), 206
Rehnquist, William H., 136, 183

Retained counsel, xii, 183, 231 (n. 21), 233 (n. 57)
Rigsby, Charles, 207
Riles, Raymond ("King Motto"), 106, 107, 189, 200
Roberts v. Louisiana (1976), 137, 224, 238
Robinson, William, 176
Ross, Larry, 42, 200, 201
Rougeau, Paul, 24, 28–31, 47, 49, 50, 86, 87, 96–99, 154, 165, 199
Ruiz v. Estelle (1980), 155, 161, 195, 198, 211, 231 (n. 29), 238
Rushing, Eli, 209, 219, 212
Russell, James, 104, 105
Ryan, George, 188, 232 (n. 41)

Sam Houston State University, 193, 198, 212
Sanne, Charles Victor, 108, 220; his picture mislabeled as Skillern, 221
Savage, Oscar ("Slim"), 194
Scalia, Antonin, 175, 186, 187
Schiller, Lawrence, 215
Skillern, Doyle ("Skeet"), 28–31, 33, 86, 87, 108–11, 139, 165, 220, 221
Smith, Ernest Benjamin, 140
Smith, Jack, xiv, 52, 53, 82–86, 141, 154, 156, 158, 160, 189, 220, 222
Sothern, Billy, 199, 208
Standley, Judy, 131
Stevens, John Paul, xiii, 180, 182, 187, 224, 226–28
Stewart, Potter, 136–38, 187, 224, 226–28
Summerfield, Scott, 7–9, 158
Supreme Court, xiii, 133–37, 140, 179, 183, 185, 187
Swift, Johnny, 231 (n. 23)

TDC (Texas Department of Corrections, now called the Texas Correctional Institu-

tions Division), 2, 194, 195, 234 (n. 3)
Terrell Unit (TDC, renamed Polunsky), 142, 171, 231 (n. 30)
Thomas, Clarence, 175
Thompson, John R., 100, 101, 161
Torres, Yolanda, 232 (n. 34)
Trusties, 8, 154
Tucker, Karla Faye, 143
Tumblin, Dean, 176
Turner, Joseph, 176
Turner, William Bennett, 211
Tutu, Desmond, 189

Vanderbilt, Jim, 176
Vargas, Richard, 160, 161
Vigneault, Donald, 176

Walls, The (TDC, Huntsville Unit), xi, 108, 131, 146, 164, 172, 173, 175, 176
Wax, Rosalie, 208
White, Billy ("Steel Bill"), 42, 48, 49
White, Byron, 136, 138, 187, 224
White, Robert Excell, 102, 103, 141, 142, 161, 162, 189, 202–4, 212
Willett, Jim, 172, 177
William, Calvin, 176
Willingham, Cameron Todd, xiii, 139, 220, 222, 233 (n. 48)
Woodkins, Calvin, 156
Woods, Billy, 201
Woodson v. North Carolina (1976), 137, 238

DEATH ROW

a film by Bruce Jackson and Diane Christian

When this film was made in 1979, 114 men were housed in the special death cells of Ellis Prison. These men spent their time waiting for the State to kill them or fighting as hard as they could to prevent that killing from happening.

The film is about how men got by on the Row, how they filled the years between the decreeing of a death sentence by a judge and ultimate resolution in freedom, commutation, or death by lethal injection. Some of the condemned men discuss their relationships with their families and attorneys; they describe how they keep from going crazy; they talk about the waiting. The film depicts the few physical actions that barely break the monotony of life on the Row: food service with trays slid under cell doors, haircuts, domino games in the small dayroom, chess games on boards suspended between two cells by strips of cloth, manufacture of picture frames from cigarette packs and tobacco wrappers, reading law books, watching television.

The filmmakers had unsupervised access to the Row. No guard or other official was in the cells when they were doing the filming and interviewing. No other documentary film shows this otherwise hidden territory in the American criminal justice system. It would be impossible to make such a film today.

The images and voices are over thirty years old, and many of the speakers have been put to death. But what these men have to say about the world they inhabit is as pertinent as the voices we would hear (if the authorities would permit, which they won't) on any American Death Row now.

In 2007 the original film was transferred to digital media and both sound and images were completely restored.

Death Row was funded by grants from the American Film Institute, the Polaroid Foundation, the Playboy Foundation, and the Levi Strauss Foundation. The digital restoration was funded by the University at Buffalo's Baldy Center for Law and Society and Samuel P. Capen Chair in American Culture.